MARITAIN'S ONTOLOGY OF THE WORK OF ART

by

JOHN W. HANKE

MARTINUS NIJHOFF / THE HAGUE / 1973

PRINTED IN THE NETHERLANDS

TABLE OF CONTENTS

ABBREVIATIONS

The following are abbreviations of titles and the editions of Maritain's works used in footnote references:

AG *Approaches to God*, Harper and Brothers, 1954.

A & S *Art and Scholasticism* in *Art and Scholasticism and The Frontiers of Poetry*, Charles Scribner's Sons, 1962.

BPT *Bergsonian Philosophy and Thomism*, Philosophical Library, 1955.

CI *Creative Intuition in Art and Poetry*, Meridian Books, Inc., 1953.

DK *The Degrees of Knowledge*, Geoffrey Bles, 1959.

E & E *Existence and the Existent*, Pantheon Books, 1948.

FP *Frontiers of Poetry* in *Art and Scholasticism and The Frontiers of Poetry*, Charles Scribner's Sons, 1962.

KTC "On Knowledge Through Connaturality," in *The Range of Reason*, Charles Scribner's Sons, 1952.

OHK "On Human Knowledge," in *The Range of Reason*, Charles Scribner's Sons, 1952.

PE "Poetic Experience," in *The Review of Politics*, 6 (October, 1944), 387-402.

PM *A Preface to Metaphysics: Seven Lectures on Being*, New American Library, 1962.

RsI *Réflexions sur l'Intelligence et sa Vie Propre*, Nouvelle Librarie Nationale, 1924.

S & S "Sign and Symbol," in *Ransoming the Time*, Charles Scribner's Sons, 1941.

SP *The Situation of Poetry*, Philosophical Library, 1955.

INTRODUCTION

1. Since the appearance in 1902 of Benedetto Croce's *L'estetica come scienza dell'espressione e linguistica generale*, the problem of the ontology of the work of art or aesthetic object – what kind of thing it is and what its mode of being is – has come to occupy a central place in the philosophy of art. Moreover, a particular conception of the identity of art objects is at present a driving force in some quarters of the art world itself. As Harold Rosenberg so well points out, Minimalist or Reductive Art has attempted, sometimes quite self-consciously, to establish the autonomous physical reality of the work of art by emptying it of all expressive and representational content.[1]

What is the ontological problem? One rather crude way of stating it is to ask *where* the work of art or object of aesthetic contemplation exists.[2] Is it, to pick some examples, to be identified with the material product of the artist's labors which exists spatially "outside of" and independently of artist and beholder? Or does it exist only "in the mind" of the beholder or the artist? Is it either one perception of a beholder or a series of his perceptions? Or is it the class of all perceptions of either all spectators or all "qualified" spectators? Put another way, it would be a question of whether and to what such purported names as 'Beethoven's Fifth Symphony' refer.

[1] Notable among works on the problem are R. G. Collingwood's *Principles of Art*, René Wellek's "The Mode of Existence of the Literary Work of Art," Stephen Pepper's "Supplementary Essay" in *Basis of Criticism in the Arts* and the series of criticisms and replies that followed on the essay, a section in C. I. Lewis' *Analysis of Knowledge and Valuation*, H. Osborne's *Theory of Beauty*, E. Gilson's *Painting and Reality*, the first chapter of Monroe Beardsley's *Aesthetics*, Roman Ingarden's *Das literarische Kunstwerk*, Mikel Dufrenne's *Phénoménologie de l'expérience esthétique*, and R. Wollheim's *Art and Its Objects*.

For Rosenberg's analysis of Minimalist Art, see his "Defining Art," reprinted in *Minimal Art: A Critical Anthology*, ed. Gregory Battcock (New York, 1968), pp. 298-307.

[2] Or as René Wellek and Austin Warren put it, "What is the 'real' poem; where should we look for it; how does it exist?" [*Theory of Literature*, 3rd ed. (New York, 1956), p. 142.]

The problem is especially apparent and complex in those arts like music which involve a performance. In them, if we identify, for example, the work with a tangible product like the printed score, we will be forced to say that there are as many works as there are scores. Further, the score is merely a record of the work and as such is sometimes erroneous. The musical work itself involves an ordered series of sounds, and the score could well be regarded as simply the recipe for producing them. We might be tempted, as a consequence of these difficulties, to identify the work with a given performance of it; but we often and meaningfully judge performances as to their adequacy to the work. And such evaluations can be made only if the latter is distinct from the various performances of it. Hence perhaps the work is more than just a performance and serves as a standard by which to judge a rendition of it.

Now we can correct inadequacies of the performance mentally, producing an aesthetically richer experience; but if, following this lead, we identify the work of art with the experience of a listener, placing it "in the mind" of a perceiver, further problems arise. For one thing, contrary to commonsense belief, the musical work would not exist when not actually being heard. What is more, the experience of no one person – however discriminating – is necessarily adequate to what we refer to as the particular work of art. Commonly, we discover new details of a work each time we encounter it. Hence we cannot with assurance say that any one experience, no matter how much past experience is "funded" into it, is adequate. Thus, one observer can be aware of things that another is not. But if we make the experience collective and say that the work is a class of experiences of all observers, past, present, and future, then it would encompass an infinity of experiences, including what surely in many cases would be purely private and irrelevant responses by isolated individuals. On the other hand, if it is only the experience *common* to all experiences of the work, the work of art would be a sort of lowest common denominator and would be only as rich as the poorest experience. Further, if a class has no existence of its own, then to equate the work with a class would be to deny its existence.

But then perhaps the work can be located by saying that it is what the artist had in mind and that the full reality of the work is to be found in the artist's mind and nowhere else – any physical manifestations being merely instrumentalities by which to convey the work, at least partially, to sensitive perceivers. Critics of this view contend, how-

ever, that we do appreciate works of art without being able to ascertain what the artist's intent was and that symbols – musical, linguistic, or plastic – have a meaning quite independent of the artist. Further, the artist may be dead, and the work would then have an existence only in the past. Again, it is difficult to discover what the artist intended; and even if this can be done, the work may have aesthetic value that the artist did not foresee when he executed it.[3]

Even in painting and sculpture, where there is a single, unduplicable, tangible physical object which we can point to as the referent of the title of the work, there still are problems. If an aesthetic object is – in the case of painting let us say – composed of colored patches of various shapes and if color be subjective, then what is ultimately produced – even at the level of sensory qualities – by the manipulation of various pigments selected for their color would seem not to be on the canvas.[4] But if we hold that color is really in the pigment, there is still the fact to be reckoned with that (1) things signified by the blobs of paint and pieces of marble, and (2) such experiences as depth in a painting are not literally existent in the material artifact.[5] The mind of the beholder must somehow bring these meanings to the physical object which serves to call them forth. But now to suppose that a painting is fully realized only when experienced is to subject this art form to many of the difficulties previously discussed in terms of music.

[3] Some excellent discussions of the problem, on which I have relied throughout the foregoing exposition of it, can be found in M. Beardsley, *Aesthetics: Problems in the Philosophy of Criticism* (New York, 1958), pp. 18-22, 25; W. Elton, *A Guide to the New Criticism* (Chicago, 1953), pp. 24-26; D. Henze, "The Work of Art," *Journal of Philosophy*, 54 (1957), 437-438; S. Pepper, "Further Considerations of the Aesthetic Work of Art," *Journal of Philosophy*, 49 (1952), 276-278; S. Pepper, "On Professor Jarrett's Questions About the Aesthetic Object," *Journal of Philosophy*, 49 (1952), 634, 637; Wellek and Warren, pp. 142-150.

[4] This view is shared by many aestheticians. Stephen Pepper, for example, says that the sensuous materials of aesthetic perception are the colors, lines, and masses resulting from the psychological responses to physical stimuli. "On Professor Jarrett's Questions...," p. 636. The physical vehicle, he suggests in *The Work of Art, possibly* does not contain the perceptual qualities constituent of the object of criticism. [*The Work of Art* (Bloomington, Indiana, 1955), p. 91.] Later he says categorically that the perceptual qualities which are the actual qualitative content of the work are only in the perceiver, having been evoked by the physical object. "The Work of Art Described from a Double Dispositional Base," *Journal of Aesthetics and Art Criticism*, 23 (Summer, 1965), 422. See also H. Osborne, *Theory of Beauty* (London, 1952), pp. 92-99.

[5] See F. Sparshott, "Mr. Ziff and the 'Artistic Illusion'," *Mind*, 61 (1952), 376-380; Beardsley, pp. 31-40; S. J. Kahn, "What Does a Critic Analyze?" *Philosophy and Phenomenological Research*, 13 (December, 1952), 241-244. Whether they exist in it at all and if so in what way will form one of the central considerations concerning Maritain's position. It is sufficient to say here that the non-recognition of the existence of the signified meanings in the physical object seems to be one of the main reasons, apart from the question of the objectivity of sensible qualities, for the generation of these problems in contemporary aesthetic thought.

2. Some further light can be shed on the nature of the problem at this point by noting its import for a philosophic conception of art criticism. The critic endeavors to explicate, as well perhaps as to evaluate, the work of art. Is there any possibility that these critical judgments can be universally valid? The solution to this properly philosophical question will depend upon what one determines the object of criticism to be. If what I am experiencing in the presence of some pigments on a canvas is not shared by others in a similar circumstance, then my interpretations and evaluations will, on this account, seemingly not be valid for someone else since we would be experiencing different objects.[6]

Further, the problem generates philosophical questions about the practice of criticism regarding what the critic is to consider relevant to the work as an object of aesthetic experience. If, for example, with Monroe Beardsley we take the work as aesthetic object to be immediate appearance as distinct from the physical basis of the appearing and if we consequently reject as characteristics of the aesthetic object those

Thus Henze, for example, says against Pepper that the work of art is not an experience nor a class of experiences, since artists do not create experiences. ("The Work of Art," p. 439) But although when we say that Leonardo created the *Mona Lisa*, we are talking about the vehicle, Henze seems to suggest that the vehicle is not the work either. (p. 441) The vehicle is the occasion for the experience; but to identify it with the work is to overlook the relativity of the experiences of perceivers of it and the consequent difficulties of fixing its properties and values (pp. 431, 439). There is a vehicle and there are the ways it appears to me, but beyond that no other entity called the work of art. This last phrase is an abstraction really, and the question "What is a work of art?" is better expressed by "How do names and expressions function in aesthetic discourse?" (p. 442). 'Work of art' will then appear as syncategorematic.

This conclusion may seem to some a little odd; even if what appears in experience is not physically a property of the "vehicle," we must ask whether it is still somehow intrinsic to it and whether in fact the fabricated object is indeed the work of art. See also C. I. Lewis, *Analysis of Knowledge and Valuation* (LaSalle, Illinois, 1947), pp. 473-476.

[6] One might note here that the desire for objectivity in criticism within an idealist epistemological commitment seems to be the chief motivation in Stephen Pepper's labors. It is interesting to see how he attempts to establish an objectivity and stability for the aesthetic work of art without identifying it with the physical object. He suggests that in addition to the relative changelessness of the physical object, there are factors on the side of the subject which make for stability – viz. (1) the biological fact that men are of one species and have the same perceptual equipment and (2) the common cultural tradition that is shared by many and gives meaning intrinsically to the object which arises in that milieu. ("Supplementary Essay" in *The Basis of Criticism in the Arts*, pp.166-167; "The Work of Art Described from a Double Dispositional Base," pp. 424-425). The aesthetic work of art is then conceived of as being a series of perceptions of many individuals, with a *convergence* (as a result of these subjective factors) toward a high degree of identity. Thus he says, "The aesthetic work of art is, in fact, the *common* object of these subjects. It is that which the constancy of the physical continuant, the common biological constitution of the subject, a culture common to these subjects, and the fully rounded experience which we call the total perceptive series of these subjects brings into being." ("Supplementary Essay" in *The Basis of Criticism in the Arts*, p. 167). From this he concludes that the aesthetic work of art is not a private object and that it is possible for there to be highly objective judgments of both the aesthetic content of a work of art and its aesthetic value. (*Ibid.*, pp. 168, 171).

that depend for our awareness of them upon a knowledge of their physical causal conditions which is not forthcoming in an experience of the completed object, then we would have to leave out of account, for example, our knowledge that this "Gothic" building is supported not but its stones by by a secret steel framework.[7] On the other hand, if the physical thing itself is the aesthetic object, we might well want to admit as relevant certain physical conditions of the "Gothic" building and to regard it as a bad piece of work inasmuch as its ostensible structure is inadequate to unify or keep together the physical building as it stands, even though it might be pleasing for an experience that confines itself only to immediate appearances. That is to say, the building would be dishonest as displaying a structure or form that is not in fact what really accounts for its physical coherence.

To take another view, if we attempt to determine what is relevant from the standpoint of those who, with regard to arts such as painting, tend to identify totally the work of art or aesthetic object with a physical object completely independent of the perceiver, then we will emphasize the geometrical aspects of the work and regard the meaning of the work to lie in the pattern of its lines and masses. Since representation requires that the mind bring something to the work, portrayed subject-matter on this view will either be irrelevant and distracting from the real business of art or at best simply function to lend more possibilities for the attainment of complex patterns, lines, color relationships, and the like – in which aesthetic pleasure will be thought chiefly to lie.[8] Hence the aesthetic relevance of what is represented would be discounted or denied.[9]

[7] Beardsley, pp. 50-52.

[8] As I interpret him, Gilson tends to take this position. It is, perhaps, only a tendency and not an explicitly held view in its extreme form. See E. Gilson, *Painting and Reality* (New York, 1957), pp. 45, 112, 129, 236, *passim*.

It should be noted that to adopt this notion of the work of art is not to hold that everything about the physical object is aesthetically relevant, but it is to say that what *is* relevant actually belongs to the physical object.

[9] Contrast D. W. Gotshalk, "Form" in E. Vivas and M. Krieger, *The Problems of Aesthetics* (New York, 1960), pp. 199-200. A very clear statement of this view is found in Clive Bell's *Art* (London, 1949), Section I, Chapter 1, where he says, "Let no one imagine that representation is bad in itself; a realistic form may be as significant, in its place as part of the design, as an abstract. But if a representative form has value, it is as a form, not as representation. The representative element in a work of art may or may not be harmful; always it is irrelevant. For, to appreciate a work of art we need bring us nothing from life, no knowledge of its ideas and affairs, no familiarity with its emotions" (p. 25). Bell's position, however, is not quite so pure as it appears from this passage, since he holds that three-dimensional effects are relevant (p. 28).

3. Such are some of the facets of the question about what a work of
art or an aesthetic object is. I will refer to it as the problem of the
ontological status of the aesthetic object or the work of art. One of the
surprising things about it is that while many thinkers have attempted
solutions to it or controverted the solutions of others, Maritain – who
is surely one of the outstanding philosophers of art in this century –
has never really been accounted for on this issue. Perhaps this can be
explained by observing that he has not participated in contemporary
discussions of it or otherwise addressed himself to the problem as a
separate affair. Its various aspects are taken up only in relation to
other concerns. I hope in the pages that follow to uncover in Maritain's
philosophy the rich resources that can be brought to bear on it, show-
ing that they contain a complex, subtle point of view about the identity
of the work of art which is highly germane to the issue as it is currently
being construed.

In setting the question within the context of Maritain's views, it
should be noted that his epistemology is thoroughly realistic; we are
aware of things, and what we are aware of – with the attendant sensible
qualities – is held to have an existence independent of our own activity.
So, while he distinguishes between a *thing* and an *object*, he does not
separate them, making a thing an unknown something concealed be-
hind the object. Thus, a thing *is* object "when it is set before the
faculty of knowing and made present to it"; and it is the thing itself,
often called by Maritain the transobjective subject, which is grasped
cognitively in some of its objectifiable resources.[10] Further, while an
examination of the medium through which we become conscious of
sensible qualities may yield only the wave movements and properties
dealt with by the physicist, still it is a means, for Maritain, through
which quality passes from the qualified thing to the knower; and the
thing itself must be thought to possess sensible quality.[11]

What we are aware of in perception, then, is not our own impressions
or ideas or the way things affect us. Considered in their "entitative"
character or mode of being these impressions are accidental modifica-
tions or properties of the knower and are other than the known thing;
but they have another function as well, an "intentional" one, which is
to make the known thing itself present to knowledge – in the completely
transparent manner of a sign which is not itself known. They do so in
such a way that the very same thing which has an entitative (real)

10 *DK*, pp. 91, 93-94, 100.
11 *DK*, pp. 114-115, 118, n. 1.

existence independently of thought may exist "intentionally" within thought in an immaterial existence which transcends the whole order of spatial distinctions and in such a way that the knower becomes, in a sense, the thing known without either one losing its entitative (real) otherness.[12]

Consequently, with respect to painting and sculpture at least, Maritain holds that we are aware of material artifacts and their qualities, which do not depend for their existence on our knowing them. This point will be taken for granted. What will be of interest here, however, is whether and in what way such kinds of works of art as paintings and sculptures can be, for Maritain, something more than self-contained material objects while also being identifiable with a physical product existing independently of human perceivers. Maritain often suggests that what we are conscious of when we behold an object such as a painting somehow transcends the physical object. He assures us, on the one hand, that the "work is an object, and must always maintain its consistency and its proper value as an object..."[13] As a work-to-be-made it is material and enclosed in a genus.[14] But at the same time he claims that as a work of fine art it is not merely an object, not merely a material thing enclosed in a genus. Rather it somehow breaks out of the confines of its status as an artifact. Thus, Maritain often says in one way or another that "... the work also will swarm with meanings, and will say more than it is, and will deliver to the mind, at one stroke, the universe in a human countenance."[15]

It is this "saying more than it is" on the part of the work of fine art that will occupy the center of attention; the objective will be to explore the kind of ontological account of the work in Maritain's thought that makes this transcendence possible. An essential part of such an account will be to determine whether in transcending itself the work of fine art – even within Maritain's thoroughgoing realism – somehow is dependent for its actualization upon the activity of the beholder, reading these meanings into the work or rather actively constituting the work. The problem is that if it is not dependent, there is difficulty in seeing how the work can be anything more than a physical object; and if it is, then the difficulty is to understand how one can avoid conceiving of the work as somehow separate from the physical object.

[12] *DK*, pp. 387-388, 103-104, 111-118. See below, Chapter III, for a discussion of the distinction between entitative and intentional being and a thorough treatment of the whole matter of immaterial, intentional existence as Maritain understands it.

[13] *SP*, p. 84; see also *CI*, p. 93.

[14] *A & S*, p. 33.

[15] *CI*, p. 93. See also *CI*, p. 165; *SP*, pp. 49-50, 76-77.

4. In exploring Maritain's ideas, I want to begin by taking up first the relation of fine art to beauty, asking first of all whether for him beauty is something objective in the work and secondly whether the presence of the former differentiates the latter from other kinds of artifacts. If beauty is objective and is necessarily found in a work, these facts may reveal something of its ontology. In this regard we shall need to determine whether the very participation in beauty of a work causes it to transcend itself in some way. Quite apart from his other utterances on the ways in which a work overflows itself as a physical object, Maritain speaks of the beauty in a thing as causing it to lead beyond itself; and this idea must be examined at the outset.

This line of inquiry will suggest a careful examination of Maritain's notion of signs and of the ontology of the work of fine art as sign or as containing signs, since the "demands" of beauty may require that there be signification. Here it will be necessary to ask whether he holds that all works of fine art as such must signify and if so whether the signified is in any way a *part* of the entity which is the work of fine art, considered as object of aesthetic contemplation. If so, a complete analysis of the work of fine art must take into consideration these meanings and at the same time determine what sort of existence they have in the work.

Thirdly, if a work of fine art must signify, it remains to be asked how and what ultimately is meant by such works. It must be seen, that is to say, how Maritain can support his view that works of fine art signify by determining what he thinks their significance is, and what the means are by which they are given meaning. Also, this particular kind of meaning may have implications for the ontology of the work which will need to be traced. What is in question at this stage is what Maritain calls *creative intuition* and its role in causing a work to be more than it is. If it is through creative or poetic intuition that a work overflows its bounds, then one of Maritain's major contributions on the problem being discussed will be his doctrine of poetic knowledge.

From these elements of his view some general conclusions can be drawn about Maritain's ontology of the work of art, especially as it applies to the plastic arts, which are perhaps the simpler and more basic cases and where if anywhere a physical object is the work or enters into the work. Furthermore, it is in these arts that the problem has become especially crucial at this time.

In developing these conclusions in the course of the book, I will be using 'work of art' and 'aesthetic object' interchangeably. As I have

already intimated and will show in greater detail later, in Maritain's philosophy what is produced by the artist and what a perceiver is aware of are the same; consequently there is no good reason to make a distinction between these terms. Maritain prefers to speak of the "work" or the "work of art." While I will generally follow this practice as well, 'aesthetic object' will sometimes be used where fitting to emphasize the role of the work as object of perception and to deemphasize its role as object of production. Furthermore, since 'work of art' often refers to the same thing as 'work of fine art', I will use this pair of terms synonymously as well. However Maritain does make some distinction between fine art and useful art or craft; where a product of the latter is clearly meant, I will use a locution such as 'work of useful art' – or otherwise indicate this meaning by the context.

As a final word on procedure, it must be noted that while many aestheticians in recent years have formally dealt with these problems in articles, chapters of books, or entire volumes, Maritain, as previously noted, does not do so systematically. Rather he takes up questions in one place or another in his works which are closely related to the problems, and his treatment of them suggests in some considerable detail a position which is never explicitly articulated in its own right. Hence it will be necessary to engage in close analysis and comparison of what Maritain says here and there throughout his writings rather than to set forth a completely formulated statement of a position on the issues under consideration. From the evidence obtained by this type of analysis and comparison, I propose to bring to light the consistent and rather profound view of the aesthetic object which underlies so much of Maritain's often obscure statements on art.

BEAUTY

1. Maritain, though he seems reluctant ultimately to define the fine arts by beauty, always understands them in terms of the special relation they have to it. Consequently, if we would fathom his philosophy of works of art, we must first of all understand this relationship.

THE OBJECTIVITY OF BEAUTY

2. What is beauty? Is it something belonging to the object which is said to be beautiful? In *Art and Scholasticism* Maritain, basing himself on Aquinas, begins his discussion of beauty with the statement that St. Thomas "defines the beautiful as that which being seen, pleases: *id quod visum placet*," which is to say that it consists of an *intuitive knowledge* or vision, and a delight – a delight in knowing which overflows the act because of the thing known.[1] Thus whatever the mind takes joy in simply as an object of direct awareness can be said to be beautiful. A problem immediately arises with regard to this definition, however. In a footnote Maritain states, without disagreeing, that St. Thomas meant to give a definition only *per effectum*, and that it is only when he assigns the three elements – integrity, proportion, and clarity – of whatever is beautiful that he is formulating an *essential* definition. Along these same lines G. B. Phelan observes that Aquinas' exact words are not "Pulchrum est quod visum placet," but rather "Pulchra dicuntur quae visa placent."[2] Emphasizing the *dicuntur*, he says that the statement is not meant to be a strict definition of the beautiful as such but only a provisional definition or a description taken from every-

[1] *A & S*, p. 23. Maritain cites the *Summa Theologiae* (hereafter abbreviated *S. Th.*) I, 5, 4, ad 1. See also *CI*, p. 122.

[2] G. B. Phelan, "The Concept of Beauty in St. Thomas Aquinas," in Charles A. Hart, ed., *Aspects of the New Scholastic Philosophy* (New York, 1932), p. 139; *A & S*, p. 161, n. 47.

one's experience and, therefore, commonly acceptable. But on the other
hand, Maritain goes on to say subsequently in *Art and Scholasticism*
that "To give delight in knowing is not simply a property of beauty, as
Gredt teaches ... but a formal constituent of it ..." and later, in *Creative
Intuition*, that this vision and delight are the *essentials* of beauty.[3] Now,
if the latter view truly represents what Maritain really thinks, it might
seem that for him beauty is a thoroughly subjective and relative affair,
dependent on nothing more than how individuals react to objects in
which there is nothing intrinsic by virtue of which they are said to be
beautiful. If such is the case, the chapter could well end just at this point.

Augustine, also with the thought in mind that what is beautiful is
pleasing, poses the question of whether beautiful things are beautiful
because they please us or please us because they are beautiful; and he
answers that the artist will without any hesitation reply that things
please us because they are beautiful.[4] A very similar point arises in
Aquinas' treatment of good. Frequently he says that the good is what
all desire, making good thus relative to appetite[5]; but the question
arises as to whether something is good because desirable, or conversely.
Aristotle had said in the *Metaphysics* that "we desire a thing because
it seems good rather than consider it good because we desire it; for
understanding is the principle of desire. And the intellect is moved by
an intelligible object."[6] Commenting on this passage, St. Thomas says
that what is desired by the concupiscible power seems to be good be-
cause it is desired, but that this is only an apparent good. Good is an
object of *will*, which is intellectual appetite; and what is desired by
such an appetite is desired because it seems good in itself. Under-
standing, which is moved by an intelligible object, is the principle of
desire.[7]

This gives a basis for reconciling Maritain's statements on this first
definition of beauty which both interpret Aquinas and establish his
own position since it shows how he can hold it actually to *be* a definition
setting forth a formal constituent of beauty and at the same time main-
tain that beauty is in the thing seen. He tells us that beauty – which
delights upon being known – is essentially an object of intelligence[8];

[3] *A & S*, p. 168, n. 57; *CI*, p. 122.

[4] *De Vera Religione*, c. xxxii, *PL* vol. 34, col. 148. Quoted by Phelan, p. 127.

[5] For example, in his commentary on the *Metaphysics* (hereafter abbreviated *In Met.*),
#71; *S. Th.* I-II, 27, 1, ad 3.

[6] 1072a26-b14.

[7] *In Met.* #2522.

[8] Since that which knows in the full sense, he says, is intelligence. *A & S*, p. 23; *CI*, p. 123.

the delight is a delight in knowing, an intellectual joy which depends on what is discerned in the object known, just as for Aquinas the good is essentially related to an appetite which is intellectual and which tends to what is apprehended as good in itself. Thus beauty must not be in the joying subject, but rather in the thing known. This is why he can go on to enumerate with Thomas characteristics in the object seen which please the intellect,[9] and it also explains how he can say that beauty "has in its *definition* to give pleasure when seen, and therefore necessarily implies a relation to appetite."[10] Something is called beautiful because of its effect on the beholder, and one could argue from this that if there were no beholders there would be no beauty. But the pleasing effect is a result of the character of the object seen, and it is the sight of the object that is delighted in. Phelan puts the point succinctly when he says that "The power of the real to reveal itself to our apprehension and in that vision to move us to delight is at once a relation to a subject and an intrinsic constituent of things."[11]

Maritain's treatment of what it is about beautiful things that causes us to delight in them will be examined shortly; at this point, to clarify matters somewhat, I must say something about what it is that does *not* give rise to this particular pleasure. Briefly stated, the apprehension of beauty is not for Maritain an interested activity.

One aspect of what Maritain means by disinterestedness, having to do with the way in which something is desired, appears in *Art and Scholasticism*. There, referring to the fine arts and their likeness to wisdom, he says that they are "disinterested, desired for themselves, truly noble because their work taken in itself is not made in order that one may use it as a means, but in order that one may enjoy it as an end..."[12] Again in *Creative Intuition* he contrasts a concern for beauty in a work to a subservience to human needs, using 'disinterested' as an opposite of 'subservient'.[13] This same sense of the word – the property

[9] *CI*, p. 123.

[10] *A & S*,p. 170, n. 57. Italics mine.

[11] Phelan, pp. 128, 130. Thus for Maritain 'X is beautiful' does not *mean* the same as 'I am pleased with x', but it does *imply* either 'I am pleased in the beholding of x', or 'I am aware that others are pleased in the beholding of x', or (in the case of the critic who judges in the absence of an aesthetic experience) 'I see that x has the capability of pleasing someone beholding it'. What it *means* is something on the order of 'X has the capability of pleasing in its beholding those who can discern the attributes of it which meet certain criteria of relevance'.

[12] Pp. 33-34.

[13] "... this art, while being instinctively interested in beauty, was always and primarily, at the same time, subservient to the needs of human life... The truth of the matter is, I think, that the art of the primitive man was undifferentiated – more disinterested than our useful arts, and more subservient to human needs than our fine arts." (*CI*, p. 300, n. 1. See

of being desired for some intrinsic value rather than for use – appears also in another place in Maritain's work, where he says that sensible beauty delights the particular sense involved but that there really is beauty only if the intelligence is pleased. Thus of color and scent, only color is said to be beautiful, "because, being received, unlike the perfume, in a sense power capable of disinterested knowledge, it can be, even through its purely sensible brilliance, an object of delight for the intellect."[14] What he means here by 'disinterested' he clarifies by a reference to the following statement of Aquinas' – in which Thomas speaks of a knowledge which is desired for its own sake, that is, a knowing or beholding in which the appetite finds its rest.

The senses most charged with knowledge are the most set on beauty. The beautiful is the same as the good, differing only in intelligibility. For since the good is what all desire, it pertains to the intelligible meaning of the good that appetite find its rest in it; but it pertains to the intelligibility of the beautiful that in looking upon or knowing it, the appetite finds its rest. Hence those sense powers that are most cognitive, namely sight and hearing, which are the servants of reason, are chiefly concerned with the beautiful. We do not use the name 'beauty' in regard to the objects of the other senses; we do not speak of beautiful tastes or odors. Thus, it is apparent that the beautiful adds to the meaning of the good a relation to the cognitive power. So, the good simply means what satisfies appetite, but the beautiful means that whose very apprehension gives pleasure.[15]

Thus, the sense powers which are capable of disinterested knowledge – in Maritain's phrase – are those which are at the service of and engaged in a knowing which itself pleases. Maritain says that beauty "in a way, falls under the grasp of the senses, in so far as in man they serve the intellect and *can themselves take delight in knowing*..."[16]

Is there another sense in which Maritain uses 'disinterestedness' regarding beauty, one in which desire does not figure at all? It would seem so. A careful look at some things in the foregoing which have not been attended to so far will reveal that the disinterestedness involved in the appreciation of beauty is such that not only is the beautiful

also "An Essay on Art" in *Art and Scholasticism and The Frontiers of Poetry*, p.89). This aspect of disinterestedness in the contemplation of beauty appears also in Aquinas, although Maritain makes no reference to it in his discussion of the point. Thomas says in speaking of sensory knowledge that "... the senses are given to man, not only for procuring the necessaries of life, for which they are bestowed on other animals, but also for the purpose of knowledge. Hence, whereas the other animals take delight in the things of sense only as ordered to food and sex, man alone takes pleasure in the beauty of sensible things for its own sake." (*S. Th.* I, 91, 3, ad 3. See also Aquinas' commentary on *II de Coelo et Mundo*, lect. 14).

[14] *A & S*, p. 25.
[15] *S. Th.* I-II, 27, 1, ad 3.
[16] *A & S*, p. 23. Italics mine.

object, in the apprehension of its beauty, not desired or valued simply as a *means* to an end but also it is not desired at all. We can find this feature even more explicitly stated in another place in Aquinas – also treating the distinction between the beautiful and the good – upon which Maritain, appropriating it for his own position, comments at some length in *Art and Scholasticism*.[17] Thomas says with regard to the relational character of beauty and goodness – discussed above in connection with their objectivity – that while the basis of goodness and beauty in a thing is the same, and in fact they themselves are fundamentally identical, the same thing will be called beautiful or good according to its relation to the various powers of the soul. Goodness relates to appetite; according as a thing is good, the appetite moves toward that thing. Beauty, however, relates to the cognitive rather than the appetitive power since it is in virtue of joy in the apprehension of something that it is called beautiful.

Beauty and goodness in a thing are identical fundamentally, for they are based upon the same thing, namely the form; and this is why goodness is praised as beauty. But they differ logically, for goodness properly relates to appetite (goodness being what all things desire), and therefore it has the aspect of an end (the appetite being a kind of movement towards a thing). On the other hand, beauty relates to a cognitive power, for those things are said to be beautiful which please when seen.[18]

Now the beautiful can be an object of desire and hence be a good, but then so can the true (the intelligible), and it is not in virtue of this sort of goodness that it is called beautiful. Thomas says elsewhere that "beauty does not have the rational character (*ratio*) of an object of appetite unless to the extent that it takes on the character of the good; for in that way, even the true is an object of appetite. By its own rational character [beauty] has clarity and the other aspects that were mentioned..."[19] We see, then, in Aquinas the presence of a disinterestedness in virtue of which the beautiful *as such* is not an object of appetite. Appetite, he says, moves toward the good *thing* and is satisfied in the possession of it. However, in the case of the beautiful it is in the *mere apprehension* of it that there is delight and satisfaction. Maritain, following this line in developing his own position, observes that the beautiful is desirable as a good, that is, as an object which is desired

[17] Pp. 167-170, n. 57.
[18] *S. Th.* I, 5, 4, ad 1. See also *In De Divinis Nominibus* (hereafter abbreviated *In de Div. Nom.*), IV, 5.
[19] *Commentary on Aristotle's Ethics*, IV, lect. 8, 738.

to be possessed. But this is not, he adds, the goodness peculiar to beauty; this desirability is not of the very notion of the beautiful.[20]

But in one of the selections from Aquinas we looked at earlier, upon which also Maritain bases his view, Thomas says that "since good is what all desire, it pertains to the intelligible meaning of the good that appetite finds its rest in it, but it pertains to the intelligibility of the beautiful that in looking upon or knowing it, the *appetite finds its rest.*"[21] Further, Maritain for his part maintains that the beautiful is not a kind of truth, but a kind of good.[22] This seems to suggest that it *is* of the very meaning of the beautiful that it be an object of appetite, in contrast to what was just said. Perhaps there is no disinterestedness in the sense presently under consideration here after all.

A careful look at the passage in question, however, reveals an important distinction, which is at least implicit in Maritain's analysis of this text. With respect to the good, appetite "finds its rest in *it,*"[23] while in the case of the beautiful it is not the beautiful itself in its own existence which appetite tends to or in which it finds its rest, but rather the *looking upon* or the knowing of the beautiful object. Later in the same passage Aquinas says "...the good simply means *what* satisfies appetite, but the beautiful means that whose very *apprehension gives pleasure.*"[24] Thus it is the beautiful as known or in its intentional existence that allays the appetite. Consequently, since the beautiful thing itself is not the object of desire, Maritain says that it faces the appetite only indirectly – albeit essentially.[25]

One might argue against Maritain's notion of disinterestedness that the contemplation of beauty fulfills a human need – one of the most human of needs, perhaps – and thus that the beautiful, or rather its contemplation, is only a means to an end; but the sense of Maritain's notion here is that it is only insofar as the beautiful object is *valued* as an end in its apprehension, it is only insofar as the appetite is allayed by the contemplation of the object that it fulfills what is meant by 'that which upon being seen pleases.' To this extent alone it would seem that it in a higher sense fulfills the "need" referred to in the

[20] *A & S*, p. 170, n. 57.
[21] *S. Th.* I-II, 27, 1, ad 3. Italics mine.
[22] *A & S*, p. 26. See *A & S*, pp. 167-170, n. 57 for a comment on this statement explaining the manner in which it is to be understood. Maritain here follows Cajetan.
[23] My italics.
[24] *S. Th.* I-II, 27, 1, ad 3. My italics. See also Phelan, p. 138.
[25] *A & S*, pp. 170, 26.

objection.[26] To put it another way, the fulfillment-of-the-need as an end is bound up with the seen object and cannot be separated from it as would be the case with something which is a mere means to an end. It is in the very contemplation itself that the need is fulfilled. The need would seem to be the satisfying of the appetite for beauty, and it is in the very beholding of the beautiful object that this appetite finds its rest and fulfillment. What is sought as the end is the seen object or perhaps fulfillment-in-the-seen-object rather than some state of fulfillment that can somehow be separated from the object as end in relation to means. Thus there is no question of seeking some isolable product which can be labeled 'delight.' The peculiar good involved in the aesthetic experience is a delighting-in, the character of which is specified or determined by the object intended. The *fulfillment* cannot be separated from the *seeing*, and the *seeing* cannot be separated from *what is seen*.[27] In this way the beautiful object *is* an end in itself rather than a means to aesthetic experience. It is not such, however, as an object of desire for possession of it in its physical self-enclosed existence, but rather as an object desired in its intentional existence as known and delighted in. So, as we have seen, there is appetition; but it does not tend directly to the beautiful thing itself, apart from the perception of it.[28] This being so, as we turn now to examine the objective aspects of beauty, we can expect to find that what brings about the delight will not be that in the object in virtue of which it is a pleasure to *have* the object, but rather that in virtue of which it is pleasing to *know* it.

[26] Here it becomes apparent that to use 'need' in this way is really to depart from ordinary usage.

[27] See G. E. Moore, *Principia Ethica* (London, 1959), pp. 188-202 for a somewhat different statement of this idea.

[28] Here we find a significant difference between Maritain's disinterestedness, which – as I have tried to show – is drawn in its details from Aquinas, and that of Kant. For Maritain we saw that there is no opposition between disinterest and appetite. This is reflected also in his *Scholasticism and Politics* (Garden City, 1960), p. 172, where he speaks of "disinterested love." (Cf. *Critique of Judgment*, Paragraph 3). Further, in the sphere of morals, Maritain opposes Kant's notion as containing no element of finality; it is only, he says, "in the very order of finality that a real disinterestedness can be attained." [Mo*ral Philosophy* (New York, 1964), pp.97-98. Cf. Kant's *Groundwork*, p. 122n.]. Maritain is of course familiar with Kant's *Critique of Judgment* – in fact he comments at some length on it in a footnote in *Art and Scholasticism* (pp. 162-167, n. 56), and he may be indebted to Kant for a *term* which as applied to beauty Kant himself seems to have gotten from Hutcheson and Mendelssohn [See, e.g. Mendelssohn's Fifth Letter of *Letters on Sensation*, dated 1755; Copleston, *A History of Philosophy* (Garden City, 1964), V, 235; and J. H. Bernard, "Translator's Introduction" in *Critique of Judgment* (New York, 1951), p. xviii]. Yet Maritain's thought here is closer to that of Aquinas not only in terms of the presence of appetite but also with respect to the objective grounding of the apprehension of the beautiful gained by this disinterested activity. See also here Aristotle, *Politics*, 1338a, J. L. Callahan, *A Theory of Esthetic According to the Principles of St. Thomas Aquinas*, 2nd ed. (Washington, 1947), p. 74.

However, since it is the beautiful *object* the knowing of which pleases, there will be objectivity; to shift to an aesthetic standpoint – that is, to take a disinterested view – is not to disregard the merits of the object. Instead, it is to regard those which belong to the object simply as open to apprehension – and moreover to place oneself in a position to be more sensitive to the latter, so that what at one time does not produce delight does so at another.

3. In both of his major works on aesthetics, *Art and Scholasticism* and *Creative Intuition in Art and Poetry,* Maritain gives two definitions of beauty – the one which has already been examined and one which enumerates three essential characteristics of any beautiful thing. The second definition is related, however, to the first and is an outgrowth of it since it sets forth what it is in the beautiful object which pleases the beholder in the knowing of it. Fundamentally, Maritain is maintaining that beauty consists in a *proportion to the knowing capability,* to sense in the case of aesthetically beautiful things and to intellect in all cases.[29] It is in terms of the proportion between the beautiful object and the intellect that Maritain introduces the three essential characteristics of the beautiful. Commenting on Aquinas' statement that the beautiful is *id quod visum placet,* he says,

> Beauty consists of intuitive knowledge, and delight... If beauty delights the intellect, it is because it essentially means a certain excellence in the proportion of things to the intellect. Hence the three essential characteristics or integral elements traditionally recognized in beauty: *integrity,* because the intellect is pleased in fullness of Being; *proportion or consonance,* because the intellect is pleased in order and unity, and *radiance or clarity,* because the intellect is pleased in light, or in that which, emanating from things, causes intelligence to see.[30]

The delight is not just a delight in knowing, but one which "overflows from this act, when the object upon which it bears is *well-proportioned for the intellect*"[31]; and the three essential characteristics appear as that

[29] *CI*, pp. 122-123; 126; 322, n. 6; *A & S*, pp. 24-25; 162, n. 55. The distinction between aesthetic beauty and beauty in general will be discussed later. Here it is necessary to say only that aesthetic beauty is that the apprehension of which requires the participation of the senses acting together with intelligence.

[30] *CI*, pp. 122-123. This is almost identical with the parallel passage in *A & S* except that in the latter he says with respect to clarity only that the intellect is pleased in light and intelligibility (p. 24).

[31] *A & S,* p. 54, italics mine. As the sequel will show, it is just this excellence in the proportion of the beautiful to the mind that causes it in a sense to be disproportionate to mind, i.e., to extend its bounds to infinity. Perhaps, rather, it would be better to say that this proportion is not a limiting-in but an echoing in the farthest reaches of the intellect's openness to being.

in the thing in virtue of which it is well-proportioned to cognition. We will see shortly why they function in this way.

At this point, however, a digression is in order to ask what account Maritain gives of the connection between being proportioned to knowledge, on the one hand, and giving delight on the other. In *Art and Scholasticism* he relates them by saying that "the intelligence delights in the beautiful because in the beautiful it finds itself again and recognizes itself, and makes contact with its own light." The intelligibility of things is a mark or ray of a creative intelligence; order and proportion in things is a work of intelligence.[32] Thus, as proportioned *in themselves*, things are proportioned *to* creative intelligence. Regarding the senses, they too delight in things which are suitably proportioned to them because sense "is itself measure and proportion, and so finds in them a *likeness of its nature*," Hence while any relation of one thing to another could in a Thomistic context be termed a proportion, the proportion in question here is one of likeness or similarity; the cognitive powers delight in what is like them.[33] This likeness can be construed as

[32] *A & S*, p. 25; cf. *S. Th.* II-II, 180, 2, ad 3. This is why he tells us that beauty is savored more by those who – like St. Francis of Assisi – "know that things come forth from an intelligence and who relate them to their author." (*A & S*, p. 25).

[33] *Ibid.*, p. 162, n. 55, italics mine; see also *CI*, p. 126; *S. Th.* I, 12, 1, ad 4; *De Veritate* (hereafter abbreviated *De Ver.*), 23, 7, ad 9; 8, 1, ad 6.

As Pouillon puts it, similars please similars. [H. Pouillon, "La Beauté, Propriété Transcendentale chez les Scolastiques (1200-1270)," *Archives d'Histoire Doctrinale et Littéraire du Moyen Age*, 21 (1946), 308. See also *Nichomachean Ethics* VII, 1; IX, 4. Maritain cites in this context *S. Th.* I, 5, 4, ad 1, where Thomas says, "Sense delights in things duly proportioned as in what are like it, for sense too is a kind of reason (*ratio quaedam*), as is every cognitive power". For an explanation of *ratio quaedam* Maritain refers us at the end of the note to *In de Anima* (hereafter abbreviated *In de An.*), III, lect. 2. Pouillon makes the same comparison and concludes here that *ratio* is to be translated as *proportion*. He says that the Latin translation of Aristotle used by Aquinas reads, "necesse est et auditum rationem quamdam esse ... tamquam ratio quaedam sit sensus... sensus ratio est." (426a29), and that Aquinas himself continues "auditus est quaedam proportio (#597). Sensus enim delectatur in proportionatis sicut in sibi similibus, eo quod sensus est proportio quaedam (#598)." Aristotle, he points out, had written λόγος, which among other things can mean *raison* or proportion. Thus he concludes that Thomas' idea under discussion in *S. Th.* I, 5, 4, ad 1 is that the senses and all cognitive faculties are proportioned. When they find proportion in their objects, they are pleased, since similars please similars (Pouillon, p. 308). Callahan finds a reason for this last dictum in Aquinas: "Similitudo, proprie loquendo, est causa amoris." (*S. Th.* I-II, 27, 3). "Similitudo est causa amoris. Amor autem est causa delectationis. Ergo similitudo est causa delectationis." (*S. Th.* I-II, 33, 7, *sed contra*; see Callahan, p. 51). Callahan suggests that the mind discovers an image of its own perfection in beautiful things and that, in fact, we see actually or symbolically a nature like ours – a soul dominating and bursting through matter. (Callahan, pp. 52-53). One might add, with respect to this likeness that in both mind and beautiful object there is a transcending of the opacity of matter or of the entitative limits each has as existing in itself. (See *DK*, p. 85; below, Chapter III). Thus there is a kind of ontological proportion within them which makes for a proportionality or likeness of proportion between them. Gilson points out the likeness between the knower and the known in the experience of beauty by observing that there is a proportion in the object and one in the constituent elements in the knowing subject. Because of these proportions *within* knower and

the likeness which is an identity between knower and known in the act of knowing. In this act a cognitive power is proportioned to what is known by a relation of identity; there is an identity between something as lived by the mind and as existing independently of it, with respect to some cognizable aspect or aspects.[34]

Such likeness or communication occurs when there is a "spirituality" or a transcending of the opacity of matter on the part of both knower and known,[35] and this suggests a kind of likeness more in keeping with what Maritain seems to mean in explaining delight in the beautiful. That is, there is a proportion between the thing known and the knowing *capability*, thanks to which there can be the proportion in the *act* of knowing just referred to. Because of the perfection; the limitation, measure, or order; and the transparency in an object it is suited to being known by a knowing capability which in some sense has a similar level of perfection, limitation, and transparency.[36] So, just as there is a likeness between knower and known in the act of knowing, there is a kind of likeness between a capacity for knowing in potentiality and the specific actuations to which it is essentially related.[37]

Now, anything it could know, the intellect would know as being, as proportioned, and as having some intelligibility. Hence everything within its ken would somehow be proportioned to intellect and *ipso facto* pleasing to it. With the senses, however, we have a capability dependent on a fleshly constitution and possessing a rather specific proportion such that some things proportioned in themselves are not proportioned to sense. And this lack of proportion comes about not just because of defect or excess that makes these things either incapable of being sensed or destructive of the organ, but also, Maritain implies, because in some cases they – while capable of being perceived

known, they are proportioned to *each other*. From this arises delight. Thus "... beauty is the cognition of a substantial similitude between two duly proportionate beings..." [E. Gilson, "The Forgotten Transcendental: *Pulchrum*," *Elements of Christian Philosophy* (New York, 1960), p. 161]. "The pleasure experienced in knowing the beautiful... testifies to the excellence of the commensuration there is between a certain power of knowing and a certain known object." (*Ibid.*, p. 162).

[34] *DK*, Chapter III, esp. p. 88.

[35] *A & S*, pp. 24-25; 32-33; *PM*, pp. 80-81; *CI*, p. 6; below, this section, on clarity and Chapter III; see also Aristotle, *De Anima* 424a16-424b20, 425b11-426b8 and Aquinas' commentary on it, #551-557, 597-598. Regarding Maritain's use of 'spirituality', see below, this chapter, n. 54.

[36] See *In de An.*, #555, where Thomas explains that the *ratio* which the sense is is proportion, form, and capacity.

[37] Thus the conformity of mind and thing, Maritain notes, is referred to by Aquinas as *secundum proportionalitatem*. [*DK*, p. 88, n. 1; *Scripta super libros Sententiarum* (hereafter abbreviated *Sent.*) IV, 49, 2, 1, ad 7]. The ad 6 of the same article distinguishes proportionality from proportion.

and thus somehow proportionate to the senses – are repugnant to the particular proportion or harmony intrinsic to the sense.[38]

So much for the digression. Maritain emphasizes that beauty consists in a certain proportion of things to the mind, and we have determined that the reason for this is that the mind delights in what is like it. However, Maritain's second definition of beauty in terms of the three constituents of the beautiful is not introduced or explained in such a way as to imply that it is arrived at purely deductively from the first definition and the premise that similars please similars. This much is clear. Hence the truth of the view that the three elements *are* the essentials of the beautiful as such does not rest for Maritain on any psychological or metaphysical explanations of why we are pleased with what pleases us. What he seems to be saying is that these are the characteristics which, while they do explain how an object is proportioned to mind,[39] are also as a *matter of fact* what pleases the intellect. Notice in the passage quoted above from *Creative Intuition*, pp. 122-123, and from the parallel text in *Art and Scholasticism* that integrity is an essential characteristic of the beautiful *because* the intellect *is pleased* in fullness of being; proportion *because* the intellect *is pleased* in order and unity; clarity *because* the intellect *is pleased* in light and intelligibility. Thus, whatever the explanation for their pleasing, the judgment that these are what does please seems, at least in part, to be founded upon experience. At the same time, the universality of Maritain's language suggests that what experience divulges here is not merely a matter of fact but also a *de re* (real) necessity.

Evidently, Maritain takes this second definition over from Aquinas, but the point still holds; Maritain is looking to experience, and Thomas for his part makes an appeal to experience in enumerating these essentials.[40] The important thing regarding this second definition for our purposes, however, is simply that beginning with a definition of the beautiful as that which upon being seen pleases, Maritain moves to a definition which sets forth objective characteristics of things which

[38] *CI*, pp. 125-126, 6; see also below, this chapter, #4 for a discussion of the distinction between transcendental and aesthetic beauty.

[39] And which therefore must be present in anything proportioned to the mind.

[40] In *S. Th.* I, 39, 8 he says that what is impaired is by that very fact ugly, suggesting thereby an experience of deficient things and the judging of them to be ugly from the discernment of their lack. He goes on to say that clarity is a condition of beauty "whence things *are called* beautiful which have a bright color"; and in another place, the commentary on the *De Divinis Nominibus* of the pseudo-Dionysius (IV, 5), he says, "For *we say* a man is beautiful by reason of the seemly proportion, in quantity and position, of his members..." Nowhere here is there an attempt to deduce the three essentials. Rather it is an appeal to our experience through the usage of ordinary language. (Italics mine).

please us in the knowing of whatever possesses them. This he will call an essential definition of the beautiful.[41] Thus he leaves no doubt that things are beautiful because of what is intrinsic to them and at the same time because of what causes them to be related to knowing and delighting-in.

Integrity, proportion, and clarity are the characteristics that things which we delight in and which we call beautiful have. About *integrity* Maritain has very little to say. It is simply "fullness of Being," "perfection or completion," or the completion required in a given case. In the language of the *Summa Theologiae*, to which Maritain refers, it is *integritas sive perfectio*.[42] Aquinas adds that things are ugly to the extent that they are incomplete (*diminutae*); ugliness is a lack, but of such a kind that what is deprived *needs* or requires that which is missing to complete it as an organized whole. Commentators suggest that integrity means not only negatively that no essential parts or functions are missing but also positively that there is a fullness of being or a richness that gives rise to pleasure.[43]

Proportion as an essential and intrinsic character of the beautiful is also treated summarily by Maritain. In addition to being proportioned to the mind of the beholder, a thing to be beautiful must be proportioned in itself, as a means of being proportioned to mind. Proportion is "order and unity," "fitness and harmony," and is found wherever there is anything existing. Proportion is *intelligent ordering*, for "every proportion is the work of intelligence"; the "proportioned parts of matter" of which the *Opusculum de Pulchro et Bono* speaks, Maritain tells us, refers to "a matter intelligibly arranged."[44] This is why he immediately adds,

[41] *A & S*, p. 161, n. 47.

[42] *Ibid.*, pp. 24, 27; *CI*, p. 123; S. Th. I, 39, 8. See Phelan for a discussion of these terms in Aquinas.

Stephen, in Joyce's *Portrait of the Artist as a Young Man*, explains integrity as the character of being marked off from everything else as one thing, as one whole. The emphasis in the passage is on discreteness or numerical unity, whereas Maritain concentrates on the aspect of wholeness. See *A Portrait...* in *The Portable James Joyce* (New York, 1964), pp. 473, 479-481 for a treatment of Aquinas' three notes of beauty which differs somewhat from Maritain's understanding of them. Wm. T. Noon, *Joyce and Aquinas* (New Haven, 1957), pp. 45-52 can be consulted for an appraisal of Joyce's fidelity to Aquinas concerning these notes.

[43] Callahan, pp. 58-59. Because being is always some definite being, integrity "looks to the fullness of all that such a definite kind of being requires." If there is privation, there is a corresponding degree of unintelligibility and lack of beauty. [R. E. McCall, "The Metaphysical Analysis of the Beautiful and the Ugly," *Proceedings of the American Catholic Philosophical Association*, 30 (1956), p. 139].

[44] *A & S*, pp. 24; 25; 27; 168, n. 57; 173, n. 66; *CI*, p. 123; *De Ver.*, 22, 1, ad 12.

The *Opusculum de Pulchro et Bono*, Maritain writes in *A & S*, is attributed to Albert the Great and sometimes to Aquinas (p. 162, n. 54). However, Maritain's list of the latter's works in the appendix of his book *St. Thomas Aquinas* (New York, 1958) follows Eschmann in not

as we have previously seen, that in the beautiful the intelligence finds itself again.

Aquinas had said "debita proportio sive consonantia," and Maritain explains that as *due* proportion it is therefore diversified according to the objects and ends involved. Good proportions for a man are not good ones for a child. He notes that because of the fixity of natural ends (of, for example, the human body) the proportions in nature may be rather stable. But while there must *be* proportion in the beautiful work of art, painting and sculpture are not bound to the determinate ones of nature because the beauty of the work is not the beauty of any natural object that may be represented. Hence there is a greater flexibility in the proportions which can obtain in the work of art.[45] This, however, does not rule out objectivity in what constitutes due proportion. The proportions, while flexible, are proper to the goal to be achieved and must meet the demands of integrity. Proportion, then, involves finality and must, along with integrity, be understood in the realm of fine art "*in relation* to the end of the work, which is to make a form shine on matter."[46]

This shining of form on matter in the case of material things, or more generally *clarity* (*claritas*), occupies somewhat more of Maritain's attention. It is a splendor of intelligibility; with Aquinas Maritain says that *claritas* is *splendor formae* because form, "the principle which constitutes the proper perfection of all that is, which constitutes and achieves things in their essences and qualities, which is, finally, if one may so put it, the ontological secret that they bear within them, their spiritual being, their operating mystery..., is above all the proper principle of intelligibility..."[47] In *Creative Intuition* Maritain adds that the splendor of the form is the splendor of the secrets of being radiating into intelligence and that it is necessary here to realize the implications of the Aristotelian notion of form as "the inner ontological principle which determines things in their essences and qualities, and *through which they are, and exist, and act.*"[48]

including this piece. See I. T. Eschmann, O.P., "A Catalogue of St. Thomas's Works," in Gilson, *The Christian Philosophy of St. Thomas Aquinas* (New York, 1956), pp. 381-439.

[45] *S. Th.* I, 39, 8; *A & S*, p. 27; see also Aquinas, *In Psalmos Davidis expositio*, Ps. XLIV, 2.

[46] *A & S*, p. 28. See Phelan, pp. 142-143 and Callahan, p. 62 for a development of the notion of proportion that is not explicitly contained in Maritain's writings.

[47] *A & S*, pp. 24-25. The description of radiance or clarity as *splendor formae* also comes, Maritain says, from the *Opusculum de Pulchro et Bono*. (*A & S*, p. 162, n. 54; *CI*, pp. 123; 314, n. 3. See also *In de Div. Nom.*, IV, 5).

[48] *CI*, p. 123, italics mine. Of this more remains to be said; see below, this section, and *In de Div. Nom.*, IV, 5.

We are told that clarity is the most important of the three characteristics; it is *the essential*, in fact, according to the ancients. This is because it is really clarity that ultimately is delighted in by the intellect; it relates to the most essential yearning of the intellect for the rays of its own light or intelligibility. Consequently, in the realm of art clarity is *that in relation to which* integrity and proportion have meaning. Thus the end of fine art is "to make a dominating intelligibility shine forth in the matter"; "to create a work of beauty is to create a work on which shines the radiance or the splendor, the mystery of *form*..."[49]

Claritas, especially if it is understood in terms of the connotations of 'clarity', appears at first glance to be a relative matter; if it is determined by subjective factors and if as has been suggested integrity and proportion are to be understood solely in relation to it, seemingly Maritain will not be able to maintain the objectivity of beauty. Ultimately, however, Maritain grounds the stability and objectivity of beauty in the divine beauty, holding that creaturely beauty is "a similitude of divine beauty participated in by things." From the standpoint of *claritas* Maritain explains, following Aquinas' commentary on the *De Divinis Nominibus*, that this is because the splendor of form which all created beings have is an irradiation that proceeds from and is a participation in the divine intelligible splendor or brightness. Accordingly, clarity is not necessarily a matter of what is clear to me here and now. Rather it has to do with *ontological* clarity or what is intelligible – and thus clear – in itself.[50] A thing has form and intelligibility whether we grasp it or not, and beauty is based upon a thing's form or inner ontological principle of intelligibility and perfection.[51] Because we are so frequently unable to comprehend the full intelligibility of things, however, Maritain calls this radiance of form – in relation to

[49] *A & S*, pp. 24-25; 27-28; *CI*, p. 123; "An Essay on Art," in *Art and Scholasticism and The Frontiers of Poetry*, pp. 86, 91. Compare Joyce, pp. 479-481.

[50] *A & S*, pp. 28n., 31; *In de Div. Nom.*, IV, 5. Dionysius, Aquinas says, shows how God is the cause of splendor of form, for "He transmits to all creatures, with a certain lightning-like brightness, a ray of His own bright light, which is the source of all illumination. And these lightning-like communications of the divine ray of light are to be understood according to analogical participation; and as Dionysius says, they are 'beautifying', that is, productive of beauty in things." Or, "every form, through which a thing has actual existence, is a certain participation in the divine intelligible splendor (*divina claritas*)." Again, "a form is a certain irradiation from the Primary Splendor of Form. And, as was said, splendor of form pertains to the essence of beauty," *In de Div. Nom.*, IV, 5 & 6. Translated by J. F. Anderson in *An Introduction to the Metaphysics of St. Thomas Aquinas* (Chicago, 1953), pp. 88-98.

[51] See Phelan, p. 132.

us – the "radiance of a mystery."[52] With time we may be able to under-
stand; but if the object escapes the capabilities of human comprehen-
sion, then we are not on the same level or "connatural" with it and will
be unable to delight in the beauty it has. It is still, as intelligible,
capable of pleasing when apprehended, but it will never please a human
perceiver.[53] One reason that what is intelligible in itself may be obscure
to us is that the form may be "buried" in matter. Matter renders reality
opaque to our knowledge, "a dead weight of incommunicability." Now
Maritain speaks of a ladder of being ascending from pure opacity – first
of nothingness and then primary matter – to the supreme transparence
of that which transcends material existence entirely; and thus, too,
something may be obscure to us "because of the transcendence of the
form itself in the things of the spirit."[54] But wherever there is being,
there is form and intelligibility, though we may not be on a level with it.

What I have said so far about clarity must not be taken to mean that
Maritain believes the intelligibility which is delighted in to be that of
an abstract meaning separable from any concrete realization. This point
is of considerable importance in determining a status for the work of
fine art; for if the material, singular, fabricated object is that in which
one takes delight as apprehended in an aesthetic experience, then the
work of fine art in the sense previously defined must at very least
partially be comprised of the material object.[55]

There are two main reasons to be found in Maritain for holding that
the beautiful is to be thought of in terms of a concrete existent. The
more fundamental one, having to do with beauty in general, is simply
that beauty is *being*, considered as delighting; it is not conformity to
an ideal, immutable, or necessary type (nor is it an accident or prop-
erty superadded to something).[56] It is rather a thing's very being itself
considered under a certain aspect. Maritain has said that one of the
characteristics of beauty is integrity or "fullness of being"; and we
might add that it is only when something in some way *has* certain
perfections that it can manifest their intelligibility to the delight of the

[52] *A & S*, p. 28n. Note also his expressions "mystery of a form," "operating mystery,"
"ontological secret," and the like, introduced in material seen earlier.
[53] See the section on transcendental and aesthetic beauty below, this chapter, #4.
[54] *A & S*, p. 28n.; *PM*, p. 80. The word 'spiritual' will be used to refer to height in its
varying degrees on this ladder. Because there are degrees of immateriality or independence
of matter, 'spiritual' as signifying the differing levels is used analogously. See below, Chapter
III, #5 and Chapter IV, n. 28.
[55] And as Chapter I has pointed out, for Maritain perception can make present to us the
thing itself.
[56] *A & S*, pp. 29-30.

mind.[57] Or looked at another way, it is the perfection that something has rather than what it might have or can have which is a delight to behold. The perfection we enjoy is the *existence* of such and such formal determinations in a beautiful thing. In fact, it is only when such determinations exist that they *are* perfections.[58]

If one speaks of beauty in terms of form, as Maritain does, then one must heed the advice given in the statement from *Creative Intuition* seen earlier concerning the implications of the Aristotelian notion of form. Form is not only that by which something is what it is but also that through which it exists and acts.[59] Maritain says that form "of itself implies a relation to existence (*esse per se convenit formae*) and... it ought not to be conceived only as that by which a subject possesses in its essence such-and-such intelligible determinations, but also as that by which it is determinately constituted for existing and receives from its causes existential actuation."[60] Thus, if with Aquinas the beautiful properly belongs to the intelligible character (*ratio*) of a formal cause,[61] form must be understood as *this* ontological configuration or structure here and now operative in a singular concrete existent; and beauty as splendor of form is the splendor of such a being as open to cognition.[62]

Further, as animated by a form an entity exists, and this fact is open to being known; a thing's intelligibility for Maritain is not just a matter of what can be seized by an abstracted concept. The act of

[57] See Chapter III for a discussion of how what is signified or expressed in or by a thing in some way exists in it.

[58] As Aquinas states it, integrity "is consequent upon perfection, which consists in a thing's very act of existing." (*In IV Sent.*, 26, 2, 4). One might contrast here the view expressed by Ingarden, for whom the aesthetic object is divorced from any real object. Sense perception is only a basis for further psychic acts over it by which the aesthetic object is constituted. In such acts we, for example, overlook certain properties of the physical object which strike us as imperfections or disharmonious factors – whether they are posterior damage or not – and supplement in thought or perception details which enhance the work. [R. Ingarden, "Aesthetic Experience and Aesthetic Object," *Philosophy and Phenomenological Research*, 21 (March, 1961), pp. 289-313. See also J.-P. Sartre, *The Psychology of Imagination* (New York, 1948), the section entitled "The Work of Art," in which the point is made that the aesthetic object does not appear to a realizing consciousness which regards physical objects in the world. It appears only to an imaginative consciousness which negates the world – positing the aesthetic object as unreal. Only the unreal is beautiful].

[59] In works appearing after *Art and Scholasticism* there is an increased existential weight put on the notion of form, as, e.g., in *Existence and the Existent* and *Creative Intuition*.

[60] *E & E*, p. 39; see also *PM*, pp. 92-93.

[61] *S. Th.* I, 5, 4, ad 1.

[62] Owens advances the same view in saying that beauty is "a splendor that emerges from actuated form. It should be present wherever form is actual, that is, wherever anything exists." [J. Owens, *An Elementary Christian Metaphysics* (Milwaukee, 1963), p. 123]. Phelan expresses the idea by his statement that *claritas* is the "power of *reality* to reveal itself to the mind." (Phelan, p. 143; my italics. See *De Ver.* 2, 3, ad 8).

existing has intelligible value, not expressible in a concept but in the act of affirming or denying. Maritain calls this the super-intelligibility of the act of existing, upon which, he says, Aquinas "hangs the whole life of the intellect."[63] The "splendor of intelligibility" is thus the splendor of an existing thing's way of *existing* and not the splendor of the *way* of existing.

Consequently, various ontological views Maritain holds and expresses in different places furnish a reason for saying that the beautiful in general is the concrete, but the approach that he actually takes to this point in his work on aesthetics is somewhat different; it is more experiential and concerns the specifically human encounter with the beautiful connatural to or most naturally proportioned to man.

Here it is a matter of returning to the starting point in the developing of a description of beauty and recalling that we call beautiful anything which pleases when seen. First of all, what does this formula itself entail? 'Seen,' of course, does not refer just to the sense of sight, but it does convey the idea of a direct or *intuitive* awareness. Now intellect is definitely essential in the aesthetic experience since the latter is a delight in knowing, and it is only the intelligence which in the full sense of the word knows. But in human knowing only the senses are perfectly intuitive; human cognition directly confronts the object known by means of the senses, and the intelligence sees only "on condition of abstracting and discoursing," performed on what is furnished by the senses. Hence the beauty which is naturally proportioned to human awareness and which belongs to human art is that which delights the intellect through the senses and their intuition, namely that of a sensible matter shaped to delight the mind. So, the brilliance of form, "no matter how purely intelligible it may be in itself, is seized *in the sensible and through the sensible, and not separately from it.*"[64]

[63] *E & E*, pp. 18-19; see also *PM*, p. 133; *DK*, p. 438.

[64] *A & S*, pp. 23-25. See also "Apropos an Article by Montgomery Belgion," in *Art and Scholasticism and The Frontiers of Poetry*, p. 114; below, Chapter IV.

Can humans take aesthetic delight in something such as a mathematical demonstration, which cannot be sensed? Maritain seems to think so; the aesthetic experience is a delight in *knowing*, and for him it is the intellect which in the full sense knows. (*A & S*, p. 23). Consequently it is the intellect primarily and the senses only secondarily which, in a manner of speaking, are delighted. (*A & S*, p. 166, n. 56). So Maritain concedes in *A & S* that humans can "doubtless" enjoy purely intelligible beauty (p. 24); and in *CI* he categorically affirms that a beautiful mathematical demonstration is an object of aesthetic delight (p. 5) because, even though it is one of the most remote from the sphere of the human, the mind can find itself in it in virtue of the intellectual proportion and consistency concealed in it. (*CI*, p. 5). But for all of this, such beauty is not connatural to man since it is not, Maritain maintains, susceptible of being grasped by humans with the immediacy that is had regarding beautiful objects which are apprehended by the intellect through the senses. (*A & S*, p. 24). Obviously

Secondly, Maritain turns to our experience of the beautiful; it discloses itself to be – when it actually occurs, not in what might lead up to it – an effortless, immediate revelation of the object. There is a clarity of a sort such that there is no "effort of abstraction" nor the disengagement of an intelligible from the matter in which it is buried; the intelligence is "dispensed from its usual labor" and "rejoices without work and without discourse." "Caught up in the intuition of sense, it [the intellect] is irradiated by an intelligible light that is suddenly given to it, in the very sensible in which it glitters, and which it does not seize *sub ratione veri*, but rather *sub ratione delectabilis*..." If the intellect turns away from this sensory immediacy in order to formulate abstractions and to reason about things, it "turns away from its joys and loses contact with this radiance."[65]

Thirdly, we are aware in having aesthetic experience that it cannot be conceptually expressed. Again Maritain appeals to our experience in saying that "the perception of the beautiful is accompanied by that curious feeling of intellectual fullness through which we seem to be swollen with a superior knowledge of the object contemplated, and which nevertheless leaves us powerless to express it and to possess it by our ideas and make it the object of scientific analysis." With Aristotle Maritain holds that poetry is more philosophical than history in that it is concerned with the universal, but at the same time the apprehension of the universal or intelligible is not the result of abstracting a concept. Of course, since the intellect is at play in aesthetic experience,

this cannot be a matter of temporal immediacy, since it requires time to hear music as well as to think through the steps of mathematical reasoning. Maritain's statements on the subject which we have seen in the text simply suggest that sensory cognition is more ontologically direct, if I may so put it, than that which requires the abstraction of a concept. They further imply that the objects naturally proportioned to material, sensing, intellectual knowers such as ourselves are those which are at once material, sensible, and intelligible. (See *CI*, pp. 125-126).

In his early book, *La Philosophie Bergsonienne* (Paris, 1914), the matter of directness is clarified by his treatment of intuition. There he says that intellectual perception which is an abstract knowledge of natures can be called – broadly and improperly – an intuitive knowledge because there is no *objective* intermediary; at the same time it is not as direct as sense perception because there is a *subjective* intermediary, the concept, between the subject and the known. Also of interest for our purposes here is the development of this distinction he makes in saying that in sensory cognition the object is attained as *physically present*, as given in actual existence. Intellectual perception, on the contrary, attains the object, not as present or actually existing, but as "enveloping in itself only an ideal existence." [pp. 149-151 of the translation *Bergsonian Philosophy and Thomism (BPT)*]. *DK* contains the same idea; intelligence detaches its object from the universe of existence in order to know it and can complete its grasp of the real only in returning by means of the senses to the singular, wherein the universal is realized. (*DK*, p. 131; see also p. 54, n. 1 for an explanation of 'ideal').

[65] *A & S*, pp. 23-26; 164, n. 56. See also V. L. Simonsen, *L'Esthétique de Jacques Maritain* (Paris, n.d.), p. 19.

there may be concepts present – having to do with the subject or other material elements and relationships; but the presence of a concept is not what formally constitutes the aesthetic experience or serves as the means of appropriating the aesthetic object. The mind is delighted by a form *as* dominating, animating, or shining upon a given proportioned matter; and this cannot be presented by a concept but only by "the sensible object intuitively grasped – in which there is transmitted, as through an instrumental cause, this radiance of a form." This radiant intelligibility as the object of aesthetic delight "cannot be disengaged or separated from its sense matrix and consequently does not produce an intellectual knowledge expressible in a concept."[66]

4. The beauty which is connatural to man must, then, be grasped by the activity of the senses in union with intelligence. Further, as we noticed, Maritain holds that some things known by us through the senses are *displeasing*; they are said to be ugly, disgusting, or nauseous, because they are "repugnant to the inner proportion or harmony of the sense itself." Consequently for us sentient beings things divide into the beautiful and the ugly, according as they please or displease an intelligence engaged in sense perception or a sense involved with intelligence. This kind of beauty he calls *aesthetic beauty*. But everything that is – whatever it is and whatever its privations – Maritain claims would be pleasing to a pure intelligence since it has, to the extent that it succeeds in existing, some perfection, proportion, and radiance. And these characteristics are present in things ultimately because every being participates in the divine beauty, as stated earlier in the discussion on clarity.[67] Thus all things are beautiful, whether pleasing to the senses or not; and Maritain calls this sort of beauty *transcendental beauty*[68] – *being* itself considered under the aspect of delighting an intellectual nature by the mere intuition of it. Aesthetic beauty, the beauty most naturally proportioned to humans, is "a particular determination of transcendental beauty" –namely transcendental beauty as confronting the united act of both intellect and sense.[69]

[66] *A & S*, pp. 55-56; 163-165, n. 56; 181, n. 95. See below, Appendix. How this intellectual knowledge which is yet not conceptual can occur, through what Maritain (and Gilson) call an *intelligentiated sense*, need not concern us here. The important notion is the testimony of our aesthetic experience that the intellect is pleased in something concrete as open to an immediate and non-conceptual grasp which is both intellectual and sensible.

[67] *CI*, pp. 125-126; *A & S*, p. 31.

[68] *CI*, pp. 124-127. Note, however, here that Maritain does not establish that beauty is a transcendental from the premise that all things participate in the divine beauty. See below.

[69] *A & S*, p. 30; *CI*, p. 125; see also p. 317, n. 16.

I will not attempt to give an extensive justification of Maritain's position on the transcendentality of beauty in the broad sense given above in which he sometimes understands it, nor in other ways to become involved in this issue.[70] It will suffice for our purposes simply to proceed here to give a brief indication of how he arrives at this view and what he means by it. What is of importance is what he does with this notion as a premise. It is on this that we shall shortly need to focus attention.

Maritain's approach to the transcendentality of beauty in both *Art and Scholasticism* and *Creative Intuition*, at least for the purpose of exposition, is based on experience – in his case a wide experience of the arts. The former work contains the fuller treatment of the notion. After having enumerated the three characteristics of that which pleases the intellect, Maritain draws on his acquaintance with the arts to say that one must not take these characteristics of beauty in any very narrow way. Integrity can be realized in thousands of ways rather than just one; the integrity of one completed thing will be different from the integrity of another. Hence it is, for example, different in a living woman than in the Venus de Milo. "The least sketch of da Vinci's or even of Rodin's is more complete [in its way] than the most perfect Bouguereau." And if in a given painting a futurist gives a lady only a quarter of an eye, this will be no offense against integrity if the quarter of an eye is "all the eye this lady needs *in the given case.*"[71]

Proportion, too, will be different depending on the objects and ends involved. Thus he observes that for their type, figures which conform to Greek or Egyptian canons are perfectly proportioned; Rouault's clowns, however, are also perfectly proportioned for what they are and for the artistic ends they serve.[72] As we have noted earlier it is a question of *due* proportion; and this, along with integrity, is determined with respect to the fine arts in relation to the end of the work – the making of a form to shine on matter.

Finally, there are an "infinity of diverse ways" for a form to shine on matter; clarity too is realized in the essentially different ways by

[70] See e.g. *A & S*, p. 172, n. 66; Callahan, p. 75; Gilson, "The Forgotten Transcendental..."
[71] *A & S*, p. 27.
[72] At one point Maritain refers to Aquinas' comparison of beauty and health in which Thomas says that health is a "proportion of humors in relation to a particular nature," so that what is a good proportion for a lion may mean death for a man. Just so, bodily beauty is a proportion of parts and colors, and the beauty of one is not that of another. (*Comment. in Psalm.*, Ps. XLIV, 2 as quoted in *A & S*, p. 171, n. 64).

which there is an intrinsic finality in a work or, for that matter, any
being.

There is the sensible radiance of color or tone; there is the intelligible clarity of
an arabesque, of a rhythm or an harmonious balance, of an activity or a move-
ment; there is the reflection upon things of a human or divine thought; th ere is,
above all the deep-seated splendor one glimpses of the soul, of the soul principle
of life and animal energy, or principle of spiritual life, of pain and passion. And
there is a still more exalted splendor, the splendor of Grace, which the Greeks
did not know.[73]

At this point in the development of the idea as it appears in *Creative
Intuition*, Maritain says that each of the three characteristics as well
as beauty itself being realizable in an infinity of ways means that they
are analogous notions. He observes that the beauty of a bunch of
flowers or of a landscape is not that of a mathematical demonstration,
or of an act of generosity, or of a human being. While all these are
beauty, the type of beauty is so basically different that there is no
univocal commonness of species, genus, or category.[74]

Attempts to attain beauty as belonging to a definite type and to
capture this in a work have in fact failed. This conclusion Maritain
draws out of the example of masters of the Renaissance. He relates
that Albrecht Dürer in particular thought such an accomplishment to
be possible, utilizing a knowledge of mathematical laws and geometrical
properties. Indeed, at one time he "hoped to capture absolute beauty
by means of a ruler and compass." His lack of success is seen in his
later admission that only God knows what absolute beauty is. Chairs
and tables as being in a genus can be produced by art; beauty cannot.[75]

Maritain completes the line of thought being traced by saying that
this characteristic of beauty, which he calls analogous, can be ex-
plained by the fact that beauty belongs to the order of the transcen-
dentals. By this he means that it belongs to the order of objects of
thought which "transcend every limit of genus or category"; the tran-
scendentals cannot be restricted to or enclosed in any class "because
they imbue everything and are found everywhere." Thus they are not
attributes of some certain kinds of things but rather are aspects of

[73] *A & S*, pp. 28-29.

[74] *CI*, p. 124. See also "Apropos an Article by Montgomery Belgion" in *A & S*, p. 114.

[75] *CI*, pp. 133; 315-316, n. 12; compare Croce, *Aesthetic*, translated by D. Ainslie (New
York, 1922), p. 122. See also G. E. Moore, p. 202. For Moore beauty is objective, but also
there can be no single criterion of it. He says that the qualities which *differentiate* one beautiful
thing from another are as essential to a thing's beauty as those qualities which it has in
common with the others.

being or of whatever exists as such; and since beauty is a transcendental, everything that is must be said to be beautiful in its own way. Because being is everywhere and in a varied manner, so too the beautiful "spills over or spreads everywhere, and is everywhere diversified."[76]

Maritain maintains that this is Aquinas' doctrine and takes some pains to establish this point against some of his Thomist adversaries[77]; but one cannot accuse him simply of arguing from authority in these matters, as the foregoing presentation of the steps in his thought on the subject indicates. This is made quite explicit by Maritain at one point in the *Creative Intuition*. There he writes that the transcendental and analogous character of beauty becomes especially apparent to us through an experience of human art; so that the more the intellect "becomes acquainted with the works of human art, the more it becomes aware of the transcendental and analogous nature of beauty." He adds that this character explains why art constantly strives to find new analogates of beauty and why a canvas of Goya, a Chinese drawing, and a Rembrandt painting all have – but in a quite different way – integrity, proportion, and radiance.[78] We are not told precisely how this acquaintance with human works of art yields the judgment that beauty is a transcendental, beyond the indications that beauty and its characteristics are found in radically different ways in the various works that can be experienced. Certainly there is no abstraction (through the simple apprehension of an essence) of a univocal concept of beauty. Rather Maritain seems to suggest that an acquaintance with several sorts of beauty – of diverse sorts of integrity, proportion and clarity – causes us to see that beauty cannot be *identified* with any of these kinds. If this is true, then – although he does not say so explicitly in dealing with beauty – it is by a negative judgment that beauty in metaphysical reflection is freed in its transcendental amplitude from any category or particular mode of realization.[79]

Consequently he does not hold just that beauty transcends any one type or category. Had he said this, he might have allowed for the possibility that some things are not only aesthetically ugly but also ugly even for pure intelligence. Rather, he is moved to say that beauty

[76] *CI*, p. 124; *A & S*, p. 30.
[77] See especially *A & S*, pp. 172-174, n. 66.
[78] *CI*, p. 127. This is to say nothing of the differences between Vivaldi and Varèse, Yeats and Ginsberg.
[79] Compare *E & E*, pp. 28-30, n. 14 on the *separatio* in Aquinas; contrast *DK*, pp. 210-216; *PM*, pp. 79-85.

and its characteristics are, as we have seen, *co-terminus with being.* Thus "wherever there is anything existing, there is being [integrity], form [clarity], and proportion; and wherever there is being, form, and proportion, there is some beauty."[80] Specifically, with respect to the most important of the three, clarity, Maritain writes that "to the extent to which anything is, it is transparent, communicable, it possesses a certain measure of communicability, a diffusiveness, a generosity."[81]

The transcendental character of beauty can be invoked to explain how there can be both relativity of taste and objectivity of beauty. As analogous and transcendental, beauty will encompass all of the diverse forms of what has been called beautiful and the diverse modes of delight in these things.[82] Maritain sees this idea in a number of Delacroix's statements – that a Greek and an Englishman are both beautiful but in a way peculiar to each and not common to the other, that the beautiful (in art) must be seen where the artist has chosen to put it, and finally that beauty cannot vary in its essence without being mere caprice. "But its character can change; a countenance of beauty which once charmed a far-off civilization does not astonish or please us as much as one which is more in accord with our feelings or, if you like, our prejudices."[83] If something appears beautiful to some and not others, it is because it is beautiful under certain aspects – some see these and others do not. [84]

[80] *A & S*, p. 173, n. 66. Gilson observes that for Thomas the three elements of beauty were directly related to what is intrinsic to fully constituted beings. Thus integrity is perfection or actuality in being; proportion is an essential constituent of the goodness of things, as measure, species, and order; clarity is everywhere present in that everything has its own brilliance and participates in God's light. (Gilson, "The Forgotten Transcendental..." p. 163). Phelan links the three elements both to the three parts of the first definition of beauty and to the three other transcendentals usually mentioned. Thus:

id cuius	=	integritas sive perfectio	=	ens	
apprehensio	=	claritas	=	verum	} = pulchrum
placet	=	proportio sive consonantia	=	bonum	

(Phelan, p. 143. See also Anderson, p. 134, n. 4; G. F. van Ackeren, "On the Contemplation of Beauty," *The Modern Schoolman*, 18 (1941), p. 54). Maritain suggests the connection too in saying that beauty is the radiance of all the transcendentals united. (*A & S*, p. 173, n. 66; *CI*, p. 124).

See Pouillon pp. 306-308 for a chronology of the appearance of beauty as transcendental in the works of Albertus Magnus and Thomas Aquinas. He notes that prior to their writing commentaries on the *De Divinis Nominibus* of the Pseudo-Dionysius neither Albert nor Thomas recognized beauty as a transcendental.

[81] *PM*, p. 80.

[82] *A & S*, p. 174, n. 66. Compare here Croce, Chapters 14, 16.

[83] Delacroix, "Variations du Beau" in *Révue des Deux Mondes*, July 15, 1857 (Oeuvres littéraires, I, Études esthétiques, Paris, Cres, 1923, pp. 37ff.) as quoted in *A & S*, p. 172, n. 65.

[84] *A & S*, p. 30. In these ideas one can find a metaphysical basis for Northrop Freye's statement in *Anatomy of Criticism* (Princeton, 1957) that "every increase of appreciation has been right and every decrease wrong." (p. 25). Compare G. E. Moore, pp. 200-201.

We are here speaking of human perceivers who as material, sentient knowers are in time, each with his own history. Implicit in Maritain's view is that what is pleasing to some person in a certain spatio-temporal situation will be proportioned to his mind, with the past that he has, while it may not be as well proportioned to minds at other times. What is well-proportioned to or connatural with the mentality of one culture may not be so with respect to another. Like the broader notion of aesthetic beauty as previously defined by Maritain, this beauty – as proportioned not to man in general but man in such-and-such a circumstance – is but a particular determination of transcendental beauty. Realizations of such beauty are all simply analogates of the transcendental analogue beauty.[85]

THE RELATION OF ART TO BEAUTY

5. Having looked at what Maritain understands by beauty, however and wherever it is found, we can now examine the relation art has to it; for this chapter means to show how the contact of fine art with beauty reveals something of the ontological status of its product.

This relation can be seen by turning to the distinction which Maritain draws between the fine and the useful arts, insofar as it is formulated in terms of a connection with beauty. We have already noticed something of the distinction in discussing Maritain's use of 'disinterestedness' since he uses the term both in the context of beauty in general and of the fine arts. Basically, it is this disinterestedness surrounding them that distinguishes the products of fine art from those of useful art; it is to delight the mind that the products of fine art exist, not to serve a need. Now the distinction in question is made in the text of *Art and Scholasticism* in a fairly rigid manner as can be seen from the following:

Art in general tends to make a work. But certain arts tend to make a *beautiful* work, and in this they differ essentially from all the others. The work to which all the other arts tend is itself ordered to the service of man, and is therefore a simple means; and it is entirely enclosed in a determined material genus. The work to which the fine arts tend is ordered to beauty; as beautiful it is an end, an absolute, it suffices of itself; and if, as work-to-be-made, it is material and enclosed in a genus, as beautiful it belongs to the kingdom of the spirit and plunges deep into the transcendence and the infinity of being.

[85] See Croce, p. 125.

In this passage we note that the works of useful art are said to be a "simple means" and "entirely enclosed" in a material genus, as opposed to the works of fine art, which are ordered to beauty and are ends-in-themselves. The language used in making the distinction suggests that it is not a question of whether *in fact* a work of useful art is beautiful or a work of fine art is useful, but rather of what is intended by the art – to what it is that a given art essentially tends.[86] This becomes especially clear in the section in *Creative Intuition* establishing "the conformity of the intellect with the straight appetite" as that which constitutes practical truth. In the case of prudential truth the straight appetite is one which is rectified by moral virtues; in artistic truth it is one which intends the good of the work as achieved by intellectually discovered rules. The difference between the rules in the useful and in the fine arts is significant. Regarding the former, the primary rule is that to which the appetite fundamentally tends, the need to be satisfied; the secondary rules are the elaborated or refined ways of achieving the desired result discovered by the craftsman in the process of making. In the latter, however, the appetite must "straightly tend to beauty"; the primary rule is the release of creativity in its "longing for beauty." Hence the direction of tendency as the determinant of how to proceed is basically different; the fine arts tend toward beauty, and a correct judgment within the sphere of fine art is one in conformity with an appetite so tending. The distinction, then, "is taken from the end pursued."[87]

It must not be supposed, however, that the fine arts tend to beauty in the sense of attempting to make it. In *Art and Scholasticism* we read that the *general* end is beauty, but that the work-to-be-made is not a material means serving such an end. This work-to-be-made is an individual, unique realization of beauty, not the general end of the artist's art but the particular end which rules his productive activity. For him it is an end in itself.[88] So, we must say that the fine arts aim to produce beautiful things but not to produce beauty. An object of making as such is in any case a thing contained in a genus, while beauty is a transcendental. The beauty of the work is a *result* of the production but not the product or direct terminus of the process of production; it is participation in a transcendental quality (which can-

[86] *A & S*, pp. 33-34. See G. C. Hay, "Maritain's Theory of Poetic Knowledge: A Critical Study" (Doctoral dissertation, Catholic University of America, 1964), p. 18; *CI*, p. 41.

[87] *CI*, pp. 38-39, 41, 43, 44; *A & S*, p. 158, n. 40.

[88] P. 46.

not be made) – a particular *mirroring* of a transcendental or an infinite. Accordingly, the beauty of the work is rather a gift, albeit, we must conclude, not an unsolicited one.[89]

Still, the distinction between fine and useful art as presented in the text of *Art and Scholasticism* seems unsatisfactory even with the qualifications so far attached to it. Maritain himself recognizes that there is a concern for beauty even by the lowliest craftsman, that both nature's and man's production of the useful involves an exercise of creativity such that what results is something more than pure utility.[90] In architecture the pursuit of beauty along with utility is especially apparent. So, while in the text of *Art and Scholasticism* he says that "certain arts tend to make a *beautiful* work, and in this they differ *essentially* from all the others," we find in a footnote to the same work that the division of arts into fine and useful is *not* an "essential division"; for some arts can pursue both beauty and utility at the same time.[91] Thus it is not that the fine arts are ordered exclusively to beauty and that the others produce nothing beautiful. Maritain states in a somewhat later piece that "in the fine arts the spiritual element introduced by the contact with beauty becomes preponderant."[92] Here there is no question of presence or absolute absence.

Developing this theme further in the later work, *Creative Intuition*, Maritain says that any art can engender in beauty and furthermore that neither beauty nor any other transcendental can be used to define a genus since as transcendental they permeate all genera. So it is better by way of definition to say that in some arts there is more concern for

[89] *CI*, pp. 133; 317, n. 14. This gift comes "from the spiritual source – poetry – in which the production of the work originates." (*CI*, p. 317, n. 14. 'Poetry' here does not refer to poems or poem-writing but to a kind of knowing to be discussed in Chapter IV which is the "inspiration" in all the fine arts. The latter is the sense of the word to be understood in this study unless otherwise indicated.) Ultimately for Maritain if the fine arts engender in beauty, it is because the virtue of art is moved by poetry or poetic intuition. Of this, much more remains to be said.

It might also be observed that it is because of the transcendental nature of beauty, with its capability of being realized in unique and diverse ways, that the criterion of artistic truth in the fine arts must be construed to be a conformity of the artistic judgment to the straight appetite tending toward beauty rather than a conformity to or an application of any set of abstract rules. The latter course would be tantamount to taking beauty as generic and the rules as so many recipes for producing it in a manner similar to folding paper hats.

With respect to the *mirroring* spoken of above in the text, see below, this chapter, n. 106 for the manner in which the mirrored quality is predicated of that which reflects it.

[90] *CI*, pp. 46-47.

[91] *A & S*, pp. 33; 158, n. 40. Italicization of 'essentially' mine.

[92] "Apropos an Article by Montgomery Belgion," pp. 113-115. This was first published in 1931. Italics mine. See above, this chapter, n. 54 and below, Chapter III, #5 and Chapter I V, n. 28 for discussions of the word 'spiritual'.

the relation to needs of human life and the work must be *good for something*, while "in certain other arts, the good of the work succeeds *more* in being a *good in itself and for itself*, a world of its own – whatever the relations it can and must continue to have with the concerns of human life may be. When the good of the work reaches such self-interiority, the art involved is not subservient, but free..."[93] Actually, therefore, Maritain prefers to call the former arts the *subservient* rather than the useful arts and the latter the *free* or *self-sufficient* arts according as the work tends to be free of the service of needs and to be an end in itself, free to be itself in innumerable ways.[94]

With respect to beauty, Maritain says in *Creative Intuition* that – in the extreme case – even if objects fulfilling needs or good for something were in a sense totally utilitarian as those produced by the mechanical arts might be said to be, they would still have a certain beauty about them, beauty being a transcendental. But he places a very important qualification on this kind of beauty; it is "the most limited form of beauty, ...[a] mute beauty, with almost no echoing power..." Such objects would have an intelligibility to be sure; yet they would be oriented, not to the irradiation of the mind, but rather to use. The art that produces them would be servile, in bondage to its primary rule, the need to be served.[95] To the extent that art is ruled by such a need, its product will be only what it is as a thing with a specific material function, tending to an end extrinsic to the object – a mere material object-in-a-genus, with its appropriate, relatively small degree of intelligibility.

However, if something is not just good for something but also good in itself, it can be enjoyed as an end in the contemplation of it. So

[93] *CI*, p. 134. See above, this chapter, #2 for a clarification of the sense in which the *object* of aesthetic contemplation must be regarded as an end in itself.

[94] *CI*, pp. 128-135; see also p. 81. A crucial point in a complete comparison of fine and useful art is found in Maritain's statement that the fine arts, being free because of their immediate relation to beauty (with its openness as a transcendental) and to the "pure creativity of the spirit," belong to the liberal arts. (*CI*, p. 47). These free arts are that part of the liberal arts concerned with producing an external work. (*CI*, p. 134). The ancients, he says, did not see this, thinking of most of what we now call the fine arts as servile because manual labor seemed servile. (*CI*, p. 47). The older distinction, which Maritain refers to, between servile and liberal arts, is that of what pertains to works done by the body and what pertains to works done by reason. (See *S. Th.* I-II, 57, 3, ad 3; *A & S*, p. 21). Or rather, says Maritain, the division is based on whether the work to be made is an effect produced in matter or is a "purely spiritual construction remaining in the soul." (*A & S*, p. 21). One can see from this latter expression why Maritain prefers the terms 'subservient' and 'free' or 'liberal' arts, even though he does not draw the distinction in quite the same way. The remainder of the book should show that Maritain's thought is perhaps somewhat closer to the older distinction than at first sight appears.

[95] *CI*, pp. 46, 81, 160.

while all products of art are beautiful, some arts – those in which the work succeeds *more* in being a good in itself – tend to make a work which is either partially or fully for contemplation and hence not at all or less totally engaged in being for some instrumental employment here and now. Since they are so oriented, such products will have a much greater proportion to mind, less opacity or muteness, greater intelligibility and spirituality.[96] Why this is so will become clearer later.

Consequently we must say that the definition in *Creative Intuition* does not deny that the fine arts have an essential relation to beauty; the distinction in *Art and Scholasticism* is simply made less exclusive and stated in terms of the good of the work.[97] Thus, while any object *can* be regarded with disinterest, the fine arts are essentially oriented to the production of objects for such a regard and consequently to the making of things which will have a greater degree of beauty, a beauty which is not at all "mute."

As we shall see, the appearance of this articulate beauty is the result of the presence of what might be called creative vision, that is, poetry or poetic intuition. But the less rigid definition of *Creative Intuition* does not really make this presence the differentia of fine art either. What does go into making the distinction, with its appropriate shadings, is succinctly stated at the close of Maritain's discussion of this point. "Poetry and beauty walk everywhere in the realm of art. But in those self-sufficient arts poetry is freer, and more prepared to master everything. And beauty demands more despotically, not to be 'produced' as an object of making, but to be loved, and mirrored in the work."[98]

THE WORK OF FINE ART AS TRANSCENDENTAL

6. So far, Maritain has described the ontological status of the work of fine art as transcending that of being simply a material-object-in-a-genus. It is more than it is, it says more than it is, it delivers "to the mind, at one stroke, the universe in a human countenance."[99] Uncovering the kind of ontological account of the work that makes this

[96] See *AG*, p. 72; *A & S*, pp. 33-34.

[97] *CI*, p. 134.

[98] *Ibid.* As he puts it in another place, poetic intuition may be present in useful art, but in contrast to fine art it is not there the "spiritual germ" or the determinative focus of the work's coming to be. (*CI*, p. 100). See above n. 89 for a brief explanation of the term 'poetry' as used by Maritain, and below, Chapter IV for a full treatment.

[99] *Ibid.*, p. 93.

surpassing possible will be of central importance to us. Since – however he chooses to put it – Maritain has made it clear that the work of fine art is eminently beautiful, his notion of the transcendentality of beauty itself provides one approach to this account.[100]

Maritain shows a great fondness for a statement of Baudelaire, virtually copied from Poe, which he quotes in full in those places where he introduces the point under discussion.

> ... it is this immortal instinct for the beautiful which makes us consider the world and its pageants as a glimpse of, a *correspondence* with, Heaven... It is at once by poetry and *through* poetry, by music and *through* music, that the soul divines what splendors shine behind the tomb; and when an exquisite poem brings tears to the eyes, such tears are not the sign of an excess of joy, they are rather a witness to an irritated melancholy, an exigency of nerves, a nature exiled in the imperfect which would possess immediately, on this very earth, a paradise revealed.[101]

That this selection illustrates for Maritain the thing here being developed can be gleaned from the way he introduces it in each case. In *Art and Scholasticism* he says, "Beauty, therefore, belongs to the transcendental and metaphysical order. This is why it tends of itself to draw the soul beyond the created. Speaking of the instinct for beauty, Baudelaire... writes..."[102] Or in *Creative Intuition*, "...it is by virtue of this transcendental nature of beauty, even aesthetic beauty, that all great poetry awakes in us, one way or another, the sense of our mysterious identity, and draws us toward the sources of being. One remembers the page where Baudelaire, to whom modern art owes its having become aware of the theological quality and tyrannical spirituality of beauty, ..."[103] Again,

> Beauty is transcendental, a perfection in things which transcends things and attests their kinship with the infinite, because it makes them fit, to give joy to the spirit. It is a reflection in things of the Spirit from which they proceed, and it is a divine name: God is subsistent Beauty, and 'the being of all things derives from the divine beauty.' Knowing this, we realize that it is impossible that the artist, devoted as he is to created beauty which is a mirror of God, should not tend at the same time – but by a more profound and more secret

[100] Here, of course, I do not wish to take up the differences between the various fine arts, but will speak in terms of those whose product most definitely has a material basis, in order to make a point which can be applied *mutatis mutandis* to the others.

[101] Preface to *Nouvelles Histoires extraordinaires*. Quoted by Maritain in *CI*, p. 127; *A & S*, p. 32; *AG*, p. 80; *SP*, p. 43. See Poe's *The Poetic Principle*; the passage from Poe is quoted in *A & S*, p. 175, n. 73.

[102] P. 32.

[103] P. 127.

[104] *AG*, pp. 79-80. See also *SP*, pp. 42-44.

urge than all that he can know of himself – toward the principle of beauty. A celebrated passage of Baudelaire... reveals in this connection its full import...[104]

From the passage of Baudelaire and from Maritain's introductions to it, one can see that the beauty of such things as a work of fine art will, as participating in transcendental beauty, "mirror" or reflect something beyond the object whose beauty it is; it will show forth its similarity with analogates of beauty which are not present.[105] Among these analogates to which a beautiful thing will be similar is the divine beauty in which it participates and which it therefore mirrors. It is the presence of this similarity that especially interests Maritain, as his use of the passage from Baudelaire suggests. Thus he observes that "Analogous concepts are predicated of God preeminently... God is their 'sovereign analogue,' and they are to be met with again in things only as a dispersed and prismatized reflection of the countenance of God."[106] And quoting Aquinas he says, "the beauty of anything created is nothing else than a similitude of divine beauty participated in by things..."[107]

7. This analogical similitude is the ontological basis for the reflection or manifestation of a higher beauty; but we should not confuse the various ways, made possible by this similitude, in which we become aware of a higher analogate through one given in experience. Maritain in many of his works explains, and often in a language similar to what he uses in treating the mirroring effect of beauty,[108] how we arrive at *metaphysical* knowledge of objects in an intelligible order disproportionately higher than that connatural to our human minds. This realm,

[105] Maritain's language implies that the beauty of things we see other than works of fine art also mirrors what is beyond. Since we shall not attempt to establish that the ontological status of works of fine art is *peculiar* to them nor to determine what the ontological status of beautiful objects other than works of fine art is, we can restrict the discussion to beauty in art. We have already seen, however, that the beauty of such things as utilitarian objects is said to have very little echoing power.

[106] *A & S*, p. 30. Maritain's notion of the analogy of being and of the other transcendentals, deriving through Thomistic commentators ultimately from such texts as Aquinas' *In I Sent.* 19, 5, 2, ad 1, is that of strict or proper proportionality. See *DK*, pp. 418-421 and *PM*, p. 67. Hence the language he uses here should not be taken to suggest that there is a πρὸς ἕν equivocity in the predication of such terms as beauty of God and of created things. The analogue (in this case beauty) is found intrinsically and properly in each of the analogates. (*DK*, pp. 213, 419).

[107] *A & S*, p. 31, quoting *In de Div. Nom.*, IV, 5. See Phelan, "The Concept of Beauty in St. Thomas Aquinas," pp. 132, 144; Hay, pp. 15, 123-124; McCall, p. 139. McCall expresses the view that "the ultimate end of all finite beauty is to manifest, even if in fragments, the infinite beauty of God."

[108] See e.g., *DK*, p. 218, *PM*, p. 49.

knowable for us only by analogy, is called the *transintelligible* and is occupied primarily by God.

Metaphysical knowledge depends upon a disengagement of a concept of being from things given in experience, by a process of abstraction.[109] Being, so intended, is definitely not the object of an intuition "centered upon a reality grasped concretely in its singular existence..." While in a sense it is gotten intuitively, it is nevertheless evoked from the intellect "by means of a concept."[110] This concept provides the basis for an analogical knowledge in which the *analogates* of the analogue being which do not fall within our immediate grasp can be known in those analogates which do "as in a mirror," "in virtue of the likeness" between them. This is knowledge by analogy or "ananoetic intellection." And speaking of metaphysical knowledge, Maritain says that "it is by means of the abstraction of the transcendental *analogue* that the transintelligible analogate is known in the analogate proportionate to our intelligence."[111]

[109] In *E & E* this process is made to cover the negative judgment of separation of a notion of being, about which Aquinas speaks in his commentary on Boethius' *De Trinitate*. See here also *PM*, pp. 61, 63-64; *DK*, pp. 213; 219, n. 1.

[110] *PM*, pp. 51, 61. Maritain tends to lean somewhat heavily on intuition, although he is careful to disassociate his views from Bergson. There are many kinds of intuition, however, for Maritain; and one must not fail to distinguish them in their various degrees of immediacy. See, e.g., *PM*, pp. 49-51; *BPT*, pp. 149-164; Hay, *passim.*; below, Chapter IV, n. 7.

[111] *DK*, pp. 218; 219, n. 1. One can, however, notice an interesting parallel between the way in which the *aesthetic* consciousness of the transintelligible works, on the one hand, and the way the movement of thought in a metaphysical awareness proceeds, on the other. Maritain admits in a note to *E & E* that the analogical abstraction of a metaphysical concept of being is produced in a *negative* judgment denying that being is *necessarily* linked with matter or material conditions. (*E & E*, p. 29, n. 14).

Further, in the primordial philosophic intuition of being operative in this disengagement, that most basic of metaphysical principles for Maritain, the principle of identity, is "seen in its ontological necessity"; (*DK*, p. 215) and Maritain's understanding of this principle is instructive. According to him, it asserts that each being is what it is. But, "if each being is what it is, it is *not* what the others are." (*DK*, p. 216; italics mine). Thus the axiom of identity is the axiom of the "irreducible *diversities* of being" (*DK*, p. 216; italics mine. See also *PM*, p. 61), the "guardian of universal multiplicity" (*PM*, pp. 61, 62), and as applied to creatures delimits and confines them within themselves. (*PM*, pp. 94-95). Thus far from being a mere repetition, the principle "expresses... the overflowing wealth of being in all its analogous degrees..." (*PM*, p. 96).

Again, we have already concluded that Maritain's observations which lead up to the *reflective, metaphysical* view that beauty is a transcendental contain the same negative moment, viz. along with an awareness of the beauty and the characteristics of beauty in many things, the recognition that the way these characteristics are realized in one object is not the way they are realized in another.

Looking now at the non-metaphysical, *aesthetic* awareness in which the transintelligible merely insinuates itself, we find Maritain in *Creative Intuition* speaking very similarly, though here there is no formation of a concept of beauty. After presenting the Baudelaire passage, he goes on to say that, "Here perhaps we can best realize why beauty does not mean simply perfection. For anything perfect in every respect in its own genus – anything 'totally perfect' on earth – is both totally terminated and without any lack, therefore *leaves nothing to be*

Now it has been shown above that in *aesthetic* perception, for Maritain, beauty is had without any labor of abstraction, in the experience of the concrete singular.[112] Hence the kind of awareness of a transcendental that obtains in metaphysics cannot be what Maritain has in mind in discussing the passage from Baudelaire.[113] What he does seem to have in mind is contained in the paragraph introduced above which prefaces the Baudelaire passage in *Approaches to God*. In it Maritain says that beauty as a perfection in things "attests their kinship with the infinite, because it makes them fit, to give joy to the spirit." It is the proper trait of the beautiful to give joy upon being seen; and Maritain implies that the experience of a limited, incomplete, or fleeting joying-in carries with it intimations of a joy that is unalloyed and complete. This idea is also found in the Baudelaire passage itself; an exquisite poem brings tears to the eyes because while it delights us, it also reminds us that we are "exiled in the imperfect." The poem being so touchingly beautiful, its defects make us all the more aware of its limitations. It gives us joy, but fails to satisfy our craving; and it is just these flaws and failures in the midst of beauty and joy which cause the poem to have the strong suggestive power. Maritain says that such a poem is graced by a "sacred weakness," the kind of imperfection "through which infinity wounds the finite."[114]

Nevertheless, although a transcendent beauty may be hinted at in our experience of created beauty, it is not a conceptualized nor a reasoned affair. Speaking of the artist's creative experience of beauty, for example, Maritain says that it is in itself an advance toward God, "a spiritual inclination in the direction of God, an obscure and ill-assured

desired – and therefore lacks that longing and 'irritated melancholy' of which Baudelaire spoke, and which is essential to beauty here below. It is lacking a lack. A lack is lacking in any totally perfect performance... A totally perfect finite thing is untrue to the transcendental nature of beauty. And nothing is more precious than a certain sacred weakness, and *that kind* of imperfection through which infinity wounds the finite." (*CI*, pp. 127-128).

[112] *A & S*, p. 26.

[113] The above considerations of themselves rule out such approaches to the transintelligible as the ways Aquinas uses in the first part of the *Summa Theologiae* and even the primordial way to the existence of God Maritain discusses in *Range of Reason* (New York, 1952), pp. 86-91, and *Approaches to God*, Chapter I. Also they are excluded because the former involves a discursive process of reasoning while the experience of beauty is intuitive; and the latter, although he speaks of it as having "in some way [an] intuitive character," still has several distinguishable moments in it, including a "prompt, spontaneous reasoning." (*AG*, pp. 19-20). See also *DK*, p. 222; *Summa contra Gentiles* (hereafter abbreviated *C.G.*), III, 38. The main ground for excluding this type of approach, however, is that it involves – through an awareness of things, their otherness from me, and my frailty and isolation from them – a disengagement of a concept of being; there is an "intuitive perception of the essentially analogical content of the first concept, the concept of Being." (*AG*, p. 19).

[114] *AG*, pp. 79-80; *CI*, pp. 127-128.

beginning of the knowledge of God – vulnerable, indeed, on all sides because it is not disengaged in the light of intelligence and because it remains without rational support."[115] Thus it is not a question of an elaborated knowledge or a clear perception but rather more a vague, obscure, arational advance in the direction of absolute beauty. The statements previously examined from *Art and Scholasticism* and *Creative Intuition* and the Baudelaire passage which they introduce do not themselves upon close scrutiny give any grounds for asserting that there is anything more to the mirroring effect of *beauty* than that.

Because the work is essentially beautiful, then, it has the characteristic mentioned above of leading beyond itself as a thing. But the way in which the point has been explained does not tell all of the story since the suggested meanings indicated in the foregoing are present because of the affect of the work as a whole on the beholder rather than because they structure the work "from within." If the work is to have the plenitude of beauty which enables it to affect one in such a way, it must have a splendor of intelligibility or a clarity which can belong to it only if its *intrinsic* meaning or structure exceeds that of being a mere thing. And this can happen only if its sense is comprised of *represented* meanings. In Chapter III I want to develop this necessity of representation along with its ontological implications. For its part, this internal sense of the work as a "new creature engendered in beauty" rather than as a copy of something will itself reflect an infinite expansiveness of meaning caught by the artist in things through what Maritain calls *poetry* or poetic knowledge. Chapter IV will explain Maritain's conception of this type of cognition, the kind of meaning it imparts to what is produced under its influence, and its implications for the ontology of the work.

[115] *AG*, p. 80.

SIGNS

1. Having seen how a certain fullness of intelligibility enters into Maritain's distinction of the fine arts, we can now determine whether this way of understanding the latter requires that the work function as a sign. If it must signify, then an exploration of the ontology of signs should be a means of gaining valuable insight into the ontology of the work. We will begin, then, with a look at Maritain's views on the sign-character of the work – that is, on the place of imitation or representation in fine art, whether it be of some "transintelligible" reality or simply, on a level more open to conscious awareness, of the appearances of things around us. Following this, we must examine the matter of signs in general and of the ontological status of whatever is signified insofar as it takes its place in the whole aesthetic experience.

FINE ART AND REPRESENTATION

2. In speaking of the place of representation in fine art, Maritain reminds us that the latter partakes of the generic nature of art (*recta ratio factibilium*), which has to do with making, "composing or constructing, in accordance with the laws of the very object to be posited in being (ship, house, carpet, colored canvas or hewn block)." Art is fundamentally creative; it produces something new, and consequently in its pure form it is not subordinate to rendering present what already exists.[1] The operative or creative idea as such is simply formative of things and is not formed by them (since the activity of art is one of creating rather than knowing); thus the more perfectly it realizes its essence the more independent of things the creative idea becomes.

But a complete independence of things is possible only in divine

[1] *A & S*, p. 53; *FP*, p. 124; see also *A & S*, p. 60.

creation, Maritain observes; and hence it is only in this case that art in the fullness of its meaning is realized perfectly. God's work, on Maritain's view, does not (and indeed cannot) copy what is already made; rather it manifests only the mind from which it proceeds.[2] In the realm of our art we are dealing with something human, and art in its pure form cannot be achieved. The reason for this is simply that human art cannot bring forth from itself a completely new form which is a manifestation of nothing other than the artist's own subjectivity. The creative independence of art *per se* is "thwarted in us by our condition – minds created in a body, placed in the world after things had been made, and obliged to draw first from things the forms they use."[3] In the case of the fine arts, because they must engender in a work which is radiant with intelligibility – which cannot be a reflection of the pure subjectivity of the artist unaffected by things – they have, insofar as they are ordered to beauty, "a certain relation to imitation, and one that is quite difficult to define." Fine art, depending for its existence upon man in whom it subsists, depends also on things, "on which it nourishes itself."[4]

Thus if fine art (or any human art) seeks to be pure art, it destroys itself in severing its connections with that which makes its existence possible. This Maritain calls "angelist suicide" since in art's attempts at pure creation it would try to leave behind the material world and to prevent its entering into the structure and texture of the work. Still, in order to realize its root spirituality, that is, its measure of indepen-

[2] *SP*, p. 49; *FP*. pp. 121, 126. In another place he says, "In God only does this independence with regard to things appear in a perfect manner. God sees in His Ideas all the ways in which His essence can be manifested, and He produces creatures according to the model of these Ideas, thus placing the seal of His likeness upon the whole expanse of that which is made, detaching things from the life they had in Him, and in which they were He, only to find again in them a vestige of Himself. Here only, on the high summits of Divinity, does the idea as artisan-form obtain the complete fullness required of it by its very notion." (*FP*, pp. 121-122).

This notion that there are degrees of realization of art suggests that 'art' is used analogously when predicated of divine and of human creation, and perhaps also so used even when predicated of different instances of human productivity – to the extent that there are in the latter *degrees* of independence of what already exists. Maritain's thought would pose considerable difficulty for anyone requiring complete univocity in the use of terms. For him the realm of what is real is full of things which can possess certain characteristics to a greater or less degree. Knowledge by analogy plays a central role in Maritain's philosophy; clarity and distinctness, which he says implies the negation of analogic knowing, does not. (*DK*, pp. 225-226; see below, Appendix. Also see below, Chapter IV, n. 32, for further discussion on this point).

[3] *FP*, p. 121. Basically, the reason implied by Maritain is simply that the human mind is a *tabula rasa*. Thus the intelligibilities it communicates to its creations must ultimately be drawn from the world.

[4] *A & S*, p. 53; *FP*, p. 123.

dence of matter, fine art must *tend* to pure art; it must struggle against
the conditions and servitudes in which it finds itself. Simply to copy
slavishly things already in existence would not be to dominate and
form a matter, and this would be not to create – the "sin of materia-
lism," suicidal also for art. Thus there is a tension between the demands
of the essence of art taken in itself in its attempts to *be* art and the
demands of the *"conditions of existence* called for by this very essence
according as it is realized here on earth," which also cannot be neglected
if human art is to be.[5]

So the dependence of fine art on things of the world – besides taking
from them its raw material – is in some way a dependence upon them
in terms of its forms. This reliance, however, is not the kind that would
obtain in a hypothetically pure useful art, which could be said to take
over in some way the forms of its products from nature. In the useful
arts, the form of the work can be like some natural thing without there-
by representing it and making it present to the consciousness of a be-
holder of the work. Not every likeness is a sign,[6] and the form of a
purely useful object would make the object it structures be just what
it is as a thing determined in its type by the use to which it would be
totally oriented. The work of fine art, however, must have an intelligi-
bility which exceeds that of a mere thing or thing-of-use; and this
effulgent intelligibility can come upon the work of human creativity
only through representation or imitation,[7] the making present of a
sense which the material artifact does not have in its own circum-
scribed being.

Here a distinction is in order. One can speak of dependence and imi-
tation with respect to forms present *in* the work and with respect to
the form *of* the work. The problem of imitation in fine art properly
understood primarily concerns the latter, since it is at this level that
the tension between art in its pure essence and the conditions of its
human existence are most crucial. On this level "...art's deepest exi-
gency is that the work manifest not another thing already made, but
the mind itself from which it proceeds"; "...the artist puts himself
– not what he sees, but what he is – into what he makes." Were it
otherwise, how could there be art or creativity? But at the same time,
"...we have nothing which we have not received." Hence the human

[5] *FP*, pp. 121-123; see also *CI*, pp. 158-160; "An Essay on Art," p. 90.
[6] *S & S*, pp. 218-220.
[7] See *A & S*, pp. 54-55. This is, of course, a necessary but not a sufficient condition – see
CI, p. 18.

artist can put his mark on the work only by the way he is affected by and transforms what passes into his mind.

... our art does not draw from itself alone what it gives to things; it spreads over them a secret which it has first seized by surprise in them, in their invisible substance or in their endless exchanges and correspondences... It transforms, it moves about, it brings together, it transfigures; it does not create [i.e., in the fullest sense]. It is by the way in which he transforms the universe passing into his mind, in order to make a form divined in things shine on a matter, that the artist imprints his mark on his work.

Thus the radiance of intelligibility or form, since it cannot come forth from the pure subjectivity of the artist, must be, as the next chapter will explain in some detail, a manifestation in their union of the intuiting, creating subjectivity and the secrets discovered in things. If in our art there is a law of imitation, it must be taken formally and in a purified sense.

What it [our art] makes must resemble, not the material appearances of things, but some one of the hidden meanings whose iris God alone sees glittering on the neck of His creatures – and by that very fact it will also resemble the created mind which in its own manner discerned that invisible color. Resemblance, yes, but a *spiritual* resemblance. Realism, if you will, but a realism of the super-real.[8]

Genuine imitation, however, the kind in which art does not betray itself, does not and cannot stop at the intuitive manifestation of only these secret meanings which comprise the form of the work. It is also bound to the representation of natural appearances themselves, employed *instrumentally*, (as forms in the work) in order that the intended manifestation can be intuitive. After all,

it is through the instrumentality of natural appearances that things reveal some of their secret meanings to the artist's intuition: it is also through the instrumentality of natural appearances – necessarily recast, and perhaps drastically so – that the same secret meaning can be intuitively revealed in and by the work.[9]

Or again,

Creative intuition and imagination... are human, bound to the alertness of sense perception. They *grasp* a certain transapparent reality through the instrumentality of the eye and of certain natural appearances – they cannot *express* or manifest it except through the instrumentality of these *same* natural appearances, recreated, recast, transposed of course, not cast aside...[10]

[8] *FP*, pp. 126-128. See also *A & S*, p. 189, n. 121; "An Essay on Art," p. 86. Note here that Maritain is speaking of the meaning or resemblance of the work, not of meanings within the work.

[9] *CI*, p. 165.

[10] *Ibid.*, p. 156. Italics mine.

Natural appearances, consequently, have a dual role in the coming to be of the work of fine art, being first of all the means through which the secret meanings caught by creative intuition are available in the world. Secondly, as recast and totally at the service of this meaning as it is brought to expression, they are the means through which and in which it is present and operative in the work.[11]

Thus it would be legitimate with respect to Maritain's thought to speak of levels of meaning and a structure of signs in, for example, a painting. Mass, color, and line can function to signify a natural thing when arranged to make such a meaning appear.[12] This represented natural object, however, in its turn will also, as we have just seen, be a sign as well.[13] Now these representations and images which themselves signify must be considered as instrumentalities rather than as the end of the work, and they enter into the work as the materials to be formed. The rhythms, sounds, colors, forms, and the like are the "proximate" matter of art; and what they signify is a "remote" matter, on which the artist must make shine the radiance of a form.[14]

[11] Maritain suggests that what he holds regarding imitation is similar to Aristotle's view. He takes Aristotle's words on the subject in *Poetics* 1448b5-14 to mean exact reproduction; but he continues that Aristotle at that point is going directly to the *most primitive* case as is his usual method and that this does not mean our understanding of imitation must be limited to this. (*A & S*, p. 54). Imitation is related to what is *most instinctive* in art, namely the pleasure of imitating and recreating forms; but it is also related to what is *most spiritual* in it, i.e., the meaning which is present insofar as it is an effect of poetic knowledge. (*SP*, p. 84, n. 9). Thus in *Creative Intuition* Maritain contends that Aristotle never really had exact reproduction in mind. "He meant that delight in seeing (or beauty) is all the greater as the object seen conveys a greater amount of intuitive knowledge: thus," Maritain adds, "in art and poetry the object is also a sign — through which some transapparent reality is made intuitively known." (*CI*, p. 164; see also *SP*, pp. 49-50).

[12] *CI*, p. 200.

[13] *A & S*, pp. 55-58. Compare with Maritain here Ingarden's notion of stratification of meaning in *Das Literarische Kunstwerk* (Halle, 1931), Chapters 3-11; Wellek and Warren, Chapter 12, which is based on Ingarden's views; and Victor M. Hamm, "The Ontology of the Literary Work of Art: Roman Ingarden's 'Das Literarische Kunstwerk'," in Paul R. Sullivan, ed., *The Critical Matrix* (Washington, 1961), pp. 171-209. For Ingarden the stratum of represented objects is the means for the emergence of "metaphysical qualities." These are not some "idea" expressed in the work but are qualities such as the sublime, the tragic, the terrible, the ineffable, the demonic, the holy, the grotesque, the charming, and the like. These qualities are neither objective properties of things nor "symptoms of psychic states." Rather they are a "specific atmosphere which penetrates and transfigures... [situations and events] with its light." In daily life these qualities seldom appear, but "Such metaphysical qualities revealing themselves from time to time are what give life its value, and for the concrete revelation of which we have a secret yearning in all our actions. Their epiphany forms the summit and depth of being... They cannot be logically defined or 'grasped', yet with their perception comes insight into the profundity of being, to which we are ordinarily blind..." (See Ingarden, *Das Literarische Kunstwerk*, pp. 300-303. Translation is by Hamm, p. 194). These qualities do not appear alone but are revealed in a whole situation. The views of Maritain and Ingarden seem very close here if these metaphysical qualities are interpreted as being what give the situation a meaning in terms of how one is affected by the situation as it relates to its global context.

[14] *Art and Poetry* (New York, 1943), p. 80; *DK*, p. 398. *A & S*, pp. 55-56.

Consequently, natural appearances as material to be shaped must, as Maritain has said in a passage previously introduced, be *transformed* in the work. They are to be dominated by the creativity of the artist, the more so the freer this creativity seeks to be. In fact, any representation whatever of natural appearance is an obstacle to this free creativity "as long as it [the representation] has not yet been purified and transfigured in the pungent night of creative intuition." This is why, Maritain says, Chagall could denounce Cubism's *naturalism* – because it did not break with these appearances, but sought instead to bring out new visual significance with regard only to external sensibility.[15]

Here we encounter a problem. For Maritain the work is shaped so that it will manifest a form or intelligibility. But if this form is somehow borrowed from what already exists, it would seem that the work, as a sign of what is "represented," will be but a vehicle of communication rather than an autonomous beautiful thing. He insists, however, that the work of fine art is an end, a "new creature engendered in beauty; not a means as a vehicle of communication."[16] Art activity is not one of knowing, but of creating – its end is the one and not the other. But at the same time, if the delight in the very act of knowing is not what constitutes delight in the beautiful, the delight which overflows from this act is, when the object is well-proportioned to the intellect.[17] Thus this delight *presupposes* knowledge and intelligibility – the more things or rather the more intelligibility given to the intellect the greater the possibility of delight. A form or an intelligibility must shine forth from the beautiful, the experience of which is valued in itself. The intelligibility will be that of the work itself; but our art for reasons already mentioned cannot recompose its *own* world, this autonomous "poetic reality," except by communicating to it the intelligibilities offered by things already in existence.[18] Nevertheless, "the imitative

[15] *CI*, pp. 154-155. Samuel Hazo refers to Maritain's view as a "transfigurative realism," had by imitating the inner spirit. As such, he says, it perpetuates a tradition begun by Aristotle of regarding imitation as being not of accidentals "but of nature as an inherent force or energy in every object." "An Analysis of the Aesthetic of Jacques Maritain" (Doctoral dissertation, University of Pittsburgh, 1957), pp. 17-18.

One might compare here the views of C. W. Morris. For Morris, while the work of fine art is a sign, the imitation involved is not necessarily literal reproduction. The artist molds a medium so that it takes on the value of some significant experience. It is this value which is of importance rather than any other objects which the aesthetic sign might denote. C. W. Morris, "Science, Art, and Technology," in Vivas and Krieger, *The Problems of Aesthetics*, pp. 109-110.

[16] *CI*, p. 208. Maritain frequently uses the expression that the work is a "world of its own" to refer to this aspect of the work.

[17] *SP*, pp. 47, 49. See above, Chapter II.

[18] *A & S*, pp. 54-55; p. 189, n. 121.

arts *aim*[19] neither at copying the appearances of nature, nor at depict-
ing the 'ideal', but at making an object beautiful by manifesting a *form*
with the help of sensible signs." We can speak of truth in art because
the radiance of a form means a radiance of intelligibility, but it will
not be a truth of imitation as a reproduction of things. Instead, it will
come "from the perfection with which the work expresses or manifests
the form, in the metaphysical sense of this word." This is the formal
element of imitation in art: "the expression or manifestation, in a work
suitably proportioned, of some secret principle of intelligibility which
shines forth."[20]

Perhaps the best way to clarify Maritain's view on this point would
be to examine and criticize an interpretation of him made by Thomas D.
Rover, in a book entitled *The Poetics of Maritain: A Thomistic Critique*.
We find in this book that Maritain is accused of subordinating cognitive
to ontological-formal values; Rover says that the form which shines
from the work "may have been constructed with the help of real forms
taken from a symbolized world to which it is materially related; it may
still manifest that world through the symbolic potential of the artistic
medium. Yet its true finality is simply *to be this beautiful thing*, this
unique and self-contained world of forms that pleases the eye and de-
lights the mind."[21] Thus, the significations in a work are for Maritain,
claims Rover, entirely on the *material* side, assisting in the manifesta-
tion of an "ontological form." Rover clearly reveals the basis for his
criticism when he speaks of this form as "nothing other" than the form
of the work. "The poem is; it manifests form; it radiates being. The
form, however, appears to be nothing other than its own form, *in the
sense of material structure*; the being it radiates is its own being, not the
being of another."[22] Rover quite clearly, I believe, misunderstands
Maritain, divorcing too radically at this point the sign from the signified.
He wants to separate the "formal" response to an art object from a
"cognitive" response and to hold that because Maritain insists on the
creativity of art, the autonomy of the work, and the truth of fine art

[19] My italics.
[20] *A & S*, pp. 57, 59; see also *CI*, pp. 207-208 and Appendix below. So, writes Maritain,
when Gauguin and Denis say that it is a perversion of art to think of it as copying, we must
understand the imitation of which they speak as deception of the eye; while when Ingres and
Rodin say the artist must slavishly copy, these words must be understood to mean that there
must be manifested with the utmost fidelity the form whose brilliance is apprehended in the
real. Rodin, Maritain remarks, was actually unaware he was changing nature. (*A & S*, p. 197,
n. 131).
[21] (Washington, 1965), pp. 151-152.
[22] Rover, p. 164. My italics.

as the manifestation of form, this must mean that the form is *only* the self-enclosed material structure of the work. To anticipate a little, this *entitative form* of a material object in a genus is not what Maritain has in mind at all. The form of the work of fine art is to be considered at once the form of the work and an intentional meaning-structure which transcends the work. It abides in and animates the work; it is the form of this concrete artifact, apprehended as a thing and as the terminus of cognitive, joying acts; but it also, as a form resplendent with intelligibility caught in things, causes the work to spill out of its bounds as a fabricated object.

3. It would seem that for Maritain purely non-representative fine art is not possible, since a work of fine art must have a super-abundance of intelligibility by which it is well-proportioned to the intelligence and since this intelligibility must, on account of art's human condition, be taken over from what already exists. But there is in fact what is called non-representative art; and Maritain is not entirely unsympathetic to it since in its origins it renounced the appearances of things and their hidden meanings in order, he says, to achieve a greater freedom for creative subjectivity to tend toward beauty in its infinite amplitude. An examination of such art reveals, however, that it does not totally break from nature. Abstract painters, for example, "...use and combine prime elements and various kinds of pure units or sensory determinants which they have extracted and singled out from nature..." Also, "...they are essentially concerned with laws of dynamic equilibrium, laws of proportional correspondences, optical laws, psychophysical laws which are grounded on nature..."[23] So there are borrowings from nature as indeed there must be, but this is not enough to insure that such noble lunges in the direction of Beauty will not end in failure. The crucial thing here is that "nonrepresentative painting breaks away from *Nature as an existential whole*, turns away from Things and the grasping of Things, and renounces seeing into the inner depths of the world of Nature, of visible and corporeal Being."[24] (And it is only through that resonance with respect to the existential whole

[23] *CI*, pp. 157-159. Concerning these laws, which – dealing with the effects on the perceiver of certain interrelated sensory elements – are of great importance to non-representative painting, Maritain claims that they can neither be known nor applied separately from things, as abstract art might wish. "Painters know them only in their concrete and factual results, and in the very Things to be manifested in the work, and through creative experience intent on the existential world of Nature" (*CI*, p. 161).

[24] *CI*, p. 159. Italics mine.

of nature which is poetic intuition that creative subjectivity is awakened.[25]) Consequently, in cutting itself off from this seeing or from poetic intuition, non-representative art condemns itself to an unavoidable tendency toward the production of mere things, deficient in what they have to offer to intelligence; thus (to reintroduce a cardinal expression in our exposition of Maritain) it tends to "the most limited form of beauty, the mute beauty, with almost no echoing power, of the best balanced objects produced by mechanical arts." The intelligibility having to do with use is not present, however; works of non-representative art like those of fine art in general are for contemplation. Consequently the meaning of such things is inclined to be confined entirely in their structure as static material objects. Regarding Mondrian and Kandinsky, Maritain writes: "Abstract art is able to provide us with an element of contemplation, and repose of the soul – only, it is true, by quitting the realm of the human, even of the living, even of the *existential reality* of being, and by offering to our eyes, along the lines of some Platonic ideal, the peace of geometrical surfaces, wire constructions, or wooden artifacts."[26] The trouble with these attempts is that they seek an ideal type, a pure realization of a geometric ideal, essence rather than existential reality in its infinitude; consequently they tend to withdraw from the transcendentals and to become simply things of a kind.[27] In short, non-representative works remain closed in on themselves and on the detached serenity of essence.[28]

Having made his point, however, Maritain to avoid being rigorously systematic softens his position. "Poetry," he says, "is capable of worming its way in anywhere." So, it is at least possible to find it

[25] See below, Chapter IV.

[26] *Ibid.*, pp. 159-160. Italics mine.

[27] See *CI*, p. 322, n. 4. For Maritain *being*, as transcendental, is not a category nor in a category; it pervades them all, so that under the title of being everything has correspondences with everything else. Further, *being* or *what exists* has existential relations with all other existents. The essence of something, on the other hand, is restricted to a certain species within a category and, moreover, is not a term of existential relations. Consequently, insofar as a thing tends to become simply something of a kind and "withdraws from the transcendentals," it will not have the unlimited expansiveness of existential meaning referred to above and more fully discussed below in Chapter IV.

[28] In contrast, as we shall see more fully in Chapter IV, let poetry enter with its divination of the hidden meanings previously mentioned, and there appears the communication in the act of existing which (above all) the poet suffers. As existents things are no longer just what they are; "they pass unceasingly beyond themselves, and give more than they have..." "... they communicate in existence, under an infinity of modes and by an infinity of actions and contacts, of correspondences, of sympathies and malices, of breakings and reformings..." (*SP*, p. 79). Thus when poetic knowledge enters into the forming of the work there is the infinite expansiveness of meaning, the openness to intelligence and its delighting that is of paramount interest to us in determining Maritain's ontology of the aesthetic object.

even in the most strictly abstract painting. The artist, having had his experiences, cannot entirely renounce them; unconsciously, at least, they are still alive.[29] Still, the possibilities of such insinuation of poetry are exceptional and very limited, and the point must be allowed to stand.[30]

Too, what is commonly called abstract art is often not really so. A painter under the influence of poetic intuition of the existential world of nature may make use of abstract forms; but instead of these really being purely abstract, they represent "be it in the most bare and de-materialized manner – some vital element, a rhythm, a contrast, a contour which has been seen in Nature and which is just enough to suggest some natural appearance with the significance it is laden with..." This is all that is needed; for even though one cannot say what thing the natural appearances belong to and even though these appearances are highly simplified, still they are there; and there, too, through them is "the existential world of Nature." This latter ulti-mately is the really fundamental thing that the work must somehow represent or make present.[31]

To summarize, this section has shown that for Maritain there is a vital connection between the work of fine art and signifying or repre-senting, considered both from the standpoint of form and of content. Further treatment of the significance of its form must be deferred until the next chapter; but we can proceed now to examine his thought on the ontology of signs, the better to open up the ontology of the work itself as affected by the presence of poetic sense.

MARITAIN'S THEORY OF THE SIGN

4. Maritain, following the scholastics, defines the sign as that which represents something other than itself to a knowing power. "Signum est id quod repraesentat aliud a se potentiae cognoscenti."[32] The sign

[29] "And thus it is possible that, while turning away from the existential world of things, the unconscious presence of this very world in the secret recesses of the painter may be enough to load some subjective feeling, unrelated to any given thing, with the spiritual élan of poetic intuition. It is possible for a painter who obeys only his merely subjective feeling (merely subjective at least in appearance), or else a free impulse of the unconscious... to trace, in total freedom from any representation whatever, lines and forms which are instinct with beauty and poetry..." (*CI*, pp. 160-161).

[30] *CI*, p. 161.

[31] *Ibid.*, p. 163. On this point see also Paul Weiss, *The World of Art* (Carbondale, 1961), pp. 144-148.

[32] John of St. Thomas, *Logic* II, q. 21, a. 1, as quoted in *S & S*, p. 218.

makes manifest or makes known; and specifically it does so with regard to something distinct from itself, which it takes the place of and upon which it depends as on its measure. Thus, "it is essential to the sign that it be: infravalent with regard to that which is signified; measured by it; and related back to it as a substitute to a principal."[33]

What Maritain has in mind is put forth in more detail in John of St. Thomas, to whom he refers often in explaining his notion of signs. The latter clearly distinguishes between the manifestative in general and the sign in particular. The manifestative as such does not require a relation since (1) a thing can be said to manifest itself, and (2) a thing can manifest another thing without depending upon and being really related to it.[34] But to manifest *as a sign* implies a *relation* to something else and a "dependence upon the thing signified, for the sign is always *less* than the signified and depends upon the latter as upon a measure." He goes on to say that formally considered, that is in terms of what is specific to sign-manifesting, a sign represents in a *defective* way, dependently on the signified and as a *substitute* for it. Thus, "it regards the signified not only as a thing that it manifests and illuminates but also as the principal object to be known." In short, a sign is formally a thing subordinated to the signified; so that while signs may be things, what constitutes the sign as such is this particular subordinative relation.[35] Consequently, John and Maritain, following Aquinas, say that the sign is a relation *secundum esse*, that is, relative in its being; its whole intelligible essence, its whole actuality *qua* sign, consists in referring. (Another example of a relation *secundum esse* would be that of master to servant. A master is a substance; but the intelligibility of being a master, mastership, is completely exhausted in the relation to the servant.) Such a relation is distinguished from a relation *secundum dici*, that is, one in which the whole actuality or intelligible essence does not consist in referring. What is primarily signified in the latter expression is not relation but an entity on which a relation follows, as for example *head* in relation to what has a head.[36]

In accord with the tradition, Maritain divides signs according to two principles of division. On the one hand, the division is into *natural* and

[33] S & S, p. 218.

[34] "A thing (a) can be manifestative of another thing (b) without *a* depending upon it (b), nay, with dependence of *b* upon *a*. Thus, the principles manifest the conclusion, light manifests colors, and... God clearly seen manifests the creatures." John of St. Thomas, *loc. cit.* Translated in *The Material Logic of John of St. Thomas*, trans. Y. Simon et al. (Chicago, 1955), p. 389.

[35] *Ibid.*, pp. 389-390. See *S. Th.* I, 13, 7, ad 1.

[36] *S. Th.* I, 13, 7, ad 1. See *S & S*, p. 218.

conventional according to whether the relation between sign and signified is a real relation "based on a really intrinsic proportion between signs and that which they signify" or not.[37] A sub-type of natural sign is one which is based upon a *likeness* between sign and signified; of course not everything which is like another or the image of another is a sign of what it is like since there may not be the ontological subordination required of a sign, but those likes which are signs Maritain calls *symbols*.[38] On the other hand, signs divide into *instrumental* and *formal* according to whether their being known as an object is a condition for knowing their significance. An instrumental sign, as for example smoke, is first known itself as a thing (with a priority of nature, not necessarily of time) and thereafter makes something other known. All the signs we experience are, in fact, instrumental signs except for "the mental signs which intervene in the act of knowing; an image, in imagination or in memory, a concept."[39] Such *formal* signs are not themselves known as objects except reflexively; their entire function is to make something else present to consciousness, and hence they are known by the knowledge for which they are a means. They are pure élans or intentions of the mind toward the object. We saw above that formally considered a sign is a relation to the signified, and consequently these beings denominated formal signs can be said to be pure signs since in all that they are they are relative to the signified; they are nothing but signs, pure makers-known.[40] Thus, rather than being a *thing known*, a formal sign is "a *form of knowing*, an internal cause or determination to know..." Actually not even a mnemonic image is an object of knowing when we remember; it is instead a mental form preserved in memory which serves as a pure means by which we become directly aware of an event lived in the past.[41]

5. Now in any kind of signification the representation of another to a knowing power is not the result of the efficient or productive causal efficacy of the sign. The sign brings about a knowing of the other insofar as it takes the place of the object known, making it present to the faculty; and this means that it will provide the same sort of causation

[37] S & S, pp. 218-219. Smoke, for example, is a natural sign of fire.
[38] *Ibid.* Such kinds of signs would be called *icons* by Morris.
[39] *Ibid.*, p. 222.
[40] Consequently Maritain also terms this division as one of "sign-things" and "pure signs." *Ibid.*, pp. 222-223.
[41] *Ibid.*, pp. 223-224. See also *DK*, Chapter III and Appendix.

in knowing as the object itself does, namely formal causality.[42] In other words it does not actively produce knowing, but it determines what will be known. We must, however, distinguish in Maritain's thought the formalities (determinants) which are present in a sign situation and the manner in which the sign makes the signified present to cognition.

In the first place, the sign and its meaning need not be thought of as completely separate; and the passage from one to the other need not require a process of inference. Consider, for example, the sensory perception of sign-images, with which we shall above all be concerned in this chapter. Maritain says that my eye sees Socrates in his statue; I see Socrates when I see it. Socrates, the signified, is thus *present in* the statue, in a mode of existence about which we must inquire further.

The external senses make use of signs (I see Socrates when I see his statue, my eye sees him in it). For the use of the sign does not necessarily involve inference and comparison. There is thus a certain presence – presence of knowability – of the signified in the sign; the former is there *in alio esse*, in another mode of existence.

Quoting John of St. Thomas he says:

What may be that element of the signified which is joined to the sign and present in it as distinct from the sign itself and its own entity? I answer: No other element than the very signified itself in another mode of existence.

This presence, then, is a mode of being distinct from that which Socrates has in his own being and also distinct from the mode of being the sign has as an independent entity. Thus I see Socrates *in* the statue; he somehow dwells there, but his mode of being in it is different from the *physical* being of the shaped marble which occupies a space in front of me. Maritain illustrates his point further with respect to the signifying of a thing which never existed, namely a Greek god. Now even though the god did not exist, the whole context of thought in which historically the god was placed is there; "all the cosmic and psychic forces, the attractions, the passions which took shape in him, the idea which the artist and his contemporaries conceived of him – all that was *present* in the statue, not in a physical sense but *in alio esse*, in another mode of existence, and after the manner of the presence of knowability. For the statue had been made precisely to make all that known, to communicate it."[43]

[42] *Ibid.*, p. 219.
[43] S & S, p. 220. See also *De Ver.*, 8, 5c; *C.G.* III, 49. One can see why Maritain can say

The "presence of knowability" Maritain explains in more detail by comparing the statue as a sign with the sign function of the concept. In both, the object known by their means is truly present, *in alio esse*, and in both we can call this mode of being that such meanings have in their sign *intentional existence*, as opposed to what Maritain calls *entitative* (real) *existence*.

In the case of the concept – or for that matter, any other cognitive species (determinant) – we have a situation to be explained which is similar to that of Socrates' statue and which serves as a model for the explanation of such signs as the latter.[44] Just as the block of stone is really (entitatively) not the real Socrates, what pertains to the being or reality *proper* to the knower possessed of a concept (or other cognitive determinant) is different from that of the known. Yet (1) Socrates is seen in the statue, and (2) the known in its otherness appears in the consciousness of the knower. In both cases what is not some other thing is such that *through* it, this other appears *in* it.[45] The statue is not Socrates and yet it is; cognitive species and the known are not the

that the relation of sign to signified is in its own order – the order of formal causality – very close. In fact, he tells us that for Aristotle and Aquinas "The motion toward the sign or the image... is identical with the motion toward the object itself." (S & S, p. 232). He cites the *S. Th.* III, 25, 3c where Thomas says, "There is a two-fold movement of the mind toward an image: one indeed towards the image itself as a certain thing; another towards the image insofar as it is the image of something else. And between these movements there is this difference: that the former, by which one is moved toward the image as a certain thing, is different from the movement towards the thing (imaged); whereas the latter movement, which is toward the image as an image, is one and the same as that which is towards the thing (imaged)." (See also Aristotle, *De Memoria* 450b21-451a4 and Aquinas' commentary on it, lec. 3, n. 340). Considered as image the *ratio* of the figure is taken from that which the figure represents. (See Rover, p. 69). This is the sense in which the figure and what it represents are a measured in relation to measure. For Aquinas one of the theological significances of this point is that man can legitimately give worship to an image of Christ, not as *thing*, but as *image*, since the movement toward image as image is the same as toward the thing imaged.

According to Aquinas, the Christian will make the necessary distinction. Maritain points out that for primitive man, however, this extreme closeness of sign and signified sets a snare for the imagination. "Thanks to the condition of experienced and lived participation wherein is established his [primitive man's] whole mental life, the presence as to knowledge of the signified in the sign becomes for him a presence as to reality, a physical interchangeability... Primitive man is intoxicated with the excellence of the sign; yet the sign never altogether loses its genuine relationship of signification (to some *other* thing). The idol is god and yet is never altogether god." (S & S, pp. 232-233).

[44] What follows is not meant to be anything approaching a complete analysis of Maritain's epistemology, which is beyond the scope of this investigation, but rather is intended simply to illustrate certain salient features of intentional being which will be helpful in understanding the sign-character of the work of art. For a brief critique of Maritain's conception of intentional being see A. Hayen, *L'Intentionnel dans la philosophie de saint Thomas* (Paris, 1942). pp. 15-17.

[45] See *DK*, p. 121. Compare Heidegger, "Origin of the Work of Art," translated by Albert Hofstadter in Albert Hofstadter and Richard Kuhns, eds., *Philosophies of Art and Beauty* (New York, 1964), p. 670.

same and yet they are.[46] But in order to avoid contradiction we must distinguish a mode of being in which they are – and are what they are – in their separateness, and a mode of being in which they are united.[47]

The concept, for example, has an entitative mode of being or an entitative function as a modification or accident of the knowing subject, entering into composition with it. As such it exists *secundum esse naturae*, "the being a thing possesses when it exists in its own nature."[48] This is the kind of being that posits a thing outside of nothingness, either in itself in the case of substances, or in another thing as accidents. But this modification of the subject can be considered only as a *condition* for knowing rather than the mode of being by which the object of thought is actually present in consciousness.[49] Rather than simply being aware of modifications of my own substance, I am aware of the other-than-myself in its *otherness*. Thus while I remain myself, my being opens out so that I live the other; and I can say that I become a thing other than myself.[50] In the entitative order knower and known are strictly diverse; at the same time the independent known somehow exists in consciousness. But since it does not exist there according to the natural mode of being of the subject (or its modifications) or the natural mode of being of the object (*esse naturae*), it must be by a special kind of existence by which the knower *is* the known and the known *is in* the knower (*esse intentionale*).[51] Consequently, the concept or species must be said to have, in addition to an entitative function and mode of being, an intentional one as well.[52]

By this latter function the concept transcends the entitative informing or qualifying activity it has and is not just absorbed in actuating a subject so as to form a composite or a *tertium quid*. "It is an existence that does not seal up the thing within the bounds of its nature, but sets it free of them." Thus while remaining myself with my various entitative modifications, I become many things cognitively that are not myself and become them in their very otherness;

[46] In drawing these parallels, the distinction between formal and instrumental signs must not be lost sight of. See below for a discussion of the distinction of intentional being in each of these two types of signs.

[47] *Esse intentionale* or intentional existence is not, however, an already known factor used to explain. Rather it is the "abutments upon which an analysis of the given leans for support..." The mind by reason of this very analysis is compelled to recognize the reality of this mode of being, since – as the above suggests – the data being analyzed require it. (*DK*, pp. 115-116).

[48] *DK*, p. 114.

[49] *RsI*, p. 59. To analyze cognition otherwise results in idealism. See *RsI*, pp. 66-67; *DK*, pp. 128-129 and Chapter III, *passim*.

[50] *DK*, p. 112.

through intentional being I can transcend my own entitative bounda-
ries. Maritain expresses these two functions of the concept succinctly
in the following passage:

Cette similitude [of the object in the subject] a deux rôles et deux aspects tout
à fait différents. D'une part, dans l'ordre entitatif, elle est une forme accidentelle
informant la faculté, entrant en composition avec elle pour constituer un *tertium
quid* (la faculté ainsi modifiée); et à ce titre elle est quelque chose du suject, un
accident de son âme, un mode de sa penseé. D'autre part, dans l'ordre inten-
tionnel, et en tant même que 'similitude' elle est le vicaire de l'objet, ou plus
exactement elle est l'objet lui-même comme signe, l'objet lui-même comme
forme ne composant pas matériellement avec la faculté, mais immatériellement
présente en elle et existant là d'un pur être de tendance...[53]

Thus by its intentional being the concept and its object are identical,
if not in virtue of the entitative existence proper to each, at least ac-
cording to the intelligible constituents of the concept, in terms of which
the known is objectified or present in consciousness.[54] It is not merely
a likeness; the intelligible character of the concept is not numerically
different from that in the thing. It is the same universal character,[55]
which – because it partakes of immateriality – is not locally isolated[56]
nor in its intentional existence conjoined with matter.[57]

[51] Just so there is also a sense in which we could say that the statue is Socrates and
Socrates is in the statue. (See below, this chapter, n. 75). For the background of Maritain's
distinction of *esse naturae* and *esse intentionale* see such places as Aquinas *S. Th.* I, 56, 2, ad 3;
57, 1, ad 2; 58, 6c; 78, 3c; *De Ver.* 27, 4, ad 4; 27, 7c; *In de An.* II, #418; *Quodlibet* 8, 4;
Cajetan, *In S. Th.* I, 55, 3; John of St. Thomas *Curs. Phil.* t. III Phil. Nat., III P., q. 6,
a. 3; *Curs. Theol.* I P., q. 27, disp. 12, a. 5, n. 11.
[52] But there are not two things; rather there is one concept with two functions. (*DK*, pp.
121, 125).
[53] *Ibid.*, p. 114; *RsI*, p. 63.
[54] *DK*, pp. 127, 388, 391-392; see also *C.G.* IV, 14; *De Ver.*, 10, 4c; R. R. Barr, "A Re-
lational Analysis of Intentionality," *The Modern Schoolman*, 40 (March, 1963), 237.
[55] *DK*, pp. 391-392. "The word of our intellect contains in an intelligible way [but not as
its predicate] *the same nature, without numerical* distinction, as is contained in the thing
known; ..." This is Maritain's paraphrase of *C. G.* IV, 14, which reads: "... ex hoc quod
verbum nostri intellectus ex ipsa re intellecta habet ut intelligibiliter eamdem naturam nu-
mero contineat." Maritain says by way of explanation that 'eamdem numero' does not mean
individual identity, since nature as such abstracts from individuality; it means that the
constitutive characters as such are the same. So we must distinguish sameness of intelligibility
and entitative diversity.
[56] R. R. Barr makes the same point with regard to sensory perception. He observes that
stones and whatever else is known are in a way immaterial in that the purely material is the
purely potential so that whatever is actual participates to that extent in immateriality. How-
ever, in perception it is not that *just* pure characteristics are known rather than that which
has the characters; what has the characters is objectified or known through them. Aquinas,
e.g., says that knowledge is through form but that a knowledge of natural forms gives some
knowledge of matter, "in so far as it is correlative to form"; and referring to Aristotle, he
notes that by the very fact of knowing snubness, snub nose is known. [*De Ver.* 10, 4; Barr,
pp. 238-239 and n. 28. See also B. Bosanquet, *Three Lectures on Aesthetic* (Indianapolis,
1963), pp. 28-29].
[57] "[Species] are the object itself divested of its proper existence and made present in an

The language Maritain sometimes uses obscures his thought on the matter, for he often employs such locutions as "in the mind" ("dans la pensée") and others like it which have a spatial, materialistic suggestion built into them. Actually, it is misleading to speak of the object as existing "out there" and as present "in consciousness." Thought is immaterial and "...the very glory of the immateriality of thought is not to be a thing in space exterior to another extended thing, but rather a life which is superior to the whole order of space. For the very glory of the immateriality of thought is to be a higher life which perfects itself by that which is not it, itself..."[58]

The passage from the *Réflexions sur l'Intelligence* quoted above, in which we have noted the immateriality of the cognitive similitude or species, also characterizes the species as a pure *being of tendency*, a vicar of the object or the object as sign. The character which is intentionally present in it does not exist there entitatively, that is, according to its own proper natural being. (If it did, entering into composition with the knower, the knower would become *other*, but not *the other*.) To put it in different language, a concept or other intentional being does not *exemplify* the character which it has in an intentional mode of being. The concept horse is not a horse; and a sensory image of a three-foot long green tie is not itself green, three feet long, and a tie.[59] From this it follows that intentional being, such as that of a concept, must be purely relative to and dependent upon – as its measure – some other thing which has, or exemplifies, the character involved, since it has the character only in relation to what does exemplify it. Thus Maritain speaks of *esse intentionale* as an incomplete, inferior mode of existing, an existing not for-itself but purely as tendency to something else.[60]

immaterial and intentional state. By this title they do not determine the faculty as a form determines a matter or a subject." This is "immaterial informing." (*DK*, p. 117; see *RsI*, p. 64).

[58] *DK*, p. 104; see also pp. 84-85; 85, nn. 1 & 2.

[59] If the analysis claimed otherwise, it would not be true to the data being explained, viz. my awareness of being other than what I know. See *RsI*, pp. 59-60; *S. Th.* I, 78, 3c; *In de An.* #418.

[60] *RsI*, p. 60; see also Maritain, *The Range of Reason* (New York, 1952), p. 12; *De Ver.* 27, 4, ad 4; *De Potentia* (hereafter abbreviated *De Pot.*), 5, 1, ad 6. Maritain refers in the *Degrees of Knowledge*, p. 390, n. 4 to Aquinas' metaphor of the mirror image (*De Ver.* 2, 6). If we transfer it to the slightly different context present here, it will provide illumination if not pressed too far. Aquinas says, "it is like the case of sight, which is brought through a likeness received from a mirror directly to a knowledge of the thing reflected, but by a sort of reflection to the image itself in the mirror." Thus the mirror image is a likeness, *identical* with certain characteristics of the object; and yet it is purely relative to the object, so that in its presence the object is seen directly rather than inferred from it. A mirror image of a green tie is not a green tie; it does not exemplify these properties, and hence they cannot be

Maritain can call this species at once the object itself existing in consciousness, the object as sign (of the thing objectified), and a vicar of the object because of the immateriality and purely tendential existence which the species has, as the foregoing discussion has suggested. The object can be said both to be *in* consciousness (according to intentional being) and to be present through the species as sign,[61] in that the species as purely relative presents that (existing entitatively) to which it is related. If this seems paradoxical, it is because the data to be explained are so.[62] What is given are things of experience gained within the bosom of consciousness itself and yet known as other than the consciousness which knows them.

Intentional being is a way of explaining how a thing, here a knower, can be both itself and something which is not itself. We have seen in our discussion of concepts and cognitive species generally that it is a pure "tendency-existence whereby forms, other than their own, come upon things," such that while remaing what they are, things ennobled by this existence have dwelling "in" them in virtue of it that to which this tendency is oriented. But this indwelling is not the latter's own proper mode of existence; rather it is an immaterial way that transcends the entitative, material isolation of both that which has and that to which this intentional being tends.[63]

Now our understanding of intentional being as Maritain conceives it will be further increased by noting the fact that – and the manner in which – such being is present in spheres other than those of cognitive species or of statues of Socrates. Maritain says that in the order of efficient or productive activity we must also admit intentional being, basically for reasons similar to those on account of which it was neces-

predicated of it (if predication denotes what Maritain calls the entitative presence of a characteristic). In the same way, the concept horse is not a horse; and we cannot predicate of it what it is *of*, even though it somehow has the intelligible constituent horse. It has this constituent, as does the mirror image "have" its characters, only in relation to what exists entitatively or exemplifies the character. The relation is one of dependence. (See *DK*, pp. 391-392). The object presented passes through a medium which does not exemplify the characters by which the object is objectified. [As we shall see later, the mirror metaphor is particularly apt because for Maritain there is in the physical processes operative in the existence of mirror images a supervening intentionality as well; note Aquinas *De Pot.* 5, 1, ad 6. See also in a different context R. E. Allen, "Participation and Predication in Plato's Middle Dialogues," *Philosophical Review*, 69 (April, 1960), 147-164].

[61] "... the concept exists in the intellect not only in an entitative manner and as an informing form, but also as a spiritual form, ... terminating the intellect intentionally and in the line of knowing, in that it expresses the object *and renders it transparent*." (*DK*, p. 126; italics mine).

[62] Further, we are dealing with something that cannot be imagined, which makes it more difficult to comprehend. (*RsI*, p. 61, n. 1).

[63] *DK*, pp. 114-115; *RsI*, p. 60.

sary to introduce it before. Here again, something which according to its natural being does not possess (or exemplify) a characteristic does have it in another way and as a tendency toward what does possess it *secundum esse naturae*. We are asked to consider an instrumental cause such as a painter's brush, which is moved by a principal agent, the painter, to produce an effect more noble than itself. "...the beauty and intelligible brilliance, the spiritual values with which the picture is charged, far surpass everything of which the brush's proper causality, bound up as it is with the material universe, is capable." Still, the picture comes entirely from the brush; "there is nothing in the picture that is not really caused by the brush." Now because no cause can give more than it has, some causality higher than the brush's own must somehow be present or pass through it. "...par cette motion quelque réalité supérieure, la vertu efficiente de l'agent principal, de l'artiste maniant le pinceau ou l'archet... passe dans l'instrument, et surélève son action: mais passe-t-elle ainsi avec son être de chose?" If we carefully examine the instrumental cause, the brush in its movement, for what is "entitative" in it (*son être de chose*), we will not find the causality of the artist but only the instrumental cause itself and what pertains to it. There are only "the substance and qualities of the brush whereby it is moved by the hand." Still, art "passes through" it. "C'est selon *l'être de tendance* que la causalité de l'artiste est dans le pinceau."[64]

The same analysis holds good with respect to the transmission of sensible quality, for example the color red or the sound of a piano striking middle C. If we determine everything entitative in the medium by which red is transmitted, we will find only the kind of thing that the physicist sees in it – wave movements and the like. We shall never find the sensible quality *secundum esse naturae* there.[65] But since the quality will be perceived by the sense when the wave arrives at it, we must say that the quality passes through the medium *secundum esse intentionale*. "It is like a dream of a materialistic imagination to want, with Democritus, to have quality pass through the medium entitatively, or, since it is not there entitatively, to deny with the votaries of modern 'scientism', that it could pass through it at all."[66]

[64] *DK*, p. 114; *RsI*, p. 60. See also *De Ver.* 27, 4, ad 4; 27, 7c; *De Pot.* 3, 11, ad 14; *De Unione Verbi Incarnati*, 1, 5, ad 12; *In IV Sent.* 1, 1, 4 for intentionality in instrumental motion; also Regis, *Epistemology* (New York, 1959), pp. 213-214; Hayen, pp. 107-119.

[65] Otherwise put, the medium does not exemplify the quality; the air is not colored and only appears so if there are dust particles and the like in it. See *S. Th.* I, 56, 2, ad 3; I, 67, 3c; also Hayen, pp. 121-138.

[66] *DK*, pp. 114-115.

Now Maritain brings together for comparison these various ways in which there can be intentional being in the following:

> ... c'est selon l'*être intentionnel* que les choses existent dans les signes ou similitudes qui les rendent présentes à la pensée: de même que dans l'ordre de la causalité efficiente, la vertu de l'agent principal passe intentionellement dans l'instrument en mouvement, à titre de tendance fluente (*intentio fluens*) qui a pour terme l'effet à produire, de même, dans l'ordre de la causalité formelle, telle que la comporte l'immaterialité du connaître, l'objet de connaissance existe *intentionnellement* dans l'âme, à titre de tendance immobile (*intentio quiescens*) qui a pour terme ce même objet effectivement connu.[67]

For Maritain, then, intentional being can appear in the order of efficient as well as formal causality. In either case it is a tendential being, dynamic in the former and static in the latter. The *active* tendency of the intentional being of the instrument is toward the *effect*, which will realize entitatively what – in an intentional mode – is causally present in the instrument. Thus we can say that the painting in its "spirituality" is intentionally in the moving brush.[68] In a similar yet contrasting manner, the *immobile* tendency of intentional being in a sign such as a concept is toward the *signified* or known, which exemplifies what is intentionally present in the sign. In spite of the contrasts, we read that it is the same sort of thing; and the comparison serves to underline how completely relational intentional being is and how completely other it is than that in which it resides. Hence we are prepared to understand more fully why Maritain can think that some clump of matter, when touched by the fingers of an artist, can – while still being what is always was – come to life within its human setting.

This mention of art brings us back to the crucial point with which this discussion of intentionality began. Intentional being is often spoken of in connection with those signs such as concepts which are cognitive species or *formal* signs. What is of importance to us in all this is Maritain's point that *instrumental* signs such as statues of Socrates and other art-signs also have intentionally existing in them what they signify, just as concepts have. The analysis of cognition furnishes a model for the analysis of other types of signs, and what has been seen indi-

[67] *RsI*, pp. 61-62. See *De Ver.* 27, 7c.

[68] No explicit mention is made of intentional being in the order of final causality in the text above, but this is surely implied. A determinate efficient tendency is present in the instrument; therefore the determinant which specifies the tendency must also be there, just as it is present intentionally to the principal cause itself in willing. (See *De Ver.* 22, 13c. Also see H. Simonin, "La Notion d'Intentio dans l'Oeuvre de S. Thomas d'Aquin," *Revue des Sciences Philosophiques et Théologiques*, 19 (1930), p. 451, n. 4, where *intentio finis* and *intentio agentis* are equated.

cates that there can be no question but that Maritain wishes to invoke a quite similar notion of intentional being to explain the peculiar experience of presence – in signs other than cognitive species – of the signified. He emphasizes this similarity in the following – positively by asserting intentional existence in both cases and negatively by implying that there is only one real difference concerning this mode of being of the signified in formal and in instrumental signs.

In the concept the object of intellection is present in a mode of *intentional* existence, in the sense that there is nothing else (as a *quod* known beforehand) in the concept than the object thus present. The concept is a "formal" sign..., and the intentionality is there is act (we shall say that it is an *intentio quiescens, in actu intentionalitatis seu immaterialitatis*).

In the statue of Socrates, also, Socrates is present in a mode of *intentional* existence, but in another fashion: the statue is something itself known beforehand (according to a priority in nature, not in time), before it makes Socrates known. It is an "instrumental" sign, and the intentionality therein is merely virtual (we shall say that such a sign is an *intentio quiescens, in statu virtuali intentionalitatis seu immaterialitatis*). It is the act of vision which, immaterial as such although intrinsically subject to material conditions, awakens this intentionality in the statue – in so far as the latter is perceived or made one with the sense power in act – and causes this intentionality to pass into act. Such is the sense in which it seems well to explain the "presence of knowability" and the *"in alio esse"* we are discussing...[69]

We must now take a closer look at the point of difference. The intentional being of signs is oriented to cognition; the meaning in a concept or the significance present in a work of art is there only for a mind. These intentionalities are in act (are actually present) only when some cognitive power is in act (actually knows) with respect to them.[70] The entitative being of concepts, however, is so closely bound up with their intentional being – they are pure signs – that they exist entitatively only when they are actually being thought or are intending their objects. Hence when they actually exist, we can always say their intentionalities are in act.[71] But the statue of Socrates is a different affair. As we have seen, Socrates is definitely not absent and apart from but rather *present in the sign*; there is intentional existence. Nevertheless, the statue, an instrumental sign, has a being which is not totally that of making something else known; its entitative being is not dependent on its meaning being thought. It can be perceived without its significance being known, and as an instrumental sign it must be perceived

[69] S & S, p. 310, n. 8.
[70] See, e.g., *DK*, p. 87; Aristotle, *De An.* 425b11-426b8; Aquinas, *In de An.*, #377.
[71] *DK*, pp. 116, 124; *C. G.* IV, 11.

as a thing in its own right as a condition of knowing its significance
when indeed the latter is known. Hence the statue can exist entita-
tively without its intentionalities being in act – without actually making
Socrates present. It requires the activity of a mind to make the absent
Socrates present "spiritually" in the stone.

This does not mean, however, that the statue is merely *capable* of
having Socrates in it. It is not like an ink blot, that simply lends itself
to having a sense imposed on it. While I must bring a certain know-
ledge of nature to an experience of smoke in order to have it signify
fire for me and a certain knowledge of history to the awareness of the
statue in order to activate the meanings in it, still the intentionalities
of these latter are already latent in them; they have a relation to what
they signify independent of my cognition.[72] Thus Maritain suggests
that the intentionality of the statue is something between being com-
pletely actual and being merely potential or possible, namely "virtual."
Thus this "presence of knowability" *is* a presence, but in relation to
knowing; and it is not actual until cognized by a mind capable of
seeing the meaning which not only *can* be there but also *is* there in a
dormant state.[73] Thus with regard to the statue of the Greek god in
our museum, the richness of meaning of its pagan content "is asleep,
but it is always there. Let some accident take place, an encounter
with a soul itself sensitized by some unconscious content: contact is

[72] We shall have later to investigate the extent to which the intention of the artist controls
the latent intention of the work.
[73] The distinction Maritain is making would seem to be the same one Aristotle makes in
the *De Anima* with respect to knowing in general. There he distinguishes three states with
regard to knowing. We can speak of man as *able* to know simply insofar as he has a certain
natural capacity by which he belongs to a class of beings able to know; secondly, we can
speak of a man as *able* to know in the sense that he possesses the acquired habitus of, e.g.,
geometry, so that he can consider and reflect on his knowledge at will; and thirdly, there is
the state of the man *actually attending* to a certain point of geometry. Only the last state is
one strictly speaking of knowing; the other two are both states of capability, but not in the
same way. (*De An.* II, v., 417a21-35). "Of the three, then, the third is simply in act; the first
is simply in potency; while the second is in act as compared with the first and in potency as
compared with the third. Clearly, then, potentiality is taken in two senses (the first and
second man); and actuality also in two senses (the second and third man)." (Aquinas, *In de
An.* #361; see also *De Ver.* 9, 4c). The second state Maritain calls *virtual* in contradistinction
to *potential* and *actual*. Socrates is present in an unhewn block of stone *potentially*; he is
present *virtually* in a piece of stone formed or actuated so that he *can* be seen there at will
under suitable conditions; and *actually* present when *actually* seen there by someone.
 One might add that even in the case of *conventional* signs in the art object the sign carries
a meaning that in a sense is really there virtually, considering the existential context of such
signs (as, e.g., language). (See Pepper, "Supplementary Essay," in *The Basis of Criticism in
the Arts*, pp. 162-167; "On Professor Jarrett's Questions," p. 636; *Work of Art*, p. 95; and
especially "The Work of Art Described from a Double Dispositional Base," p. 425).
 As a further observation, the above comparison between a statue and a *habitus* of the soul
can be strengthened by noting, as Professor Kenneth Schmitz has pointed out, that the
habitus is to an individual what its works of art with their virtualities are to a civilization.

established; the pagan content will be awakened and will unforgettably wound that soul."[74]

6. We have seen in this chapter the necessity of representation in fine art. Also we have had a look at Maritain's idea that a representation or sign has present in it that which it signifies.[75] The work of fine art

[74] S & S, p. 220.

[75] Though Maritain says nothing about it, it is of interest to observe that because of this presence one can even in some cases and in a sense "predicate" the significance of a sign. In a preceding note (this chapter, n. 60) the point was made that the signified cannot be predicated of the sign if predication denotes exemplification or, in Maritain's language, entitative presence. In fact, however, we sometimes do truthfully assert something of a subject which does not exemplify the attribute in question. In such a circumstance, as Aristotle explains, there is equivocity in the application of the term; healthy as said of climate, a man, and his complexion, e.g., does not mean the same thing in each case nor is it purely by chance that it is applied to such diverse things. Rather there is an equivocity of reference (πρὸς ἕν). Healthy is said of the man as actually having health and of climate and complexion as productive or indicative of the one health possessed by the man. Thus in the latter two cases it is by reason of the *relation* or reference to the health of the man that these things are called healthy.

Applying this analysis to the signification of an *individual thing* by, e.g., a statue, we can say "This is Socrates," meaning not that the statue is the real Socrates but rather that the statue is related to him as his sign. If such a statement meant entitative presence, we could not legitimately make it; but if we broaden our view to allow for equivocity of reference, then indeed we can at least in some cases assert the signified of the sign. When do we ordinarily do this? First of all, if we follow Maritain's view previously set forth, we must say that the particular reference of a sign to its signified is such that the signified is present in the sign. This reference and presence have been called the intentionality of the sign or the intentional being of the signified in the sign. While Maritain speaks of this presence in terms of signs which resemble the signified, the generality of his language is not of a sort as to restrict it to such cases. [See here Mikel Dufrenne's discussion of the phenomenal presence of the signified in conventional signs such as words. *Phénoménologie de l'expérience esthétique* (Paris, 1953), pp. 266-273]. Nevertheless, the signified is only sometimes said of the sign, and we can look to the factor of resemblance for a reason. Among instrumental signs some resemble to a high degree what they signify, some do so to lesser degrees, and still others do not resemble the signified in any significant way at all (i.e., as Chas. Morris would put it, there are degrees of *iconicity*). Thus mirror images are at one end of the scale of resemblance or iconicity, followed, e.g., by photographs and then by statues and paintings (although looked at from a standpoint other than external appearances, statues and portraits of a person may well be more highly iconic than mirror images). Footprints are perhaps less iconic than any of the above mentioned examples, and a person's social security card or a dog's collar as a sign of its owner may have no significant resemblance to him at all. Ordinarily we might assert the signified – by πρὸς ἕν equivocity – of the mirror image, the photograph and the statue or portrait, but not of the footprint or social security card. There would seem to be a greater, fuller, and more concrete presence in the signs of greater iconicity than in those of lesser degree. In seeing a mirror image, e.g., I can say without hesitation that I am seeing the person whose image it is; I pass by the image, giving it little or no notice whatever in order to see the person imaged. In looking at a photograph or a television image I may also regard the experience as one of looking at the original present in the likeness because of the high degree of resemblance and the complete dependence of the likeness upon the original not only for its character but also for its meaning. But below a certain degree of iconicity – even though there is a presence of the signified, of which we may be aware simultaneously with the awareness of the sign – we do not consider ourselves as actually perceiving the signified and do not ordinarily apply its name to the sign. (Although there are exceptions such as, e.g., healthy said of complexion, these have to do with a signified *characteristic* rather than an individual and do not take from the general validity of our description of linguistic usage concerning the latter).

will have meanings dwelling in it, some of which will be there as a material to be structured. And as the first part of the chapter has indicated and as the sequel will show more fully, the *form* of the work also and more importantly is intentional; consequently there will be meaning in the work which will order and structure all the other elements. This intentional being which the work has elevates the work, "spiritualizing" and ennobling it in that it gives to it a wealth of intelligibility, an ordination to mind that it does not possess in its merely physical or natural being. As Maritain says, this sense animates it and makes it say more than it is.[76]

This addition in being which results from the intentionality of the work, activated by cognition, must be said truly to belong to the physical work. The work has a transparency that allows us to see these meanings, but to see them as they occupy a place in the concrete arti-

Further – again taking up matters not explicitly dealt with by Maritain – this reference of the sign to the signified, which in some cases makes possible applying the name of the signified to the sign, also makes possible saying that it is the historical Socrates which is (intentionally) present in his statue. The old man is not "really" or entitatively there; some of his characteristics such as height, shape, color, and the like may be so present, but he is not. Nevertheless, these iconic characters are there in order to point to or intend the real Socrates, *if* this is what is meant by the statue. It is the individual which is intended rather than just his attributes. Unlike a percept, however, the statue does not make me acquainted with him, as Peirce points out (Peirce, "Logic as Semiotic: The Theory of Signs" in J. Buchler, *Philosophical Writings of Peirce* (New York, 1955), p. 100.); it presupposes that I have some prior knowledge of what it signifies. In the measure that I already in some way know its meaning will its significance awaken to my glance. But whether I know him or not, it would seem that a statue which is *of* the historical Socrates has him dwelling in it as its meaning, in a way analogous to his presence in a percept of him.

An important qualification to this notion is that a representation of Socrates, especially in a work of art, may not intend the historical individual. In this regard we can observe that if it is a purely *fictional* entity such as Hamlet which is pointed to by a sign, all that has so far in this note been said of the signifying of an individual will apply except that the signified will not have an entitative existence but rather only an intentional one – *actual* when minds are actually conscious of the character and *virtual* when he is merely latent in instrumental signs the meaning of which no one is conscious at the time. The character is present in its sign, from which it is distinct; it will "have" the attributes of the sign which are meant to be iconic with it as well as others which are presupposed or anticipated by these iconic features. One can see the character in the sign – Hamlet is seen in the actor portraying him – and can apply his name by an equivocity of reference to the sign. Also one can say that the sign intends a certain individual, although there is no belief that such a person really exists. Now on the case of a historical figure signified in a work of fine art, as Prince Hal in Shakespeare's *Henry IV* plays, for example, it is necessary to remember – at least on Maritain's view – that the work is "a world of its own." The work is not meant primarily to convey historical knowledge but to be an object of apprehension and delight. Consequently, if we take it as a work of art, then we will regard signified real persons in a work – even when faithfully represented – in the same way as purely fictional characters. The relevant historical meanings will be present, but what will be intended is an individual whose whole existence is in the world of the work.

[76] *SP*, pp. 49-50; see also "An Essay on Art," p. 88. In *Bergsonian Philosophy and Thomism*, p. 145, Maritain makes the comment that language or the word "is most noble among material things, since it is matter putting on the immaterial and becoming one with it..." In contrast, the mere letter of language, i.e., passive repetition of sounds, is "congealed in its materiality."

fact. The discussion on the concreteness of the beautiful should convince us that for Maritain what appears as beautiful is the chiselled stone statue there before me rather than simply a structure of universals for which the artifact is nothing more than a vehicle of presentation. The following perhaps best captures the gist of the chapter:

This work is an object, and must always maintain its consistency and its proper value as an object, and at the same time it is a sign...
... there would be not a poetic work but a servile work if the object were only object. And if the object were only sign, there would not be a poetic work either, but allegory. And it is only *through* and *in* the object, *through* and *in* sensible signs in which the object abounds, that at the terminus of the poetic operation the content of the poetic experience is finally manifested and known in an express and communicable way.[77]

[77] *SP*, pp. 84-85. Italics mine.

POETIC INTUITION

1. Clearly, Maritain wishes to distinguish works of fine art, even in the plastic arts, from mere things, which are restricted to being something of a given definite kind. A necessary condition for there to be this differentiation is that the work represent, but that this is not a sufficient condition for Maritain is suggested by his discussion of a type of art given to copying things slavishly – either as they are or in terms of a fixed ideal of them. He speaks in this regard of the products of such imitation as "deaf-mute melting shapes, imprisoned in themselves and mirroring nothing..."[1]; and we have seen that a work of fine art cannot for Maritain be closed in upon itself like that. Now if these shapes were employed only for their value as an aesthetically interesting design lending a physical structure to the material as Bell believes to be the case in so-called representative art, Maritain's contention that they are mute would seem more clearly and consistently to follow. But since the shape is present in a copy as the shape *of* something, the work – as the previous chapter has shown – does have an augmented or intentional being for Maritain as well as a physical, "entitative" being. What he is saying, however, is that mere copies, along with things that do not represent in any way, have not the richness nor the expansiveness of meaning essential for a work of fine art.

In this chapter, then, I want to continue the investigation of Maritain's ontology of the work of fine art by examining more closely what he calls poetic intuition; for it is poetic intuition which contributes the kind of meaning whose dominance in the work entitles the latter to be called a work of fine art. We must seek to determine just what sort of meaning this is which poetic intuition gives to something, making it *be* a work of fine art; for if such significance both constitutes a work to

[1] *CI*, p. 18.

be such and adds an ontological element to it and further if a certain ontological character is presupposed of a work in order for it to have poetic meaning, then the notion of poetic experience will be crucial in determining the ontological status of the work. Specifically, Maritain can maintain his position against views such as Bell's if he can establish that the work must embody these meanings. That is, it is in this way that he can hold that the work is something more than a physical structure or a collection of materials arranged in a certain spatial configuration. On the other hand, if these meanings – as Maritain holds – are expressible at least in the visual arts *only* in a concrete, physical artifact, then we shall find support for Maritain's views, contrary to those of such thinkers as Croce and Collingwood, that the work is not simply a mental entity completely distinct from the fabricated physical object which serves as a means for its preservation and communication.[2]

This chapter, then, will look briefly at what Maritain understands by poetic intuition, after which it will focus on what it is that is grasped by this activity. This will enable us to determine what in general works of fine art mean. Then we shall examine Maritain's reasons for holding that this poetic knowledge is expressible only in a fabricated work.

INTUITIVE KNOWLEDGE IN GENERAL

2. In his very early work, *La Philosophie Bergsonienne*,[3] Maritain sets forth a scheme of types of intuitive knowledge; and though he does not seem to refer to this scheme in later writings, he does often speak – and with but minor variations – of the individual types which are distinguished in it. Hence it will be helpful in understanding his view of poetic intuition to situate it in this framework.

First of all, 'intuition' has two basic meanings according to Maritain:

(I) *Immediate knowledge* or perception, without intermediary. This is the philosophic use of the term, meaning that there is no other object known first as a condition for the knowing in question. 'Intuition', Maritain says, is etymologically close to 'vision'; and the latter refers to the obvious case of this sense of the word.

(II) *A divination.* This is advanced as the common non-philosophic meaning of the term, as in the expression 'intuitions of the heart.' Involved here is the *spontaneity* rather than the immediacy with which

[2] See, e.g., Croce, *Aesthetic*, Chapter VI (especially pp. 50-51); Chapter XV; and *passim*.
[3] In translation *Bergsonian Philosophy and Thomism (BPT)*.

that act of cognition arises; the right idea just seems to spurt forth.[4]

Now intuition as direct or immediate knowledge can be subdivided into three types:

(A) *Sense perception* – an immediate knowledge of a concrete, individual object in terms not of its essence or what it is as an organized whole but in terms of its accidents or properties, "and in the very action it exerts upon us."[5]

(B) *Intuition of the self* – an immediate knowledge of subjectivity in a concrete way, that is, in terms not of its essence but of its existence and its individual acts or operations.[6]

(C) *Intellectual perception* – an abstract knowledge through concepts, which is immediate in the sense that although there is a *subjective* intermediary – namely a means of presentation, the concept – there is no *objective* intermediary or interposed thing between the mind and the object.[7]

Distinguished from intuition as immediate knowledge is intuition as *inclination* or *divination*. Maritain does not subdivide this type in *Bergsonian Philosophy and Thomism*; but it encompasses many sorts of

[4] *BPT*, p. 149. Maritain suggests that this is principally the kind of intuition Bergson had in mind.

[5] *Ibid.*, pp. 149-150. See also *DK*, p. 118, n.1; *E & E*, p. 11.

[6] *BPT*, p. 150. See also *PM*, p. 61. Elsewhere Maritain distinguishes two kinds of intuition of subjectivity – one sort of felt presence of the self to itself in all its mental activities, and the other a knowledge by mode of inclination or divination. This latter knowledge of the self is present in all forms of intuition in the sense of divination. See *E & E*, pp. 69-71.

[7] Thus we can distinguish degrees of immediacy, and the order of types of intuition as direct perception as set forth above is one of decreasing immediacy. (*BPT*, pp. 150-151; see also *DK*, pp. 127, 131, 137, and "Sur l'expression «intuition abstractive»," Appendice II of *RsI*). We must note here that, for Maritain, to say that conceptual knowledge is immediate is not to say that any very complete knowledge of what something is does not take time to acquire.

Maritain maximizes the role of intuition in intellectual knowledge. Excluded from intuitive intellectual knowledge is knowing by analogy, in which the object is not understood by means of an idea of it but only by something else which is thought to resemble it. Whatever knowledge we might have of deity, for example, would be a knowing by analogy and hence indirect. (*BPT*, p. 151). On the other hand we have an intuition, says Maritain, of the metaphysical notion of being (*E & E*, pp. 20, 23); and in this primordial philosophic cognition the metaphysical first principle of identity is known in its ontological (rather than just its logical) necessity. Other metaphysical axioms proceed from similar intuitions, "provoked in the mind by some sensible example." (*DK*, pp. 215, 127). Further, even discursive knowledge is intuitive. While the discourse itself is not such, it presupposes immediately known truths as a starting point for the discursive movement; and too, whatever is achieved in the final result is intuitive insofar as at the end of the process there is a direct intellectual perception of the object itself without interposition of some other thing. Hence I may initially have a very sketchy understanding of what it means to be human, but through discursive labors this understanding will be increased; my concept will be enriched. What is known by the enriched concept, however, will be the object itself; and hence in a very broad sense the resulting knowledge can be said to be intuitive. (*BPT*, pp. 153-154. Maritain refers in Aquinas to such places as *S. Th.* I, 79, 8; 16, 2; 85, 3, ad 3; 85, 5; II-II, 8, 1, ad 2. Compare *CI*, p. 55).

what can be called intuitive activity, including poetic experience. It is a spontaneous, non-conceptualizable knowing without discourse; and as such it is not possessed of the kind of certainty that a logically demonstrated knowing would have. In contrast to Bergson, Maritain holds that such an intuition requires no special faculty; it involves intelligence, but not exclusively. It is a complex affair and requires other activities as well as those which might strictly be termed intellectual.[8] The mind in its many operations is a unit and acts as such; many acts cohere in a process of the sort presently being examined. Principally involved in addition to intelligence is the imagination, from which can emerge random images capable of precipitating insight (as in the formulation of scientific hypotheses). Also we can add sensory acts of sizing up in the here and now what is hurtful or beneficial to the perceiver – and related to them, the kind of instinctive sympathies and presentiments that shepherds have for their sheep, machine tenders for their machines, and mothers for their children. Volition can also play a part since what is loved or desired is present in the loving or desiring, though not clearly known but rather obscurely experienced.[9]

As will become more apparent later on, knowledge by inclination is knowledge in virtue of the totality that we are – a Gestalt arising out of the whole person with his manifold tendencies. Moreover, it is an experience not only *by means of* these tendencies but also *in* them.[10] One knows through and in the unitary operation or inclination of his various powers or capabilities of functioning, through and in his own personal response to whatever serves as an occasion for this kind of knowledge; and because of this, the subjectivity of the knower is inextricably bound

[8] Maritain's insistence that this intuition is indeed intellectual causes him to part company with Bergson in these matters. Surely Bergsonian intuition and the very language Bergson uses to describe it can be recognized in Maritain's explanations of this kind of cognition, and Maritain says that it is to this sense of intuition that Bergson really refers. But Maritain maintains that there is no special cognitive power distinct from the intellect which is responsible. Rather there is a "spontaneous exercise of the *intelligence* under the influence of certain causes, above all in its vital imbrication with the imagination." (*BPT*, p. 163; see *PM*, p. 51). It would seem here that Maritain, with his reservations about the capability of abstractive intelligence to tell us all, wants to preserve Bergson's intuition but to reformulate it in terms of Thomistic psychology and metaphysics. (We shall need in due course to look to the fact that for Maritain the intelligence can be active in poetic intuition without the result being abstract). As a glance at Chapters III and IV of *CI* amply show, this becomes highly complex and the exposition of it more than usually obscure. (See Hay "Maritain's Theory of Poetic Knowledge," p. 113 and *passim*).

[9] *BPT*, pp. 162-168; see also *DK*, p. 109, n. 2.

[10] See *CI*, p. 82. In this way Maritain is enabled to synthesize many ideas into one conception of poetic knowledge – namely a radically modified Bergsonian intuition, Aquinas' notion of connatural knowing, and the idea of divine creation as a pattern on which human creativity is analogously modelled.

up with what is known.[11] Thus Maritain calls this divination *affective knowledge* since the way the subject is affected as a total, living, responding person becomes a means of knowing. It is also why he calls it *connatural knowledge,* and it is to this latter expression we must now turn in order to clarify intuition as inclination and poetic intuition as one of its forms.[12]

3. Maritain explains that connaturality means "agreement in the same nature," and he calls knowledge by connaturality or inclination also knowledge through *sympathy* or *congeniality.*[13] The paradigm case would seem to be the particular way of knowing about virtue which Aquinas, basing himself on Aristotle, distinguishes from a conceptual or purely theoretical mode of cognition.[14] The latter manner of knowing virtue is that of moral science, and is open to a moral philosopher who may himself not be virtuous. In contrast, we can know of these matters through connaturality: "...we can possess the virtue in question in our own powers of will and desire, have it embodied in ourselves, and thus be in accordance with it or connatured with it in our very being. Then, if we are asked a question about fortitude, we will give the right answer, no longer through science, but through inclination, by looking at and consulting what we are and the inner bents or propensities of our own being."[15] In short, we can be said to be connatural with the virtue known in that we *are,* for example, temperate, chaste, etc. We are of the same nature as what we know. Further it can be called a knowledge through inclination in that what has been

[11] See KTC, pp. 26-27.

[12] A comparison of the various types of connatural knowing with one another will make is clear that *connatural knowing* is an analogous notion. Consequently the general characteristict just indicated cannot be made to apply equally and in the same way to each type; they can serve to give an impression of this kind of knowing but should not be understood in a more precise and systematic way than they appear in Maritain's thought. Further, the divisions of this most obscure notion which follow are not meant to be exhaustive. He mentions from time to time instances which do not fall into any one of the types distinguished when he makes the division.

[13] *DK*, p. 270; OHK, p. 16. We can note that since nature is tendency, to be of the same nature is to be inclined in the same way.

[14] *S. Th.* II-II, 45, 2; I-II, 94, 2; *Nicomachean Ethics* X, 5; KTC, pp. 22-23.

That this is the primary instance of such knowing is clear from the fact that Maritain usually introduces his discussions of it by referring to connatural knowledge of virtue. See, e.g., *CI*, p. 85; *DK*, p. 260; OHK, p. 16; KTC, p. 23; "The Natural Mystical Experience and the Void," in *Ransoming the Time* (New York, 1941), p. 256. Also it seems, at least to Maritain, that this is historically the first type recognized; further it is one of the least complex cases and closest to common experience, as should be evident from what follows. Finally, he calls it the "*basal* type, the type best proportioned to human beings..." ("The Natural Mystical Experience and the Void," p. 257).

[15] *CI*, p. 85.

incorporated into our make-up or nature tends or inclines us in a certain way, and a recourse to these leanings constitutes a practical knowledge of what is responsible for them.[16]

It follows that intuitive knowledge through inclination is not universal since an individual's inclinations are particular tendencies which are what they are because of their particular circumstances. By it one would not know what it means in all cases to be chaste or temperate, but rather what it means here and now under these circumstances for me. Thus, this sort of knowledge is not conceptualizable but is an obscure, lived awareness of the individual or the concrete. Maritain refers to it as "existential knowledge."[17]

Now the traits of this connatural knowledge of virtue we shall find present in one way or another in the other two forms of intuition-as-divination distinguished, namely mystical experience and poetic knowledge; but we can observe that they are less accessible to common experience than the connatural knowledge of virtue.[18]

Mystical experience, Maritain tells us, is of an entity which far exceeds our intellectual comprehension. Through our concepts or ideas we could know of divine things only by analogy with creatures and therefore at a distance. But there are those who have an intuitive knowledge of divinity, and the connaturality with such things must be a gift superadded to what we are endowed with by nature. Specifically, it is, we are told, a supernatural love, a participation in divine love that "connatures" man with what he experiences in this way. We know through the inclination of the will; and whereas ordinarily concepts are the intentional means of knowing,[19] here love or the intention or direction of volitional acts becomes the medium uniting – albeit in an obscure way – the intellect with what is known. Through infused love

[16] See "The Natural Mystical Experience and the Void," p. 256. Maritain does not explain why this knowledge of virtue is affective. It would seem that it is a matter of knowing through the way a subject, possessed of whatever virtue he has, is affected by a situation involving the need for moral choice.

[17] *A & S*, p. 195, n. 130; KTC, pp. 23-24; *Man and the State* (Chicago, 1951), pp. 91-92; Hay, pp. 35, 37.

This knowledge is none the less intellectual. One's inclinations are "refracted through the crystal of reason in its unconscious or preconscious life." (KTC, p. 27). See below, #7, for a clarification of pre-conscious intellectual life.

[18] Also, the characteristics of this first member of the division do not fit the other forms without some changes, as has been previously noted.

[19] See above, Chapter III.

[20] *DK*, p. 261 and n. 3. It should be noted that for Maritain there are two kinds of mystical experience, supernatural or God-given and natural. Only the former is by means of affective connaturality, and it is this type that is being compared with poetic knowledge. See KTC, pp. 24-25.

Maritain says that divine things are "embowelled in us." One exper-
iences his love in its resonance within himself, that is, in its affects on
him; and this experience becomes a means of knowing that which has
touched him in it.[20] Now this that is experienced is loved and exper-
ienced as infinitely transcending our power to know; hence it is ex-
perienced in darkness as well as in a state of not being disengaged from
the subjectivity of the knower. Consequently, what is loved is exper-
ienced as unknown, and the knowledge is spoken of by Maritain as in
the mode of "possession-giving not-knowing." There is an intentional
union of subject and object within the interiority of the knower; yet
the object is veiled in darkness. Mystical experience in short, like moral
knowledge through connaturality, (1) is existential, that is, of some-
thing concrete, individual; (2) is therefore of what cannot be concep-
tualized; (3) is had through the inclination of the subject, here the
tendency of volitional or love acts; and (4) is a result of how the sub-
ject is affected, so that it emerges from a union of subject and known
in which an object is not disengaged for itself.[21]

 Lastly, Maritain distinguishes an intuitive knowledge by inclination
or connaturality which he calls *poetic intuition* or *poetic knowledge*. Like
the other forms of connatural knowledge it is non-conceptual and ob-
scure, grasping a singular concrete thing or interrelated set of things
– in this case in terms of some of the "inner secrets of their being."[22]
Also it is an affective knowledge, though here the means of knowing is
not a volitional act like love. Instead the means is an emotion bearing
into the subjectivity of the knower whatever gives rise to it – in a non-
conceptual way issuing in a cognition which does not separate subject
and object. What is grasped is the subject as affected by things or
things as "resounding" in the subjectivity of the knower. This intuition
as creative, however, comes to full consciousness and expression only in
a process of externalizing it. Hence, unlike mystical experience it is
not "possession-giving"; that is, it comes to term not in the interiority
of the knower, but rather independently, in a work. Further, though it
can be spoken of as inspiration, it is a phenomenon to be explained only
in terms of the poet and that which he grasps. As W. K. Wimsatt puts
it, speaking of Maritain, it is "the Platonic muse naturalized, descended
into the soul of man. It is *mousike*."[23] Maritain's own concise statement

[21] See "The Natural Mystical Experience and the Void," pp. 263-266; KTC, pp. 24-25;
DK, pp. 260-262.
[22] See below, this chapter #10-13, for an explication of such phrases as this.
[23] "Gay in the Mystery," *Poetry*, 87 (February, 1956), 309.

in one of his later formulations can perhaps best serve to introduce us
to this last – and for us most important – category of intuitive know-
ledge in the sense of divination or inclination.

> ... poetic experience also implies a typical kind of knowledge through connatu-
> rality. Poetic knowledge is non-conceptual and non-rational knowledge; it is
> born in the pre-conscious life of the intellect, and it is essentially an obscure
> revelation both of the subjectivity of the poet and of some flash of reality
> coming together out of sleep in one single awakening. This unconceptualizable
> knowledge comes about, I think, through the instrumentality of emotion, which,
> received in the preconscious life of the intellect, becomes intentional and in-
> tuitive, and causes the intellect obscurely to grasp some existential reality as
> *one* with the Self it has moved, and by the same stroke all that which this
> reality, emotionally grasped, calls forth in the manner of a sign: so as to have
> the self known in the experience of the world and the world known in the ex-
> perience of the self, through an intuition which essentially tends toward utter-
> ance and creation.[24]

POETIC KNOWLEDGE IN GENERAL

4. The psychology of Maritain's poetics is an intricate adaptation of
traditional Thomistic philosophy of mind to certain problems and ob-
servations of artists concerning the element of inspiration in fine art.
A complete treatment of it, while it would illumine the doctrine as a
whole, would be of little relevance to this enterprise[25]; however certain
pertinent points of the theory require additional examination.

5. Maritain is careful to distinguish the emotion essential to poetic in-
tuition from other kinds which appear in art. It is not *depicted* emotion,
which is a sort of material element in the work, nor is it the artist's own
emotion *expressed* by a work, featured by exponents such as I. A.
Richards of the emotive theory of art-as-language.[26] In poetic knowing
one divines the inner meaning of things, the "secrets of being," by a
"suffering" or being affected by the things of the world; and it is emo-
tion which is the bearer of that which is suffered into the mind of the
artist. Hence the emotion is a *cause* of knowledge rather than a *result*

[24] KTC, pp. 25-26.
[25] The reader who wishes further details on aspects which will not be further treated is
referred to *SP*; Chapters III and IV of *CI*; W. J. Grace, "A Scholastic Philosopher and the
New Criticism," *Thought*, 17 (September, 1942) 489-498; M.-D. Phillippe, "L'esthétique de
Jacques Maritain," *Revue des Sciences Philosophiques et Théologiques*, 41 (1957), 245-248;
E. A. Sillem, "Jacques Maritain and the Philosophy of Art," *Dublin Review*, 229 (1955),
176-189.
[26] For a discussion of art as emotive language see M. Weitz, *Philosophy of the Arts* (Cam-
bridge, Massachusetts, 1950), pp. 134 ff.

of knowing.[27] Specifically, it takes the place of the intelligible species or mental content[28] in determining the character of the work that issues from it. Thus it is emotion as *form*, which as intentional carries a meaning which will structure the work. The meaning is illuminated, the emotion is made intentional, by Maritain's version of Aristotle's active mind or intellect; but no concept is formed – poetic knowledge cannot be formulated in abstractions.[29] Intelligence must be present, but it renders the emotion meaningful in such a manner that it becomes the germ for a producing – also involving intelligence – which issues in a concrete work rather than an abstract notion.

6. If fine art is not just the expression of purely subjective emotion, neither is it a purely objective presentation of nature either. Poetic

[27] On this point Maritain's theory owes much to Bergson. See *Two Sources of Morality and Religion*, pp. 43-44.

[28] By intelligible species is here meant *species impressa*. To clarify this point and some others to be treated shortly, a brief review of the Thomistic view of concept formation is in order; and to see this doctrine as Maritain understands it, we can do no better than to turn to a section of *CI* where he summarizes it in connection with some of the very matters under discussion here. In the first place, the intellect, as the tradition conceives it, is a capability of the human person which is "spiritual," i.e., not material. (Aquinas arrives at this notion of the intellect as non-material from a reflection on *what* and the *manner in which* it understands, and reasons that nothing which is in any way material could know in such a way. See *Q. D. De Anima*, 13c; *S. Th.* I, 75, 2). In this regard the intellect is distinct from the senses and imagination, which intend only individual, material things rather than natures as abstracted from individuating matter.

Secondly, whatever the intellect knows it knows ultimately by that which is perceived through the senses. Further, the intellect which knows, originally a *tabula rasa*, is only in a state of potentiality to the act of knowing and to the forms which it will receive to specify that act – and in a state of potentiality only to what, like it, is spiritual. The problem becomes one of explaining how this spiritual, potential intellect can draw its non-material content from – i.e., be actuated by – sensory intentions, which are imbued with materiality and as such not actually but only potentially capable of being understood.

There is required, consequently, something to explain how the potential intelligibility of material sensory images can be brought to a state of spirituality and actual intelligibility. This something is called by Aristotle and the Schoolmen active or agent intellect and by Maritain Illuminating Intellect. It is purely activating, bringing potential intelligibility to a state of actuality, rather than like the knowing intellect being in a state of potentiality or passive receptivity to whatever might come along to specify or give form to its knowing activity.

Finally, the intelligible content of sensory experience as brought by Illuminating Intellect to a state of *actually* being *capable* of being understood is a spiritual form called a *species impressa*, an impressed pattern or "intelligible germ." The knowing intellect, "impregnated" by this germ, produces an understanding of what is known –- expressible in a definition; and such an understanding as an *actual* understanding of the intelligible content is called the *concept*, the *species expressa*, or mental word. (*CI*, pp. 70-72).

With regard to emotion as intentional, Maritain conceives the process of poetic knowing as analogous to concept-formation. Poetic emotion as irradiated by Illuminating Intellect becomes like the *species impressa*, but in poetic knowing intelligence so impregnated fructifies externally in matter instead of producing a concept within itself. Thus the work of fine art is analogous to the word or *species expressa*. (*SP*, p. 77).

[29] *CI*, pp. 87-89.

knowledge is a grasp of both the subjectivity of the artist and things discerned as identical with or a part of himself; that is, it is a grasp of the self-as-affected-by-things.[30] Now for Maritain creation is an analogical notion; the "supreme" analogate of poetry and creativity is the divine art. The poet is like a god in that, since there is no need to be served, the creativity of the artist is free to tend toward beauty in an infinity of possible realizations. But in the case of God, Maritain tells us that the creative idea is not drawn from things; it is purely *formative of* and not *formed by*. What the work manifests, therefore, is only the self of the creator who knows himself in himself and the ways in which things can imitate him in a diminished way. Consequently, poetic knowledge in its highest form would be exclusively a knowledge of the self. For the human artist, however, this knowledge is not possible. The poet can know himself only "as refracted by the world of his acts which itself refracts the world of things."[31] Thus things and the self are known together; the resonance of things in the self is the means by which the latter is known, and the subjectivity as resonant with things becomes the means of gaining poetic insight into the world. In accordance with the paradigm of creation, however, it is the subject that is primarily reflected in the work. If there were no element of the creative subject in the work, it would not be a creation or a work of fine art but would simply mimic in some way that which already exists independently of the artist. The human artist is always dependent upon his surroundings for his materials; but if he is truly to *create*, he cannot be wholly dependent with respect to the form of the work. His activity cannot just be formed by things – he must manifest himself; and it is this manifestation of self (in union with things) which will form the work. Of this, more remains to be seen.[32]

[30] PE, p. 395. See also OHK, p. 18; Hazo, "An Analysis of the Aesthetics of Jacques Maritain," p. 137.

[31] "Freedom of Song," in *Art and Poetry*, p. 89; *CI*, pp. 80-84. This language suggests again that things are not grasped as *other* than the poet, as in the case of speculative knowledge, but rather that subjectivity is grasped in things and conversely. There is no question here, of course, of literal, physical identity; at the same time poetic intuition does not occur at a level on which there is a separation in knowledge of an object from the subject. Maritain proposes that even in the wildest untamed nature man can see or project something of his own feeling into things, which reflect it back to him. (*CI*, pp. 5-6). Compare Bergson's notion of interpenetration in *Creative Evolution* (New York, 1911), p. 195; see Hay, p. 103.

[32] S & S, p. 254. See also *CI*, p. 93. Maritain includes in his little volume on Rouault these words of the painter: "Subjective artists are one-eyed, but objective artists are blind." [*Georges Rouault* (New York, 1954), p. 27].

The conception of the fine artist as creator is modelled on that of divine creation as the "supreme" case, in which the creator is dependent on nothing other than himself; but ultimately the latter notion would seem to have to be elaborated from an experience of human making.

7. Poetic intuition involves what in the tradition of Scholasticism has been called the intellect. There are, of course, concepts present in a poem,

> either concepts in a nascent state, and virtual, as it were, carried along by the images; or implicit, unapparent concepts, serving only as supports for the expression of images; or concepts which are explicit and used with their full intellectual meaning...[33]

But this presence of concepts is as a material element in the work: no concept or set of them provides the overall structure of the poem – especially in modern poetry. Rather they themselves are structured by a poetic knowledge which is not conceptual. But still Maritain holds that poetic intuition is more than just a sensory, imaginative affair. He notes in the traditional doctrine of conceptual knowledge that there is a pre-conceptual and pre-conscious life of intelligence which conditions the formation of concepts. Before being expressed in concepts and judgments, "intellectual knowledge is at first a beginning of insight, still unformulated, a kind of many-eyed cloud which is born from the impact of the light of the Illuminating Intellect on the world of images, and which is but a humble and trembling inchoation..."[34] It is from this world of activity that new ideas, scientific hypotheses, and solutions suddenly emerge.[35]

Now he argues that since there is a non-conceptual or pre-conceptual activity of intelligence with regard to concept formation, it can be assumed with even greater reason that there is such a non-conceptual activity of reason operative in poetic intuition prior to its coming to expression in a work.[36] In both instances what emerges into the full light of consciousness is the expression of the activity; in the case of concept formation it is the concept, and in the case of poetic intuition it is the work made. Consequently, one might say that poetic knowledge is largely an unconscious affair (or rather "pre-conscious" to distinguish it from the Freudian unconscious, which is "structured into a world of its own apart from the intellect"),[37] arising into consciousness

[33] *CI*, pp. 222-223.

[34] *Ibid.*, p. 73. This is to say that what concepts intend is known directly, and also that concepts themselves can be known reflexively. However we have no awareness of any illuminating process of images by agent intelligence, nor of the intelligible germ produced by it, nor of the process of producing the concept itself. We can, for Maritain, establish philosophically that there must be these preconceptual, pre-conscious activities and elements; but they cannot be experienced. (*CI*, pp. 72-73; see above, this chapter, n. 28).

[35] *CI*, pp. 68-69; 307, n. 21.

[36] *Ibid.*, p. 74.

[37] *Ibid.*, p. 67. See pp. 66-69 for a discussion of the distinction.

in an experience which "gives notice of its existence but does not express it."[38] Hence while poetic intuition is analogous to concept formation, its cognitive aspects correspond to the activity which is prior to the active production of the concept.

The reasons for Maritain's insisting on a role for intelligence in poetic intuition would seem to be just that there is meaning in fine art, even though it is not abstractly formulable, and that poetry is indeed more philosophical than history. Without intellect there would be merely a "gushing forth of images," with no reason for their inclusion or their interrelations. We actually have an example of such an attempt in the efforts of Surrealism – at least in its announced intentions as expressed by Breton. There it is a case of rejecting reason, of separating imagination from intelligence and allowing the former to spew forth what it will in the process of "automatic writing." Such an undertaking is neither free not is it creative, since it is uncontrolled and nothing new is really revealed by it.[39]

8. Poetic knowledge is said to be a knowledge by *inclination*. Maritain's mode of conceiving and speaking of things is rich with analogy and – more loosely – with metaphor, producing a compression and at times an obscurity of meaning. A sense of the mystery of things is reflected in his writing, which manifests a habit of mind content with flashes of insight rather than systematic analysis; Maritain dislikes system. Hence his thought tends to defy a systematic account of it.[40] This difficulty is especially apparent in his speaking of poetic intuition as connatural knowledge or knowledge by inclination. Not only is this type of knowing not exemplified in poetry in the same way as in the other forms of cognition so labeled but also even in poetic knowing itself these terms are not used univocally in describing its various phases. One can, within the framework of Maritain's thought, speak of the connaturalities one has with things because of a basic ontological similarity – in being composed of matter and form; he can also refer to a connaturality which

[38] *Ibid.*, p. 86; see also p. 202. The poet is aware that he is pregnant, but with what he will not know until he has given birth to it. See below for a discussion on whether the creative idea in fine art is an examplar.

[39] *Ibid.*, pp. 58, 176-177; see also pp. 3-4, 55; S & S, p. 252; *DK*, p. 109, n. 2. Whether it is actually possible for the human artist completely to disengage intelligence so that the production is fully automatic is another question.

[40] And yet there is a remarkable sense of coherence in it just because of the similarities which run through everything. It is only similarity, however, not sameness; Maritain's world is not a tidy affair which falls into precise categories and lends itself to description in univocal language.

results from all one's past experiences with things which have sedimented into characteristic attitudes and ways of acting. (I shall call these residual connaturalities.) But what seems chiefly to be on Maritain's mind in this context is the connaturality which arises within the union of things and the self in the very poetic experience itself brought about by intuitive emotion.[41] The main problem of interpretation here, it would seem, is to discover in what sense the connaturality involved in this can be called a knowledge by *inclination*. One can know virtue or a skill such as swimming – by inclination as opposed to theoretically knowing – in the tendencies one has to act. But how does one know through inclination some thing or complex of things, in other words that which is not an operative ability?

There is, first of all, a sort of sympathy with that which is known; we might say that one is both inclined *toward* and sympathetically inclined *with* the known. One shares sympathetically the nature and hence the tendencies of the known.[42] And since poetic knowledge by union or connaturality takes form only in a work made, we can also admit an inclination toward production. The union presses toward externalization, and his very inclination to express in a material what is grasped also becomes for the artist a means of knowledge by inclination. Hence as in moral knowledge one knows what temperance is by consulting one's own bent toward action, so here one knows things in his bent toward expressing, by making, some meaning caught in them which is responsible for the bent. Further, this making or creating has its *means*; and there is a connaturality with regard to them, a spontaneous inclination in the direction of the appropriate means-to-be-used.[43] We find as early as the *Bergsonian Philosophy and Thomism* this statement which summarily indicates the main inclinations present in fine art:

... in his work the artist is directed by a kind of sensible sympathy which unites him to both the living reality he wishes to express and the means of expression he employs...; and the poet knows his heroes the better for the fact that it is always some aspect of himself that he expresses in them. One might say that art attempts precisely to make us divine sensibly in its very singularity that individual nature that our senses give us in its accidents and its material operations but not in itself, and which our intellect... does not know directly as individual...[44]

[41] See, e.g., *CI*, pp. 83-84, 85, 88.
[42] See *PM*, p. 70.
[43] Unlike instinct, this is acquired and so admits of degrees and flaws which affect the success of the work.
[44] *BPT*, p. 165. The intellect has a direct, objectifiable knowledge only through universal

This statement deserves further explication. In it we see implied that the artist's own tendencies as a person (or residual connaturalities) are bound up with his vision or with the means of expressing it – here his characters – or both.[45] Of course the characters are not antecedently known, the artist creates them; they are a part of the way he expresses his vision. At the same time we might add that they are not created from the whole cloth; the artist recognizes them from a sympathy with people he has known, a sympathy which enlarges the scope of his own tendencies. So there are residual connaturalities with respect to other humans involved as well. The spark of poetic intuition energizes these latent sympathies that they might serve the expression of just that with which the artist becomes connatural in the poetic experience proper.

Further, it is the singularity of an experience or a thing that poetic intuition seeks to grasp. And such an accomplishment can be had only by an expression which shares this property of individuality or concreteness – in a material in the case of the visual arts and through sound and imagery working against the tendency of language toward the abstract in the case of poetry (that is, poem-writing).[46] As Maritain says, "...poetic knowledge, like the knowledge of contemplation (when it expresses itself), employs similitudes and symbols – in order to *seduce the reason*, as St. Thomas says; precisely because both of these kinds of knowledge have to do, in different ways, with the non-conceptualizable."[47] Now W. J. Grace, in an article written shortly after the appearance of *Situation de la Poésie*, points out that the poet who is attempting to express his experience of the beauty of some individual flower will be able to do so when a sudden metaphor comes to him intuitively. One knows the flower by means of the metaphor (and the metaphor arises only in the creative act, in the movement toward expression). Such intuitive flashes result from an "instinctive" thinking of the image which illumines the experience; hence the residual connaturality with the imaging thing is to be included in the connaturality

concepts of the intelligible aspects of things. Intellectual knowledge of the singular is either through an indirect "reflection" upon the senses, which are the sources of its content, or (non-objectifiably) through affective connaturality. See *DK*, pp. 22-28; 28, n. 1; 435-436. *S. Th.* I, 86, 1 contains a concise statement of the reasoning behind this point.

[45] This is reiterated in *CI*; the novelist knows his characters through himself, through connaturality or his own inclinations. (p. 280).

[46] 'Poetry' and 'poetic' are to be understood in the wide sense as present in all forms of fine art unless – as here – otherwise indicated.

[47] *SP*, p. 68; *In I Sent.* prol., q. 1, a. 5, ad 3. See *CI*, pp. 144, 155, 167, 170-171, 203, 227-229.

with respect to the means of expression. Thus we could conclude that in the tendency to create one is inclined toward these latent images as aroused by poetic intuition, and the poetically experienced reality is known through this inclination toward them in bringing the experience to expression.[48]

For all of this, Maritain's doctrine of *inclination* in poetic intuition remains somewhat disconnected, a beginning of an account rather than a completely worked-out scheme. Maritain never goes very far beyond stating that it is similar to moral knowledge; the reader must, as we have attempted to do here, make the modifications necessary to fit it into poetic experience.

9. We can bring to a close this general discussion of the relevant features of the intuitive process in virtue of which the work receives its form. At this point it might be observed that Maritain's views are open to the objection that there is very little evidence for them; one critic has even contended that his expression of them is unmeaning.[49] If the process is as unconscious and pre-conceptual as it is described to be, then *ipso facto* it is not open to an immediate reflective inspection of its workings. Further, while some philosophers can be presumed to be virtuous and can therefore reflect on their prudential decisions, it seems less likely that many are artists (or mystics). Hence few would be in a position to verify reflectively the aspects of Maritain's view which purport to describe that part of creative experience which is open to introspection. On the other hand, Maritain's close contacts with certain French composers, painters, and writers – including his wife, a poetess – and his careful attention to what they have said on the subject suggest that he has enjoyed a vantage point from which to develop his views available to few philosophers.

He does, however, offer some evidence. Following the chapters of his *Creative Intuition* are sections entitled "Texts without Comment," which include poems and statements by artists. In Chapter IV he says:

The *Texts without Comment* which follow this chapter contain lines which seem to be significant for my present purpose. I think that by reading those collected under heading II we can see better than through any philosophical arguments how the subjectivity of the poet is revealed (but together with things) in his poem; and by reading the texts collected under heading III, how the *Another*, the things of the world and of the intellect, and their meanings, are also (but

 [48] See *CI*, pp. 88-89.
 [49] See the review of *CI* by V. Turner, "M. Maritain on Creative Intuition," *Month*, 12 (November, 1954), pp. 270-280.

together with the Self) revealed in the poem; and how, in this single *and* double revelation, everything derives from a primal creative intuition, born in the soul of the poet, under the impact of a definite emotion.

The direct, intuitive contact with any genuine work of painting, sculpture or architecture, or music, which has spiritual depth and conveys a message of its own, affords us the same evidence.[50]

How far does this evidence take us? Surely it can make us aware that there is this "double revelation" of which he speaks. Beyond this it seems clear from our discussion that the theory in its details is a construct modelled by analogy on prudential knowledge, accounts of mystical experience, and – more remotely – on a theology of divine creation. It is safe to say that Maritain has wished to vindicate modern poetry and painting as he conceives them and to preserve a free, creative role for the human artist who is totally dependent on his surroundings for his materials – including imaginal and conceptual material – and yet is able to bring forth something new in its form. The construction has been formulated within a framework of Thomistic philosophy which has been rethought in Maritain's characteristically original way and into which have been incorporated some modifications of Bergson's thought, but that this is the only way to account for the phenomena with which he is concerned or that what he is accounting for is universal in creative experience will no doubt be challenged by some. We shall have later to determine the extent to which the ontology of the work would be affected by whether his position on poetic intuition can be supported.

Having presented a general view of certain of the relevant features of Maritain's theory of poetic knowledge, we are now prepared to draw out the implications of two very crucial aspects of it for an ontology of the work of fine art.

WHAT IT IS THAT IS GRASPED BY POETIC INTUITION

10. The part played by subjectivity in the meaning of a work has been noted, and it is possible to say very little further about that element in the work. However, we must dwell at greater length on the aspects of *things* which are caught by poetic intuition and which enter into the meaning of a work as its form,[51] for it is in terms of such considerations that the claim of an expansiveness of meaning must be seen.

[50] *CI*, p. 90.
[51] Actually, though Maritain is more concerned in his theory to give the dominant position to subjectivity, he allows that for the beholder of the work there is more interest in what has been seen in things. (*CI*, p. 210).

Maritain emphasizes that poetic intuition is directed toward concrete existence rather than simply abstractly formulizable meaning, "toward some singular existent, toward some complex of concrete and individual reality, seized in the violence of its sudden self-assertion and in the total unicity of its passage in time." Then he adds:

> But poetic intuition does not stop at this given existent; it goes beyond, and infinitely beyond. Precisely because it has no conceptualized object, it tends and extends to the infinite, it tends toward all the reality, the infinite reality which is engaged in any singular existing thing, either the secret properties of being involved in its identity and in its existential relations with other things, or the other realities, all the other aspects or fructifications of being, scattered in the entire world, which have in themselves the wherewithal to found some ideal relation with this singular existing thing, and which it conveys to the mind, by the very fact that it is grasped through its union with, and resonance in, subjectivity spiritually awakened.
>
> Such is, I think, the thing grasped by poetic intuition: the singular existent which resounds in the subjectivity of the poet, together with all the other realities which echo in this existent, and which it conveys in the manner of a sign.[52]

What does all of this mean? First of all, Maritain is clearly opposing the view that fine art is nothing but a vehicle for the conveyance of abstract messages or meanings. As we have said, the emphasis is on the concrete. The poet with his non-conceptual grasp may have no theoretical knowledge of psychology, sociology, cosmology, ethics, or anything at all.[53] But this is not to say that poetic intuition apprehends and tends to express that which is merely concrete and singular, immersed in a welter of apparently fortuitous, meaningless circumstances which result from its materiality.[54] Maritain agrees with Aristotle that poetry is more philosophical that history. We have seen that for him the intellect has a role to play in poetic intuition illuminating a significance in the particular emotion-laden experience. Nevertheless this significance is not expressible abstractly; poetry grasps the meaning not as universal but as thoroughly particular. The portrait painter does not give us a particular thing or experience devoid of anything upon which intelligence can fasten, nor does he represent "humanity" or "womanhood" or "virtuous womanhood." Instead he captures – or

[52] *Ibid.*, pp. 91-92.

[53] OHK, p. 17. Maritain really wants to call it knowledge, but it is of a sort that is not able to account for itself. The poet as such cannot instruct others in the actions that make men better or worse, but he may be able to create a work that reflects a world in which there are moral values. Maritain writes to Cocteau that there is a conception of the world in his poetry but that it is "too immersed in the concrete to be put into a system." [Art *and Faith* (New York, 1948), p. 116].

[54] See *CI*, p. 92.

attempts to — the particular human person that he divines his model to be. Poetic experience does grasp a meaning or an intelligibility, but the mode of knowing is not abstract; "this *quid* is not seized by mode of quiddity, of essence, or of intelligibility."[55] So in terms of *what* is grasped poetry is more philosophic than history but not in terms of the *mode* of apprehension.[56] Intelligence opens up the meaning; but instead of attempting to express or formulate it in a concept, it presides over the making of a work in which the meaning, divined in the concrete, is expressed in the concrete. Thus, "Poetry is a divination of the spiritual in the things of sense – which expresses itself in the things of sense, and in a delight of sense… Metaphysics snatches at the spiritual in an idea, by the most abstract intellection; poetry reaches it in the flesh, by the very point of the sense sharpened through intelligence… Metaphysics gives chase to essences and definitions, poetry to any flash of existence glittering by the way…"[57] Poetry is "existential," but what it discerns is a "*flash* of existence," an insight or meaning forcing itself on the poet. There is significance or openness to mind – that is, "spirituality" or transcendence of the opacity of matter[58]; but it is a meaning dwelling in and seen *in* the things of sense. So while it requires intelligence brought to sense and poetic intuition to apprehend it, it nevertheless is not universal nor capable of being formulated abstractly.[59]

[55] *SP*, p. 77; see *DK*, pp. 208-209; PE, 396.

[56] *CI*, p. 92; *SP*, pp. 76-77. In a footnote to *A & S*, quoting Max Jacob, Maritain says that "for a child, an individual stands alone in a species; for a man, it enters into the species; for an artist, it emerges from it." Again, speaking of Lourie's music, Maritain says that its poetry gives the work produced a "concrete charge of universality." (p. 192, n. 123; *Art and Poetry*, p. 97).

[57] *CI*, pp. 173-174.

[58] As noted elsewhere, 'spirituality' is used analogously by Maritain; the independence of matter which it signifies has varying degrees, any one of which can be meant by this term.

[59] See, e.g., *A & S*, pp. 24-25; 197, n. 131; 199; *CI*, p. 123. See also Maritain's book on Rouault for an application of these ideas to the latter. Unfortunately, Maritain discusses Rouault in general terms rather than illustrating his contentions in any detail with examples of Rouault's work.

W. K. Wimsatt, in an essay "The Structure of the 'Concrete Universal' in Literature," *PMLA*, 62 (March, 1947), suggests with respect to the experience of literature (which is really the difficult case in this regard since it is a work of words) a view which in many respects is like Maritain's. What a literary work represents is neither wholly universal nor totally concrete, though in the past theorists have often insisted on one to the exclusion of the other. Any abstract statements we make as to the poem's meaning can approximate to what the poem says – there is meaning which the intelligence can grasp and express conceptually. But this only approaches a totality of meaning which cannot be expressed in terms other than those used by the poet. As Maritain puts it, if it can be stated in other words, it is not a poem.

A similar notion is expressed in a paper on poetic knowledge by John Oesterle. While he differs in many respects with Maritain's views in that he stresses an *imposition* of meaning on what often appears as meaningless events of life and in that he denies poetic knowledge to be "some mysterious intuition of reality," he also makes the point that the universal in art

11. We have been examining Maritain's view of what it is that is grasped in poetic intuition and have seen that is it a meaning in the concrete singular. We must now return to the passage in *Creative Intuition* which served as the point of departure for this discussion to see what further is involved in this conception.[60] Whereas a concept isolates an aspect from that in which it is found, poetic intuition attempts to obtain the integral whole. But any one actually existing whole has a place among many others in an entire tissue of relationships: spatial relations, relations of cause and effect, relations of similarity, associative relations in the minds of men, and the like. Poetic intuition, therefore, in seizing something concrete obtains it in its setting – so that these other things to which it is related enter into the intuition as well.[61] The passage being commented upon implies that poetic intuition has this expansiveness of meaning in at least three ways:

a. What a thing existentially, historically is related to can be said in a broad sense to be signified by the given thing. Accordingly, for someone sensitive to it, a ledger book, for example, brings with it a swarm

[if we can call it that] is merely a mean between the purely singular and the purely universal. It is in fact what is best proportioned to the minds of most humans. We do not understand the purely singular as such. Nor are most people able to cope with universal knowledge disengaged for itself; it needs to be seen in the instances of what it is about. The universal of art, then, is the universal in the singular or the singular universalized. ["Our Poetic Knowledge," *Proceedings of the American Catholic Philosophical Association*, 29 (1955), 97].

The views of both Wimsatt and Oesterle are similar to Maritain's, although there are some differences between the way his notion and theirs is stated. Doubtlessly he would not deny that there is in some sense an element of universality or potential universality in the experience and in the work (though for him duplicable structures or properties in a thing are not in it as universal; they are there as *this* man or *this* red), but the meaning is not a universal-as-instanced and seen in the instance. It is the whole fleshed-out experience in its meaning as a unique occurrence that the poet wishes to capture: "This transient motion of a beloved hand – it exists an instant, and will disappear forever... Poetic intuition catches it in passing, in a faint attempt to immortalize it in time." (*CI*, p. 91). Singular things have an intelligibility, and this element in them is completely individual; consequently for Maritain there would, strictly speaking, be no universal-in-the-singular. (See *RsI*, p. 19). Furthermore this intelligibility is a whole, completely unitary meaning, from which universality can be had only in concepts, which abstract or isolate aspects of the whole. What is more, the intelligibility of what we experience is immersed in matter (which individuates it). It is a structuring of matter, comprising one thing with it, rather than matter and the intelligible structure of the matter being separate entities. Now in Maritain's view for an intelligibility to be in matter is for it to be at least partially covered up to the understanding. (*RsI*, pp. 57-58). No amount of intellectual analysis, therefore, will be able to comprehend the total meaning of a singular thing or event in its unique wholeness; its meaning is not in terms of universals. On this point, see the Appendix below for a comparison of Maritain with some other contemporary ontological views.

[60] *CI*, pp. 91-92.

[61] Precisely because poetic intuition has no conceptualized object, "it tends and extends to the infinite, it tends toward all the reality, the infinite reality which is engaged in any singular existing thing..." (*CI*, p. 91; see also pp. 173, 160).

of meanings having to do with the world of which it is a part.[62] Speaking of a poetically inspired work of another era, Maritain suggests rather clearly that this is at least part of what he means by "the secret properties of being involved in its identity and in its existential relations with other things." He says that the pre-historic cave drawings of deer and bison "are the prime achievements of human art and poetic intuition. By virtue of the Sign, they make present to us an aspect of the animal shape and life, and of the world of hunting." (And they reveal as well something of the men who drew them). So not only are some of the inner secrets of the animal itself as it exists manifested, but also there dwells in these drawings the context of the animal's appearance in prehistoric human existence.[63] It is a hidden meaning of their historical setting, therefore, as well as of their own peculiar intrinsic structure that things offer to the poet. Thus, though raw Nature is not excluded from that which can give rise to the poet's vision, Nature is meaningful for Maritain if it reflects the human. The observer who passes the Pillars of Hercules entering the Mediterranean is filled with emotion because of the Greek heroes (even though one is not conscious of them) and "the impalpable breezes of memory which freshen your face." It is because there is a union of man and Nature accomplished historically by men living in and impressing their mark on Nature that the latter becomes radiant with significance.[64] Something is meaningful because of the contact it has had with events of human life.

b. But such contacts or metonymic relationships are not all of what Maritain means by the "secret properties of being involved in its [any singular existing thing's] identity and in its existential relations with other things." In addition, what exists is full of all manner of similarities and correspondences.[65] These can consist in specific or generic likenesses, or similarities resulting from sharing other common attri-

[62] It would seem here that grasping this significance is not the sole prerogative of the poet. What Maritain seems to mean, however, is that the poet feels in its affect on him as a whole (and with the world that is his) the integral matrix (hence non-conceptually). Further he grasps it in a flash of revelation of some of its peculiar, profound significance which urges toward the expression of it (in the only way possible) concretely. Cf. Ingarden, *Das Literarische Kunstwerk*, pp. 300-303, 221.

[63] *CI*, p. 30. Heidegger makes the same point in the "Origin of the Work of Art." (pp. 669-675). Even a Greek temple, for example, which does not represent, does this. "It is the temple-work that first fits together and at the same time assembles around itself the unity of those paths and relations in which birth and death, disaster and blessing, victory and disgrace, endurance and decline take on for the human being the shape of his destiny. The all-governing expanse of this open relational context is the world of this historical people. From and in this world the nation first returns to itself for the fulfillment of its vocation." (p. 669).

[64] *CI*, p. 7; see *SP*, p. 84.

[65] See *SP*, p. 79; PE, p. 398; *CI*, p. 92.

butes. But there are also analogical correspondences. In the Thomistic tradition everything is analogous to everything else in that each thing is truly, in its own way, and in all that it is a being.[66] Further, there is a kind ot likeness such that the concept of one thing can be applied to another[67] in which the intention of the concept[68] is *not* really present. This happens because what the concept (for example, the concept eagle) *properly* applies to (a certain kind of bird) is related to something else (lofty flight) in a way similar to what it is *actually* applied to (an orator) is related to something which is to be manifested by the analogical similarity (sublime eloquence). This similarity Maritain calls analogy of *metaphor*.[69] That analogical similarities are a large part of what Maritain has in mind when he speaks of poetic intuition as expansive to the infinite is indicated by the following:

> The work will make present to our eyes, together with itself, something else, and still something else, and still something else indefinitely, in the infinite mirrors of analogy. Through a kind of poetic ampliation, Beatrice, while remaining the woman whom Dante loved, is also, through the power of the sign, the light which illuminates him.[70]

Further, by the example of Beatrice which it contains, the passage suggests that it is metaphorical analogy that is meant by the "infinite mirrors of analogy." Now one can use metaphorical likeness in a logical manner. Wishing to illumine in something a characteristic which is already known and seized conceptually, one will search for a ready-made image that participates analogically in the character grasped by the concept to serve this "purposive comparison." Maritain illustrates this use by the example of worldly felicity; the poet may form a concept of its fragility; and, desiring to portray it vividly, select glass. But the intuitive pre-conscious, non-conceptual way of most concern to poetry works to illumine that which is *not* already consciously known (but

[66] See "On Analogy," Appendix II of *DK*, pp. 418-421, for a discussion of various types of analogy, including "analogy of proper proportionality," which is the one referred to above. The origins of this particular notion of analogy can be found in Aquinas' analogy *secundum intentionem et secundum esse*. See *In I Sent*. 19, 5, 2, ad 1. Also see the treatment of analogy above, Chapter II.

[67] The *tenor* in I. A. Richards' terms.

[68] Richards' *vehicle*.

[69] See "On Analogy," p. 419 for a discussion of this type of analogy, sometimes called *analogy of improper proportionality*. Note that what has been said above about it mpilies that it can involve a real similarity in things and not just in our way of conceiving and speaking of them. See *S. Th*. I, 1, 9 and ad 2 & 3; I, 18, 1, ad 3; I, 33, 3c; *De. Ver*. II, 11; *CI*, p. 155. See also Anderson, *Bond of Being* (St. Louis, 1949), pp. 167-207.

[70] *CI*, p. 94; see also p. 124. It might be noted here that the *symbol* is defined by Maritain as a sign-image, "something sensible *signifying* an object by reason of a presupposed relationship of *analogy*." (S & S, p. 219).

which is latent in the experience) and by a connection which is not conceptual. Poetic intuition stirs the images which are irradiated by Illuminating Intelligence, but they keep "their own wild life, beneath the threshold of the abstractive process of formation of ideas." The image becomes a vehicle of an intelligible meaning but one which is not grasped conceptually.[71] In taking to itself the latter kind of image, creative knowledge is the more free; it is at liberty to range over any likeness rather than just those susceptible of being formulated in concepts.

Now the brief selection from Maritain just previously introduced concerning the infinite mirrors of analogy indicates that these likenesses do not stop at any certain point – one thing suggests others and still others; and perhaps what is suggested, because of its likenesses to other things, is itself rich with these meanings available in the original experience for intuitive grasp as well. This non-discursive expansion can continue indefinitely in the poet's concrete vision of things as they affect him in the receptivity which is peculiarly his as a poet. (This extending process, of course, could obtain in the other contacts and relationships previously discussed as well as in analogical likenesses.)[72] In the case of metaphorical analogy, it would seem that poetic expression mentions *some* of the elements which are present, in order to illumine others. Thus A's being contained in an intuition may call up B, and B (the vehicle) may be used in the expression of the intuition to illumine A (the tenor).[73] But what Maritain implies is that many things may be present in the artist's vision and in the reader's or spectator's experience of the work – because of the mirroring effect of poetic intuition –

[71] *CI*, p. 227. See *CI*, pp. 224-232 for a full treatment, with illustrations, of the illuminating image.

[72] Yeats' "A Prayer for My Daughter," for example, contains a progression from the threatening wind screaming on the tower to the sea to which the wind is both spatially and causally related. This place of origins – primitive, wild, irrational, and characterized paradoxically by "murderous innocence" – leads by a metaphorical likeness to a savage society. These meanings become concentrated in "Dancing to a frenzied drum" and, together with all that this latter suggests, are used to illumine the future years, which figure in the statement about *being* that the poem in its concrete ways is. In the abstract we can speak of it as a presentation of the One and the Many in the temporal order – i.e., of the problem of the retention of identity by a person or a society amid the flux of uncivilizing, destructive, dispersing influences. But the poem works in the concrete, and through the mirrors of analogy the sea wind, the tower, and the rooted laurel tree in their diffuse correspondences become some of the means by which the whole range of reality in its constancy and its mutability are present.

[73] See *CI*, pp. 144, 167, 224-232. Also see pp. 323, n. 10; 167 for a treatment of the use of the illuminating image in painting.

which are never mentioned and yet which nevertheless subtly assert somehow their presence in the formation of the work.[74]

c. Lastly poetic intuition "extends to the infinite" in tending toward

the other realities, all the other aspects or fructifications of being, scattered in the entire world, which have in themselves the wherewithal to found some ideal relation with this singular existing thing, and which it conveys to the mind, by the very fact that it is grasped through its union with, and resonance in, subjectivity spiritually awakened.[75]

In this passage the key features are the notion of "ideal relation" and the emphasis on the fact that the singular thing the knowing of which makes present something else evokes the other because of its union with *subjectivity*. So far, we have been discussing the "existential relations" which a concrete thing has with others. As these have been interpreted, they are real relations which obtain independently of the relata being known. Now Maritain introduces relations which are present only in knowing, connections which in the case of poetry are made because of the associations either in the mind of the poet alone or in the collective mind of the whole culture in which the poet lives. Thus a statue of a Greek god may arise from poetic experience in which the depictable attributes of the deity are thoroughly enmeshed with the world of the poet; these connections can be regarded as mind-dependent since they are contingent entirely upon belief and the collective associations which stem from it. Allusions to legends, literary works, and certain elements in literary works could also be construed to fall in this category. In "The Love Song of J. Alfred Prufrock," for example, the speaker's situation is illuminated by a comparison with Hamlet and Polonius.[76] We are speaking here of things having only an intentional existence; yet they may very well enter into the complex of relations which things as known can have. Something real can be associated with a fictional situation and, through the meaning it acquires thereby, become related to something else with which it would not otherwise be associated – as for example an embroidered handkerchief might.

12. Poetic experience has been described as expansive to the infinite.[77]

[74] See *CI*, pp. 225-229 for a discussion of some psychological aspects of the use of imagery in fine art.

[75] *CI*, pp. 91-92. See above, this chapter #10, for the passage of which this is a part.

[76] See Pepper, "The Work of Art from a Double Dispositional Base," pp. 424-425 for a brief statement on the historical meaning of cultural symbols in the setting in which the work of art is produced.

[77] Maritain has the poet as poem-writer uppermost in mind with regard to this notion since a writer of poems is not so confined in his encounter with things as the painter is. Still,

To have it is

> To see a World in a Grain of Sand
> And a Heaven in a Wild Flower.

Speaking of the work produced under its influence, Maritain says that it will present at the same time as itself something other than itself and "at the furthest limit, the entire universe, as if in the mirror of a monad." What we have seen so far suggests how this can be, since a thing is somehow related to everything else – spatially, causally, by likeness or unlikeness, etc.[78]

But Maritain explains the matter in another way as well. Our interpretative work so far, in the interests of clarity, has of necessity had to make the presence of these boundless meanings in poetic intuition seem much more rigidly fixed, conscious, and elaborated than Maritain thinks they are. However, illustrating his point with such contemporary poets as Jean Cocteau, Dylan Thomas, and Wallace Stevens, Maritain notes that certain poems or passages of poems convey little intelligible sense. We are aware that they signify, but what is meant is not

what he says applies also to the painter. The latter must look into things through the aperture of visible appearances; nevertheless the same secret meanings are there but "more obscurely, and only in the manner of resonances or overtones." (*CI*, pp. 94-95).

[78] *SP*, p. 84. Although Maritain uses the expression "mirror in a monad" in describing an "object" of poetic intuition, he does not develop the notion to any extent beyond what has been presented so far. His logic and metaphysics are certainly not Leibnizian (nor Whiteheadian). One entity is not everything else, nor is it formally constituted by its relations to other things. (A thing, for him, is determined by its *own* entitative form, which is something positive, and not by relations to what, in the world, is other than it. See *PM*, p. 141). At the same time any given thing is involved in a tissue of relationships with everything else (which may serve to explain how the thing became what it is or which result from what the thing is but which do not constitute it to be what it is); and an apprehension of it in its concreteness must take it in its setting. Because of this relatedness, a given thing can function as a sign for all that to which it is related. (Just as smoke is a sign of fire because fire stands in a causal relation to smoke). Thus provided I know something about the world of which a given concrete thing is a part, to apprehend the thing is to awaken in however slight a degree the meaning of it as it occupies a place in the world (As, e.g., I must know the relation of smoke to fire in order to be aware of fire in the experience of smoke. See above, Chapter III, on the *virtual* presence of the meaning in a sign). This being so, even on a more prosaic, surface level I am always aware of its global setting when narrowly preoccupied with some object.

It would seem to follow from the views of Maritain under examination that since any concrete thing can function as a sign of all that to which it is related, these latter must be present in it. This presence is not an *entitative* one, nor even an *actual, intentional* one – the thing is not in any sense a perception of the universe. Rather it is, as in the statue of Socrates, a *virtual intentional* presence only, for it requires *other* entities, namely knowers, to actualize these latent meanings. Taken in this highly qualified sense, then, we can say that for Maritain any concrete thing is among other things the universe from a perspective, or perhaps a perspective on the universe. In its manifold relationships it can be a means of opening up that universe in the depth of some of its meaning for poetic knowledge.

known. This is almost to say that it is the unknown that is signified. Certain ritual dances are also mentioned in this connection.

> The essential thing is that there should be a sign and signification. If I do not know exactly what a given sign signifies, well, it is then free to signify *everything* for me. In a sense, poetical joy and affective exaltation will then only become vaster in becoming more indeterminate.[79]

A work may present itself as having significance but resist the claims of any definite meaning. We might say that since its sense is not restricted it has a sort of "transcendental meaning," a signifying of everything.

13. At the outermost edges of this nebulous significance Maritain places God. It is not that this is a conscious meaning in the experience as expressed in the work nor that poetic experience is a form of mystical experience but that it is an "advance toward God." How is this possible? In *Approaches to God* Maritain states that the artist is held "in the grip of a twofold absolute...," the "demands of that beauty which must pass into his work, and the demands of that poetry which incites him to create."[80] With respect to *beauty*, Chapter II has already shown how for Maritain the experience of it can lead beyond that which is immediately encountered as beautiful. Beautiful things give joy to the mind; but in their flaws and limitations as they confront our longing for an unalloyed delight, they turn us in the direction of that which can give complete joy, a perfect and unlimited beauty. This tendency is present especially in the artist, who is devoted to the discernment and the creation of beauty, though not necessarily in a conscious way. Regarding *poetry*, Maritain observes that rather than being mystical experience, "It is concerned with the created world and with the innumerable enigmatic relations of beings with one another...," with the "intercommunion of things with themselves and with the subjectivity they reveal." Still, though it is a "blind man's glance," the poet sees into things and his gaze "meets, at the bosom of the created the glance of God." Thus we read that "...many poets are convinced that all poetry is religious by essence, though they hardly believe in God or confuse Him with nature." The poet can turn aside from such enigmatic reflections in the mirrors, but even so he cannot free himself

[79] *CI*, pp. 198-199. Elsewhere he says, "Unexpressed significance, unexpressed meanings, more or less unconsciously putting pressure on the mind, play an important part in aesthetic feeling and the perception of beauty." (*CI*, p. 8. See also pp. 6-9).
[80] P. 79.

from "every metaphysical anguish or passion." "...the nostalgia for God whom he has rejected remains immanent in the poetic experience itself, whether he wills it or not." Even from Lautréamont evidence is introduced in support of this contention.[81]

In spite of all his qualifications and restrictions, these claims for poetic knowledge may seem somewhat strong, and one can question whether it is as encompassing as Maritain maintains. A theist, for whom the meanings attributed by Maritain to poetic experience indeed belong to the world, might well object that the world which is exposed in the expression of poetic intuition is not *the* world but rather the *world of the poet* since poetic experience is of things as resounding in subjectivity. Perhaps there are none of the ultimate meanings in a given poet's world that Maritain thinks there should be.[82] Or if there

[81] *AG*, pp. 79-83; "The Natural Mystical Experience and the Void," p. 263; *Art and Faith*, p. 90.
Something of the same idea as Maritain's is contained in Clive Bell's "Metaphysical Hypothesis." Bell suggests that some arrangements and combinations of form move us because they express the emotion of the artist, while others do not. The former are "significant forms." Such structures are so called because they arise from the artist's own experience of the formal significance in material things. Things have a meaning as a means for practical activity; but they also can be regarded as pure forms, which is to say as ends-in-themselves. To consider something in this way is to see it in its meaning as a "thing in itself" or as "ultimate reality." Hence the artist can feel a certain emotion for pure form which he transmits through the work, expressing it by means of pure form, however different the latter may be from that which was originally experienced.
Thus significant form is "form behind which we catch a sense of ultimate reality," and the artist's emotion in virtue of which the work has this form is the emotion "felt for reality revealing itself through pure form." The one explanation Bell gives of what he means by 'ultimate reality' is the following: "... when we consider anything as an end in itself we become aware of that in it which is of greater moment than any qualities it may have acquired from keeping company with human beings. Instead of recognizing its accidental and conditioned importance, we become aware of its essential reality, of the God in everything, of the universal in the particular, of the all-pervading rhythm." (C. Bell, *Art*, Chapter 3). Thus, for Bell as for Maritain there is on the part of the artist an awareness of the significance of things in terms of ultimates, and – in Bell's words – it is "a more or less unconscious apprehension of this latent reality of material things." Maritain however, as we have seen, holds that the poet divines this meaning (and expresses it) not just by pure form but also through anything or everything that things are which lend themselves to this purpose. Further, Maritain would grant that aesthetic or poetic contemplation is disinterested, but this does not at all imply that the significance things have as means in a human context must be ignored. Rather it has to do with the attitude of the contemplator toward such objects so regarded, as we have noted in Chapter II. Hence for Maritain the artist does not turn from but utilizes to the fullest extent the meanings which forms can represent.
Bell's view about the irrelevance of representation in art was pointed out earlier. Of this doctrine, which is part of his "Aesthetic Hypothesis," he is quite certain. The "Metaphysical Hypothesis," in contrast, is proposed as little more than a conjecture.
[82] This is one reason a person cannot really say that a work of fine art, if it has been produced honestly, does not in its own imaginative way truly reflect how things are, or that some works of art contradict one another. The world that each brings forth is the one refracted at some particular moment by the subjectivity of the individual artist, and that world may be truly reflected regardless of how things are in themselves or how they affect someone else.

are, one might question whether the "echoing power" of the intuition and the work extends that far. Must ultimates have any relevant presence in, for example, "Upon Julia's Clothes"? Certainly they need not be there in any clear or explicit way. The divine might perhaps be felt in it only as the limit of the meaning it has, or the unspecified value in the context of which certain human actions and attitudes are set. Accordingly, this presence might well be there by its very absence. The characters in a film may lead lives apparently devoid of any meaning and purpose, becoming increasingly vice-ridden and miserable in their futile attempts to escape boredom. The beholder perhaps will feel in the experience of this by way of contrast or in its absence some sort of cosmic meaning or purpose which might make a difference in the situation depicted, regardless of his beliefs in the matter.

Actually for our purposes – as we shall see before long – the ontological status of the work is affected by whether there must *be* poetic meaning present in a work of fine art but not by how extensive that meaning is. Consequently the position we are attempting to discover does not stand or fall on whether Maritain is correct in his views about poetic meaning extending as far as to the infinite or as somehow involving God.

THE TERMINATION OF POETIC INTUITION IN A WORK MADE

14. For Maritain poetic intuition like intellection generally comes to full consciousness only in the expression of it. But the expression of poetic experience must be an external one, a work made. In this regard we have already noted the analogy of the work to the *species expressa*, mental word, or concept in the Scholastic tradition.[83] The need for this externalization is supported by several explanations which Maritain gives, among which are the following:

a. Poetic intuition grasps subjectivity as such, and this can be accomplished only in terms of the subject's being "a center of productive vitality." But such an experience will, just because it apprehends subjectivity in this way, be a stimulus or fecundation of that very productive vitality; and hence it will necessarily be a creative, formative experience.[84] However, this line of explanation, found in *The Situation of Poetry* and "Poetic Experience," is not put forth in the more recent and expanded treatment of the subject, namely *Creative Intuition*, per-

[83] See *SP*, p. 77.
[84] *Ibid.*, pp. 73-74; PE, pp. 393-394.

haps because of its seemingly rather gratuitous character. Consequent-
ly I shall not dwell further on it.

b. In poetic intuition things are grasped in union with or as affecting
the subjectivity of the poet rather than as standing as an object over
and against the subject. There is no abstraction in it from the indi-
vidual subject. In fact, it is subjectivity as such that is principally
manifested in poetic knowledge,[85] and subjectivity cannot be concep-
tualized. At the same time poetic experience we have seen to be intel-
lectual, and intelligence is by nature expressive. It is only in expressing
or producing the mental word, for example, that intelligence can know
an object. Now since the intuition cannot be expressed abstractly
through concepts, it must be accomplished concretely in matter.[86]

c. Poetic intuition is in no way a model of which the external object
is merely a copy or – as Croce holds – a monument to preserve it. This is
the explanation of the point under examination which is given the most
prominence in *Creative Intuition*, dominating the whole of the section
"Poetic Intuition as Creative"; hence it is the one we shall focus on.
Maritain explains that not even the craftsman's "creative idea" is a
model to copy; it is not a concept since it does not represent nor is a
means of knowing. It is purely generative rather than cognitive. "The
craftsman's creative idea is an intellectual form, or a spiritual matrix,
containing implicitly, in its complex unity, the thing which, perhaps
for the first time, will be brought into actual existence." Now Maritain
observes that not only has the craftsman's idea been wrongly given a
cognitive emphasis, but also it has been taken over from the useful into
the fine arts wherein it is held to be "an ideal model sitting for the artist
in his own brain, the work supposedly being a copy or portrait of it.
This would make of art a cemetery of imitations."[87] Maritain does
concede to the view he is opposing that poetic intuition is "full and
complete" from the beginning; all the vitality and insight is given in
advance. If it is to be the meaning and form structuring and unifying
the work, it assuredly must in some sense have a completeness about
it from the start, "whatever part adventitious chance may have in the
development." This requirement is analogous to that in the useful arts,
wherein the need-to-be-satisfied which organizes the work is present in
its integrity from the first. But the meaning is hidden; "all that which

[85] *SP*, pp. 73-74.
[86] *Ibid.*, pp. 73-74, 83-84; PE, pp. 388, 394.
[87] *CI*, p. 100.

will be manifested in operation was already there, but we knew it not."[88] Thus it must be said that this containment of the whole of the work is only one of *virtuality*.[89] The painter may have the urge to paint and something to say, but he is not really conscious of what it is that is there until the work takes shape. It requires the "steady labor of intelligence intent on the elaboration of the form" to unfold this virtuality and bring it to a state of actualization. As virtual, poetic knowledge is preliminary to the work; but as actual it is *one* with creative activity, "consubstantial with the movement toward the work..."[90] Thus if we wish to speak of a creative *idea* [a phrase which belongs rather with the useful arts] in connection with poetic intuition, it can be regarded as complete only when the work is finished. It has to be worked out. As Maritain puts the case in *Art and Poetry*, the work is not the *copy* but the *body* of the artist's ideas. When the work is finished, the idea is finished with respect to its expressibility, the details of its determinations, and its contours.

A model to copy? The creative idea is an intuitive flash (given at one stroke but unexpressed, and without contours) in which the whole work is potentially [i.e., *virtually* as he puts it in *Creative Intuition*] contained and which will unfold and explain itself in the work, and which will make of the work itself an original and a model...[91]

Consider the use of metaphor in poem-writing, for example, and the fact that the poet need not compare two already known things metaphorically. Through the very process of creating, something which is contained as unknown in the obscurity of emotive intuition may be brought to light and expressed by means of what is already known. Only then and by the same stroke is the likeness uncovered.[92]

Actually this third approach seems to be more a description of human creative experience than an argument, at least with regard to the necessity to create or work something out in order to bring inspiration to light. Have we any evidence that artists visualize something in the imagination and then simply copy it onto the canvas? Maritain's other explanations for the necessity of externalizing the work depend for their

[88] *CI*, pp. 38-39, 99; Raissa Maritain, "Sens et Non-Sens en Poesie" as quoted by J. Maritain in *AG*, p. 81.

[89] *CI*, pp. 98-99, 103; PE, p. 394. See above, Chapter III, #5 for Maritain's use of 'virtuality'.

[90] It is with this distinction in mind that we must understand some apparently conflicting statements on this score. See PE, pp. 394, 395; *SP*, pp. 51, 74; *CI*, pp. 98-99; OHK, p. 18.

[91] *Art and Poetry*, p. 80.

[92] *CI*, p. 228; see Grace, pp. 492-493.

validity on whether his views on the intuitive process itself are correct, but this approach is not only independent of such views but also is more convincing in its immediacy. It would seem that there *is* indeed a form of experience which cannot in its depth and complexity be conceptualized nor imagined but which can be expressed (and is essentially oriented to being expressed) in an existing material thing[93] having all the concreteness, ambiguity, and multiplicity of facets the experience demands. There are other ways of knowing, but that there is – at least in some persons – a knowing which is oriented to creation-in-matter seems to be a fact. For Maritain it is the formation of the work through this kind of vision that essentially constitutes a work of fine art.

15. If Maritain's description of aesthetic and creative experience in these questions is correct, clearly Croce's account – with its idea that the work of fine art as expression has its existence in the imagination – will be less than completely accurate. Maritain can agree that artistic inspiration is gratuitous; but to express it, for him, requires all the resources at the disposal of practical activity in the line of art.[94] The closest Croce comes to this view is his allowing that a painter may make a stroke not to externalize his expression but as a "kind of experiment and in order to have a point of departure for further meditation and internal concentration." This statement must, of course, be weighed in the light of its context. In what immediately precedes it, for example, Croce claims that it would be a superficial way of understanding artistic procedure to suppose that the "artist creates his expressions by painting or by sculpturing." Rather, "the artist... never in reality makes a stroke with his brush without having previously seen it with his imagination..." *If* he has not seen it, he will make the stroke as an experiment.[95] From Maritain's point of view, however, a rather constant interchange between the artist and what comes to be on the canvas is required to realize or bring to light what is seminally in his vision. Hence it is not just a matter of simple "aesthetic vision" which takes shape in consciousness without any deliberative and volitional activity adapting means to its expression.[96] Poetic inspiration is not

[93] Here what is primarily in mind, of course, are visual art works, the ontology of which forms the focus of this study.
[94] "Technique" for Croce. See Croce, pp. 111-112.
[95] Croce, p. 103.
[96] See *ibid.*, pp. 50, 51, and Chapter 15; *CI*, p. 40.

primarily knowledge; it is rather a "minimum of knowledge but a maximum of germinal virtuality..."[97]

While it is true in poem-writing that the poet can compose his work mentally, using and remembering verbal symbols to fix the poem, still as in the other fine arts the poem must be *worked out* with all the resources of art at the disposal of the poet – it is not *actually* given all at once in a simple *cognitive* vision. Furthermore, what is in the poet's imagination is not the poem as actually sounding, in all the complexities and nuances of a given performance of it.[98]

In the case of the visual arts the working out of the artist's vision does not for Maritain occur in the imagination.[99] It seems to be a matter of immediate aesthetic experience in these arts that the work has all the color and its variations, the texture, solidity, and density which comes from being material.[100] The form and the qualities organized by it present themselves as the structure and characteristics of a *material* which is susceptible of such a form, even though the form gives to the work meaning which transcends mere physical structure. We might add that the qualities of the material cannot be represented by the imagination in any detail approaching the visual perception of them (particularly with regard to irregularities of texture), and there are no symbols which could be used with any adequacy as counters to fix them.[101] Furthermore the skill of the artist, the behavior of the

[97] PE, p. 394; Croce, p. 17.

[98] *DK*, p. 397; *CI*, p. 191. Maritain does not really discuss the differences between the various art forms in this regard, nor does he take up the problem of whether a poem or musical composition is anything apart from its performances.

[99] See *DK*, p. 397.

[100] Heidegger, in the "Origin of the Work of Art," observes that while in utensils the material is used up or disappears into the serviceability of the implement (i.e., the material is totally taken up by or oriented to the use), in a work it comes forth and takes on a value of its own. Although the work exposes a world, it is not just an openness; there is also an opacity, an undisclosability, in which or upon which the openness is rooted, viz. the Earth or material basis of the work. The world is grounded on the Earth, giving it a locus; and the Earth rises into or appears in the world. So Heidegger says that the essential traits of a work are to expose a world and also to *compose the earth*. We have already referred to the former aspect of the work of Heidegger (this chapter, n. 63), and by the latter he means that the earth is brought into openness of the world as the self-enclosing. This is to say that the material is made to come forth but to appear in its density and resistance to penetration by thought. ["Origin..." pp. 669-676; see T. Langan, *The Meaning of Heidegger* (New York, 1959), pp. 199-200].

Heidegger's view seems to be broadly similar to what Maritain is describing. It is an existential or embodied meaning with which the poet is concerned. The work is a tension of obscurity and clarity or a clarity shining through matter so that it is not entirely open to human cognition. It retains the ambiguities of poetic experience, and as an existential rather than a purely intentional expression of the artist's vision it is enabled to take on this vision's vastness and diffusiveness of meaning.

[101] Also, it does not seem entirely in keeping with the imaginative visual phenomenon to regard it as a picture.

material, and chance seem to play a large part in what the work turns out to be. Thus, in the visual arts not only is the artist's intuition not to be looked upon as a cognitive vision of the work but also – and as a matter of what seems to be common experience – it must be worked out in the only place it can be, the materials whose qualities are to be structured in the work.

Thus for Maritain the expressive externalizing process is not primarily – as it is for Croce – born out of a need or desire to *communicate* to others the artist's vision but out of a need to bring it to a state of conscious realization for the artist himself. This is not to deny the very real need to communicate nor to deny that communication is possible.[102] But it is to say that (in the visual arts especially) the work of fine art, which in order to be such must receive its form and meaning from poetic intuition, will be a physical thing since this is the way poetic knowledge is expressed. And yet it will have a meaning – derived from this knowing – which surpasses that of physical organization.

[102] The artist's vision *is* for Maritain communicated in the work. See *CI*, pp. 208-209; *SP*, p. 49.

CONCLUSION – MARITAIN AND SOME CONTEMPORARY VIEWS

1. Any determination of the ontology of a work will of course depend on what is denoted by 'work'. Maritain has indicated that while no exact delineation is possible, 'work of fine art' is applied to human artifacts which succeed more in being a good in themselves. In their production the primary rule is not some consideration extrinsic to the work, a need to be served; no craftsman's creative idea formulated in terms of utility will function as the "spiritual germ" of the work. Instead the work will be an autonomous world of its own; and its germinal principle will be poetic intuition,[1] which gives a work a wealth of meaning simply for display in the work itself. It is this manner in which productivity is fecundated that perhaps best distinguishes in Maritain's later thought the work of fine art from all others, since this is the most basic element in the distinction. The result is that what is produced is resplendent with intelligibility (or perhaps, intelligible mystery) and is only for contemplation. While everything for Maritain is beautiful in some measure, to differentiate fine art as Maritain has done is also to say that it is essentially oriented toward beauty. That is, fine art aims to produce something which is valued only in its contemplation and which is radiant with meaning[2] available for aesthetic encounter.

The dominance by poetry and the abundant presence of beauty, which issues from this control, characterizes then the work of fine art. As a result, the ontology of the work can be approached either through beauty or through poetry. In Chapter II, following the lead of Maritain's earlier approach, which emphasized the orientation to beauty as the differentiating factor, we have explored the ontology of the work in terms of this determinant; and in Chapter IV we have done the same thing with respect to the determinant poetry. We need not here give

[1] *CI*, p. 100.
[2] I.e., has clarity.

an extensive review of all these findings; rather, in addition to casting a synoptic glance at some of them, we can draw them together by showing how Maritain's views may be situated with respect to certain of the contemporary discussions about the status of the work. In doing this, I will indicate what in his thought seems capable of making a distinctive, and I believe hitherto unnoticed, contribution to the present state of the question.

2. In both the approach through beauty and the one through poetry Maritain maintains that the work – in the visual arts at least – on which we have chosen to focus attention in this study – is a physical object and yet that it transcends the status of being merely a material-thing-in-a-genus. With respect to the work's being a physical object, the approach through *beauty* would maintain that the beauty which is connatural to humans is concrete and intuitable through the senses. And since what is intended through the senses are physical objects, the work must be such. Maritain's metaphysics of the beautiful provides other reasons which bolster this position, but these are not explicitly employed by him in his works on fine art with regard to this point. Against what he does have to say about it, Croce's position could be urged – that the work as beautiful is concrete, experienced only in an intuition, which is of individuals in their appearances, but none the less is an imaginative formation, whatever the role of physical objects may have been as a stimulus. On the *poetic* approach to the work's being a physical object, Maritain shows that to be expressed poetic vision must be externalized in matter; and this line of thought together with his realistic epistemology gives a much firmer base for opposing Croce and such idealist-tending views as those of Stephen Pepper.

With regard to the work's transcending its status as a self-enclosed thing, the conception of the work as essentially oriented to beauty would proceed against the background of a rather complex Thomistic metaphysical structure, which has in part been traced in Chapter II. It would hold that beauty being a transcendental, the work will have correspondences with other beautiful things including complete, unalloyed Beauty.[3] Further, as Chapter III has shown, a work oriented to beauty must have a superabundance of intelligibility, which can come upon it only if it represents. In that event it will have – on Mari-

[3] See above, Chapter II; *A & S*, p. 33.

tain's analysis of the ontology of signs – an augmented, intentional character in virtue of which we could indeed say that it transcends its status as a self-enclosed material thing. Thus, whether the work actually mirrors infinite beauty or not, if Maritain's views in Chapter III about representation can be supported, it will truly surpass its own thing-like character.

Finally, Chapter IV, exploring the kind of meaning which poetry gives the work, has shown that whenever poetry is present, what is produced under this influence will have a significance or intelligibility structuring it that causes it illimitably to spill out of the confines of what it is as a physical artifact. But it nevertheless remains rooted in and identified with this artifact since the latter is not just a vehicle of the meaning. Rather the meaning is embodied in the work which displays it as an autonomous intelligible microcosmos.

> Be it a painting or a poem, this work is a made object – in it alone does poetic intuition come to objectivization. And it must always preserve its own consistence and value as an *object*. But at the same time it is a sign – both a *direct* sign of the secrets perceived in things, of some irrecusable truth of nature or adventure caught in the great universe, and a *reversed sign* of the subjective universe of the poet, of his substantial Self obscurely revealed. Just as things grasped by poetic intuition abound in significance, just as being swarms with signs, so the work also will swarm with meanings, and will say more than it is, and will deliver to the mind, at one stroke, the universe in a human countenance.[4]

3. Basically, then, a work such as a painting or a sculpture must be physical, and it must in some way represent or be significant of something other than what it is as a material object. The view that (a) it is physical and (b) it represents is not at all startling or new; and this much, to whatever extent it may be opposed in some quarters, represents no real contribution to the problem. Of course, Maritain's doctrine of creative intuition and its implications for the matters now under consideration represents a real addition to aesthetic speculation and has been widely recognized – if not in terms of its bearing on the ontology of the work, at least for its insights into poetic cognition and the type of meaning which it expresses. But a factor that seems to have gone virtually unnoticed and that is of rather striking significance in the present context is Maritain's theory of signs. Now actually he does not enter into the contemporary debate on the status of the work nor treat of it in any systematic way[5]; yet his thought is capable of

[4] *CI*, p. 93.

[5] In fact, as stated earlier the whole project of this book has largely been to trace out the implications and presuppositions of Maritain's views which bear on the problem in order to

making a decided contribution to it not only with respect to the impli-
cations of his poetic theory which we have already examined in Chapter
IV but also, I shall contend, with respect to his view of signs. We can
perhaps best show this by looking at some representative contemporary
views insofar as they are affected by an explicit or implied theory of
signs (or lack of it), observing how the rather precise position that
results from Maritain's conception of signs fits into this network of
views and at the same time how well it squares with our immediate
experience of works of art.

Maritain's position can be summarily formulated by saying that
aesthetic experience of a work of fine art:

(1) is immediate, direct, or intuitive;

(2) is
 (a) of that which has to some degree a sign character, and
 (b) of that which, as signified, can be present other than phy-
 sically or "entitatively";[6]

(3) is of a physical, produced object which has its meaning embodied
in it rather than separated from it, so that the experience of the work
is the experience of the produced object and not of some ideal or other
entity which it conveys or suggests.[7]

4. On the whole these propositions seem intuitively to accord with
aesthetic experience. What is of interest, however, is that theoretical
difficulties or perhaps even the lack of a highly developed sign theory
has caused some contemporary thinkers to deny or place into doubt
certain of these propositions as a result of the others. That is, there
appears to be some incompatibility or tension among them. Thus (1)
seems to be beyond question, but because of it (2) is called into ques-
tion in some quarters for one reason or another.

The immediacy of aesthetic experience causes C. W. Morris, for ex-
ample, to deny (2b). He holds that *values*, which are for him the most
important thing signified in aesthetic "discourse," must be physically
present or exemplified by the sign vehicle (produced object) rather
than merely signified by it. Aesthetic experience must be immediately
consummatory; that is, aesthetic interest must be fulfilled or terminate

determine that there *is* any consistent stance on Maritain's part regarding the status of the
work.

 [6] In addition to the purely sensory qualities of the work, which are physically present.

 [7] In the context of Maritain's realism there is no need to separate (1) and (3). But in an
idealist position such as Croce's (1) does not imply (3).

in what is directly given.[8] In order for this to take place it is the pro-
duced object which must satisfy the experience; what is only signified
by it can have no place in the process. Thus the signified values are
aesthetically relevant only if the produced work itself as a sign vehicle
embodies or exemplifies them as well as signifying them. But how can
this be?

First of all, for Morris the signs used in fine art are largely *iconic*,
which is to say that the sign has to some degree or another the pro-
perties of what it denotes[9]; and while what is signified may have pro-
perties other than those of the produced work or sign vehicle,[10] what
is immediate and relevant in aesthetic experience would seem to be the
properties of the signified which are actually physically embodied in
the sign as iconic of its denotatum. It is this actual embodiment of the
characters of what is denoted which constitutes the imitative nature of
art for Morris. But because the sign is not fully iconic of its object or
denotatum (if it were, it would *be* the object), Morris holds that not
everything which a painting, for example, designates is there in it for
direct inspection. In short, what Morris is claiming is that it is only of
those properties of the object which are signified directly in virtue of
the iconicity of the sign – which are, that is, physically embodied in the
work – that one can be immediately aware.[11] In this regard Morris
speaks of both a mediated and an immediate taking account of these
properties, as both *signified* and actually present in the sign vehicle
physically.[12]

Further, looking more fully at a point alluded to above, we note that
for Morris the denotata of aesthetic signs are at least for the most part

[8] See Dewey, *Art as Experience* (New York, 1934), pp. 14-17, 35-38, 41, 55, 56 and *passim.*;
R. B. Perry, *General Theory of Value* (Cambridge, 1926), Chapter 5, for discussions of *con-
summatory experience* and *interest*.

[9] C. W. Morris, *Signs, Language, and Behavior* (New York, 1946), p. 191. See above, Chap-
ter III, n. 75, for a discussion of iconicity. Morris defines an iconic sign in his glossary to
Signs, Language, and Behavior as follows: "A sign is iconic to the extent to which it itself has
the properties of its denotata; otherwise non-iconic." (p. 349; see Peirce, "Logic as Semiotic:
The Theory of Signs," p. 102).

[10] Morris distinguishes the *aesthetic sign* from the *aesthetic sign vehicle* following Dewey's
distinction of *work of art*, which is active and experienced, from the *art product*, which is
physical and potential. [Morris, "Esthetics and the Theory of Signs," *Journal of Unified
Science*, 8 (1939), 132; see Dewey, p. 162]. Thus, though he does not make the work of art or
aesthetic sign mental, Morris says that it "exists only in a process of interpretation which may
be called esthetic perception." In his rather lucid article, "Science, Art, and Technology,"
(reprinted in Vivas and Krieger, *The Problems of Aesthetics*, pp. 105-115) Morris tends to slur
over the distinction; and I shall follow this practice here since for the purposes of this expo-
sition it is not crucial.

[11] "Esthetics and the Theory of Signs," pp. 136-137, 139.

[12] I.e., as exemplified by it or, in Maritain's language, as "entitatively" present.

values or value properties, which are properties "of an object or situation relative to an interest – namely, the property of satisfying or consummating an act which requires an object with such a property for its completion."[13] Morris says that though they are relative to an interest, value properties like any other attributes can be had by objects, which can be "insipid, sublime, menacing, oppressive, or gay in some contexts..." Now the aesthetic media themselves can embody certain of these properties depending on the character of the particular medium. Hence Morris tells us that

the artist is one who molds some medium so that it takes on the value of some significant experience... The work of art is a sign which designates the value or value structure in question, but has the peculiarity, as an iconic sign, that in spite of its generality of reference, the value it designates is embodied in the work itself, so that in perceiving a work of art *one perceives directly a value structure and need not be concerned with other objects* which the aesthetic sign might denote... Art is the language for the communication of values.[14]

Consequently, Morris says that the sign vehicle is not to be looked upon as an instrument to direct one to something else with the shared property nor as an occasion for a reverie or contemplation of the value apart from the sign; rather aesthetic perception is focused upon objects, and what these objects signify is discerned – if only partially – in the very objects themselves. Thus, in holding (1) Morris is affirming (3) as well, albeit in a much stricter sense than Maritain. And because the value the object signifies is physically embodied in this very object, the experience of it will be a consummatory one.[15]

Such in brief is Morris' position on the issue,[16] and a reflection on it reveals that it turns on an ambiguity concerning the word 'immediate'. What is at work here is the assumption that the mediation brought about by being signified causes the experience of the signified not to be

[13] "Esthetics and the Theory of Signs," p. 134.

[14] Vivas and Krieger, pp. 109-110; italics mine. See also "Esthetics and the Theory of Signs," p. 139; Benbow Ritchie, "The Formal Structure of the Aesthetic Object," in Vivas and Krieger, p. 230.

[15] But Morris allows that since there may be more signified than is physically present in the work of art, it is still a sign. "Esthetics and the Theory of Signs," pp. 139, 145-146; see Ritchie, p. 232. See also *Signs, Language, and Behavior*, p. 195.

[16] See Morris' more recent *Signification and Significance* (Cambridge, Massachusetts, 1964), pp. 65-72, where he reexamines his widely discussed position presented in 1939. It appears that he is now less certain of some aspects of it, especially those having most directly to do with aesthetics as a branch of semiotic and with the uniqueness of aesthetic signs. The features of his views which are presented above, however, are not rejected in this book although the idea central in the above account, namely that art is the embodiment of signified value, is illustrated in what seems to be a less defensible way than in the earlier statement. (See p. 71).

immediate or intuitive. Morris wants to save the obviously direct char-
acter of aesthetic experience as well as the equally obvious feature of
it as encountering a physical object with its perceptual properties,
rather than passing such an object by for something beyond it to which
it points.[17] To do this while maintaining his central thesis that aesthe-
tic experience is a form of semiosis (that is, a sign process),[18] he seems
to think he must hold that what is aesthetically relevant or consumma-
tory is physically embodied in the sign vehicle itself. Otherwise it can-
not be *in* the sign vehicle in any way and thus not immediately ex-
perienced in the experience of the latter.

5. Richard Rudner, opposing Morris but working on the basis of a
similar confusion, also denies (2) in order to save (1) and (3); but in
his case it is (2) in its entirety which is rejected. The work as such is
not of a sign character at all. He argues against Morris that there can-
not be at once a mediated and an immediate taking account of the
same properties. If semiosis is by definition a mediated taking account
of, then "insofar as we are taking immediate account of the value pro-
perties of an aesthetic object, it is not functioning as a sign." Now
Morris holds that in aesthetic experience the value property is imme-
diately consummatory; consequently, argues Rudner, if we are taking
a *mediated* account of some value property in an aesthetic experience,
the mediating sign cannot be called immediately consummatory as
Morris claims. (Unless one says that something is a sign of itself, and
then an experience of anything would be an experience of a sign signi-
fying itself.) Clearly then, Rudner believes that if one holds (2) he can-
not hold (1). That this is his assumption is made explicit by him more
than once in his statements that he is assuming "immediacy" and
"mediateness" to be mutually exclusive predicates.[19]

Furthermore Rudner denies (2) on the basis of (3). What in ordinary
language is referred to by 'aesthetic object' is, he says, the art work as
natural object. But since he does not see the significance of a sign as
somehow residing *in* it and since it would for him be strange to hold
that the aesthetic object is what is ordinarily called such *plus* what is
signified by it, he denies (2) – that the aesthetically experienced work

[17] See Vivas and Krieger, pp. 109-110.

[18] Morris defines 'semiosis' in his glossary as "a sign process, that is, a process in which
something is a sign to some organism. It is to be distinguished from semiotic as the study of
semiosis."

[19] Richard Rudner, "On Semiotic Aesthetics," *Journal of Aesthetics and Art Criticism*, 10
(September, 1951), 70-71, 73-74.

of art is a sign.[20] Otherwise, he claims, we would have to take account not only of a Bach partita but also of something which the music signifies, as a necessary condition of aesthetic experience.

An analysis which holds that it is not what in ordinary usage we call "the aesthetic object" which consummates aesthetically, but rather something signified by that object or even that object together with what it signifies, seems to me less preferable to a theory which holds that it is what we ordinarily call the aesthetic object which consummates. A semiotic aesthetic could not regard what are ordinarily called "aesthetic objects," e.g., our art works, as consummators. A non-semiotic aesthetic – regardless of the special difficulties it itself encounters[21] – could regard what we ordinarily call "aesthetic objects" as the consummators of aesthetic experience.

Indeed, that the art work arrests us – does not conduce to something beyond itself – does not lead us to take account of anything other than itself, seem to have been the factors which led Morris originally to specify that the art work is an *iconic* sign.[22]

What is immediately consummatory and a part of the aesthetic object, then, is only that which is actually present in the physical art product; and since for Rudner there seems to be no way other than physical embodiment to be present-in, significations are not immediately consummatory nor a part of the aesthetic object and hence not aesthetically relevant.

6. Maritain's sign theory, I believe, offers a way of surmounting the difficulties which are involved in these differences. He would agree that the aesthetic sign *mediates* between what it signifies and the knower in that it is the means by which we become aware of the signified. At the same time, the experience of the significance is *immediate*, but in a different sense, namely that nothing stands between the knower and the known to obscure the known or to serve as a stepping-stone in a discursive gaining of the known. There is no process of inference, and Socrates is seen in the statue directly. In other words, the statue is a *transparent* means,[23] allowing a direct inspection of its meaning. This being the case, Maritain can hold both (1) and the entirety of (2) as against Morris. Something which is not physically present is seen in the work directly as a result of the sign character of the work, and this that is signified is immediately consummatory in the experience of the

[20] The gist of Rudner's argument is that either (1) or (3) implies the denial of (2b), and the denial of (2b) implies the denial of (2a).

[21] Doubtlessly the big difficulty is how to explain away our experience of (2).

[22] Rudner, p. 73.

[23] See *FP*, p. 150. It remains to be seen, however, that it is not *purely* transparent.

work. Maritain's ontological explanation for this view, explored in Chapter III, is that the signified exists in the sign but is not exemplified by it or embodied there "entitatively." Maritain would surely agree with Morris that iconic signs play a central role in a work, but for him the work has aesthetically relevant significances[24] which may be signified by iconic signs but which extend beyond the iconic properties of the physical object. Thus there are for Maritain meanings which are a part of the work of art but which are not exemplified by the sign vehicle or physical object. They are *present* in the sign vehicle, however, in an *intentional* mode of being. And because they are truly there in the physical object, the experience of them is immediate, is a part of the experience of the physical object, and is immediately consummatory. Hence it could be said that the physical object or sign vehicle *embodies* what it represents – Morris would be right in not wanting to deny (3) and go *through* the vehicle to its meaning – but we must say that it does so in a mode of existence other than that possessed by the statue as a physical thing.

Now in the case of an aesthetic, instrumental sign such as a statue, the meaning is not present in it in such a way that the sign is purely transparent. It has a density of its own and is not *just* a means of presentation of a meaning which is entitatively other than or separate from it. Its own qualities and materiality enter in. So if on (2) the meaning is aesthetically relevant or a part of the work, the physical object is still to be considered the work; and (3) need not be called into question. The statue is an object *in* which a wealth of meanings abide.[25] As a mere physical object functioning as a sign it can be said to point *beyond* itself; but it does so in such a way that what is signified is gathered into it rather than it simply emptying itself out in an orientation to something entirely other than it.[26]

The analysis so far, with Morris in mind, also shows how Maritain's views bear on Rudner's position. There are two senses of 'mediate' and of 'immediate', and hence there need not be an opposition between them. Awareness of something signified is mediated by a sign, but this cognition is immediate in the sense that the significance is intuitively given in the perception of the sign. Again, (1) is not a basis for the denial of (2b).

[24] See above, Chapter IV.
[25] Hence the even greater appropriateness here, in speaking of meaning presence, of the word 'embodied'.
[26] This is the point Rover seems to miss. More on this remains to be seen in the sequel. See also *SP*, p. 85.

Further, one basing himself on Maritain's view could agree with Rudner that there is a real difficulty in Morris' idea that the signified can be physically present in the sign and while regarded as such still be signified. Apprehension would terminate in the real, physical presence, as Morris in fact wants, instead of the signified meaning. This difficulty is not found, however, in Maritain's view that the signified is *present* in the sign in a mode of being other than that possessed by the sign vehicle as a purely physical object, since this other mode is purely relational. And because there are these two modes of being in a sign situation, the sign is enabled to be[27] – *in alio esse* – what it signifies, without the consequence that everything is a sign of itself. Hence on Maritain's view one can agree with Rudner concerning (3), that it is the physical object which is referred to by 'the work of art' and not something else nor the object *plus* something else; but at the same time one will not be forced to deny (2), claiming that there is not something signified or that it has no aesthetic relevance.[28]

7. Because of the apparent tensions among them, then, one might accept either (1) or (3) or both and on this basis reject (2) either partially or in full. Some thinkers, however, accept (2) and as a result either explicitly deny (3) or place its truth in doubt. Thus, holding that what is signified by the signs is not physically present but is aesthetically relevant, one might tend to separate the work of fine art which is being perceived in an act of aesthetic awareness from the physical, produced object. Of course, on a causal theory of perception such as is implied in Pepper's or Harold Osborne's views of the work of art, the work would become disassociated from the physical vehicle in any event[29]; but within the context of a realism which makes the physical thing present in consciousness, there is still the problem of the status of the *signified* – as it takes its place in aesthetic experience – in relation

[27] The *is* here cannot be construed as the is of exemplification. See above, Chapter III, n. 75 on analogous predication in sign situations, as well as below, the Appendix, on propositional structure and its lack of isomorphism with what is in the world.

[28] On the level of formal signs and the whole problem of knowledge one sees the same considerations at work. There it is a question of how the same thing can both be *in* consciousness and *independent* of it or of how what is signified by the content of consciousness can both be *mediately* known through this content and yet known *directly*. We have seen how Maritain approaches the problem with his doctrine of intentional being in the discussion of formal signs and concepts as formal signs in Chapter III. In speaking of art objects as signs, we are speaking not of what Maritain calls formal signs but rather of instrumental signs; nevertheless there is in both an intentional existing-in of the signified.

[29] Stephen Pepper, "On Professor Jarrett's Questions," p. 636; "The Work of Art Described from a Double Dispositional Base," p. 422; *The Work of Art*, p. 91; Harold Osborne, *Theory of Beauty* (London, 1952), pp. 91-100. See also above, Chapter I.

to the perceived physical object. In the case of the statue of Socrates, Socrates is not "really" in the stone; it somehow requires an act of consciousness for him to be there. Perhaps, then, the shaped stone is only a means or a stimulus for the imagination to proceed to form for itself an object of aesthetic awareness or a work elements of which are suggested or signified by the statue but which are not actually there.

8. Roman Ingarden expresses a view of this nature in an article devoted to the formation in consciousness of the aesthetic object. The article is of particular interest here because it deals not specifically with the literary work, as does his *Das Literarische Kunstwerk*, but with objects of fine arts generally and takes its illustrations from the more tangible forms that have been our central concern.[30] In it he grants that we see this autonomous block of stone referred to by 'the Venus of Milo' but denies that the aesthetically experienced work or aesthetic object, which includes its represented meanings, is to be identified with it.

He distinguishes perception of real objects in the world – in an investigating attitude – from aesthetic experience. The latter can begin with the perception of a real object, but this perception is only a *"basis* for the further peculiar psychic acts, built over it," which lead to the object of aesthetic experience. A real object is shaped by the artist such that it "provides a psychic subject with stimuli to form a corresponding aesthetic object." Thus the aesthetic object is not identical with any real object, but some real objects furnish a starting point and basis for the building up of some aesthetic objects.[31] Even on the level of the sensory qualities of the work taken just in themselves we *supplement* details that add to the value of the experience or *overlook* things that shock us, that introduce a disharmonious factor if noticed. We act as though we do not see the dark stain on the nose of Venus; we fill up the rough spots and cavities in the stone, seeing the surface of the breast as smooth. It is not merely a question of doing this with respect to posterior damage in order to reconstruct the original, as would be proper to an investigating attitude directed to ascertaining

[30] Ingarden, "Aesthetic Experience and Aesthetic Object," *Philosophy and Phenomenological Research*, 21 (March, 1961); referred to hereafter as "Aesthetic Experience." One might note that Ingarden holds that the literary work is *purely* fictitious and that in constituting it as aesthetic object we need not begin with the perception of a real object. ("Aesthetic Experience," p. 290; *Das Literarische Kunstwerk*, pp. vi-vii).

[31] Ingarden calls the physical, produced object in sculpture, painting, and architecture the *work of art* and the object of aesthetic awareness the *aesthetic object*. Since he, unlike Maritain, makes a distinction, I will adopt Ingarden's usage of these terms in discussing his views. (See "Aesthetic Experience," pp. 289, 294, 301, 304).

the character of the original real object.[32] Rather, there is a movement toward the optimum aesthetic experience. Consequently even at this level there tends to be a separation of the physical from the aesthetic object.

What is of importance in the present context, however, is how this separation happens with regard to signification or representation. Ingarden says that in the process of aesthetic perception there are two kinds of formation of qualities, namely into *categorial structures* and into *qualitative harmony structures*. It is his treatment of the first kind which is of especial relevance here since it is specifically an "imposition" of the represented object by the percipient. In beholding a statue, for example, in the aesthetic attitude, we see the shape as the shape of a human body though pure vision alone would reveal only a piece of stone. What happens is that

We pose a corresponding *subject of properties*, which would underlie the quality of the given shape: *a human body*, and *not this* subject of properties which belongs *in reality* to the said shape (i.e., a piece of stone or that of a canvas covered with pigments). Similarly, in other cases of the so-called "representational art": upon the qualities given we are, as it were, imposing the categorial structure of such an object represented as may appear in the *given* qualities. Thereby we *leave the realm of the real* objects perceived (of a given work of art – stone, building, canvas), substituting an entirely different subject of properties for the removed subject of properties. The new subject should be chosen in such a way that it could be a substratum just of the qualities given; or, in other words: *this substratum is determined in its qualitative equipment by the choice of the qualities grasped as well as by the relations between them.*[33]

The language in this passage suggests – perhaps hyperbolically – that the role of consciousness in the formation of the aesthetic object is a more active one than in "ordinary" perception; we "pose" a subject or even "impose" it, "substituting" it for the real subject. It is actually "chosen" by us to harmonize with the "choice" of qualities of the work we have elected to grasp. If in the "constituting" of a new subject of properties we "add" to the given qualities a *psychic* subject, then we "project" into the aesthetic object, along with the subject, its particular *psychic states*, depending on the outward expressions which appear among the given qualities. The implication in all the above is that the aesthetically relevant signified subject is not in the work, that it comes from the percipient and even that there may be a trace of arbitrariness about its selection, though this point will need to be examined in more

[32] *Ibid.*, pp. 292-293.
[33] *Ibid.*, p. 304.

detail shortly. And because this meaning tends to be conceived as sepa-
rate from the work, there is further reason for regarding the aesthetic
object as separate from it. In the formation of the aesthetic object the
realm of real objects is left behind and the new subject of properties
"assumes the *character of a separate entity, which becomes present to us.*"[34]

Now it is because of the active role of consciousness in making these
substitutions in representative art, projecting the meaning in the phy-
sical object or work, that the question arises as to whether the signified
is actually present in any way in such an object. Ingarden's language
leaves us with little reason to suppose that it is. Perhaps, however,
there is some interaction between the percipient and the work so that
the constitution of the aesthetic object is not a purely arbitrary affair
and is somehow controlled by the work. What does Ingarden have to
say about that?

First of all, there is passivity in aesthetic experience. He speaks of
it as including both active and "fleeting" passive phases, which are
"the moments of turning motionless and contemplative." In these pas-
sive phases the object is not *given* us as a piece of marble but as a
woman which we see. Nevertheless, on the whole the process is not a
passive, non-creative contemplating. Aesthetic experience is rather a
part "of a very *active*, intensive and creative life of an individual..."
The passive moments about which we have spoken in fact *follow* the
active categorial formation-phases. "After the phase of the categorial
forming of the object (represented) there follows correlatively the phase
of *perception* (as if of reception) of this object..."[35]

But this does not yet come to the crux of the matter, and we must
inquire about the role of consciousness and the influence of the pro-
duced object with regard to the character of the represented in the
active phases of building up the aesthetic object. The rather lengthy
passage previously introduced contained the view that the "choice" of
represented subject is influenced by the choice of qualities grasped.
Now there is a preliminary quality or pattern of qualities which origi-
nally strikes us and invites us to adopt an aesthetic attitude. In the
formation of the aesthetic object further qualities are added to the
preliminary quality, and there are in this regard two cases to be con-
sidered: (a) there is a deficiency noticed in the preliminary quality it-
self which requires a finishing or filling in, or (b) *new* details of the

[34] *Ibid.* Compare Sartre, *The Psychology of the Imagination* (New York, 1948), pp. 273-282.
[35] "Aesthetic Experience," pp. 300, 304. Note that it is not really reception; it is *as if*
there were.

work impose themselves on us. In the first case, the work may suggest the additional qualities which it does not possess; the preliminary quality may "call" to be completed in a certain way. In this event – and it is interesting to note the emphasis on activity – we may "search ourselves" for these qualities which "suggest themselves." But further, it may happen that the work does *not* suggest that which would give rise to a completion or harmony of all the given qualities or which would lend itself to being formed into a certain categorial structure. Then we must *find* such an element, which – if vividly enough present in consciousness – may be imposed upon the work, "though the work itself does not authorize us to do so." (This is perfectly in order since an aesthetic object is formed having a richer qualitative content than what is suggested by the work, which is only a starting point. However, because of the "imposing" of this gestalt of qualities on, for example, a piece of marble, the latter may seem to function as the basis of these qualities; and we may forget the difference between the aesthetic object formed and a real object, thinking that it is the latter we are experiencing.) Even in case (b), where the new details are really furnished by the work rather than just suggested by it or imposed upon it, Ingarden says that we do not wait passively for the new qualities to be imposed on *us* by the work but rather actively search in it for new qualities that will harmonize with the initial one.[36]

Does the work or the perceiver, then, determine the selection of qualities and ultimately the "represented" subject? Ingarden's position is not unambiguous on this point as the foregoing suggests. Certainly the work at least *lends* itself to the result and causes us to reject certain possibilities. If qualities which the work actually possesses do not "agree" with the complementary elements, this circumstance can prevent the imposition of the latter on the work. Also, the work may actually "suggest" or even possess these elements, but even here Ingarden says that it need not lead to a single precisely determined result. There may be a number of admissable qualitative harmonies suggested to the percipient.[37] Now, coming to the representation itself (or the substituted subject of the properties), which is one of the supplementations of the preliminary quality, Ingarden's statement that this is "determined by the qualities themselves"[38] at first glance appears actually to place the significance in the work. But he also says

[36] *Ibid.*, pp. 302, 303.
[37] *Ibid.*, pp. 303, 307.
[38] *Ibid.*, p. 312.

that the representation is that which *may* appear in the given qualities.[39] Thus the determination of represented subject could well be principally negative, an exclusion of some alternatives rather than a positive demand for any single one of them. Furthermore, the selection of qualities themselves which are said to provide the determination is hardly independent of the perceiver.

Consequently, we must conclude that in spite of these recognitions of an important role which the produced physical object (or work of art as he calls it) plays in aesthetic experience and of the contribution it makes to the aesthetic object, the tendency of Ingarden's thought is to emphasize the active role of consciousness in forming the aesthetic object and to avoid saying that the physical work must in some way embody its represented meaning. The work may influence the imposition of the sense and perhaps even be a *vehicle* of it, but nowhere do we read that it really has it.[40] Ingarden implies that *phenomenally* speaking the representations are seen in the work, since the preliminary quality is said to appear "against the background of the so-called work of art."[41] And he does not say that the represented subject I see is totally unrelated to what the artist had in mind. But there is a fundamental ambiguity about whether or in what sense the representations are embodied or are present in the work.

9. The same problem is evident in the position expressed by Virgil Aldrich in his *Philosophy of Art*. A brief look at some of his views will be helpful. He distinguishes two categories in the mode of perception of a given material thing, namely *observation of a physical object* and *prehension of an aesthetic object*. In the latter category the characteristics of the material thing are realized as "aspects" ("objective impressions") that "animate" it as opposed to "qualities" that "qualify" it. Representational works of art feature the kind of animation in which there is a "seeing the thing as something that it is not thought really

[39] *Ibid.*, p. 304.

[40] Mikel Dufrenne criticizes Ingarden sharply on this point even in the sphere of words and their significations. He observes that Ingarden opposes the heteronomy of the represented object to the autonomy of the perceived object, separating too much the sense of the word from the word itself. Thus he cuts off the significations too radically from the perceived. Dufrenne suggests that actually the sense of a work of art is perceived, because it is *in* that which is perceived. The perceived carries the represented sense in it, offering it to perception. M. Dufrenne, *Phénoménologie de l'expérience esthétique* (Paris, 1953), pp. 266-273.

[41] "Aesthetic Experience," p. 301.

to be..." Thus this figure

can be seen as – among other things – a lampshade from above or below, and "the figure is not mistaken for a lampshade while it is being seen as one, but it is animated by the image of something else."[42] Aldrich's notion that a representational work of art is to be seen *as* something involves a distinction of Wittgenstein's between *seeing* and *seeing as*. In the case of this figure

where there is no ambiguity it is appropriate to say that "I see a face" or "I see a picture-face" and not "I see it *as* a face."[43] But with the previous figure, where there can be many interpretations such as a square suspended in a frame, a tunnel, and an aerial view of a truncated pyramid – as well as the lampshade views – it is appropriate to say "I see it *as* a lampshade viewed from above," rather than "I see a lampshade" or "I see a picture-lampshade."[44]

Aldrich explains that what such a figure is seen as is conditioned by what the beholder has in mind, but nevertheless the aspect seen is not just subjective; "the figure objectively accommodates the various aspects." So it is not just a case of imagining something. I do not imagine that the figure is a lampshade; I *see* it as such. "Nor does such seeing involve a projection of an image into the material; the material... exhibits it for prehension."[45] Here again the problem is whether the tunnel-pyramid-lampshade figure really embodies its meaning or whether it merely *lends* itself to such structures, which will be seen *in* it and which it will be seen *as* – in a manner similar to ink blots, cloud formations, or Leonardo's damp-stained wall seen as a landscape. With the

[42] (Englewood Cliffs, 1963), pp. 22-23.
[43] L. Wittgenstein, *Philosophical Investigations* (New York, 1953), pp. 193-195.
[44] Aldrich, p. 20; see Wittgenstein, pp. 193-208.
[45] Aldrich, pp. 20-21, 25, 51. For Aldrich this is the case even for something like a damp-stained wall or a cloud formation, which exhibits what it does as a result of completely fortuitous happenings. See p. 51.

last-named illustration in mind Aldrich attempts to clarify his view with respect to art by saying that the artist can produce something that is not vacillatingly seen as this or that, "but [is] to be regarded as something definite."[46] Now while it may not *vacillatingly* be seen as this or that, still Aldrich implies that it is seen *as* whatever it is interpreted to be – it is interpretation rather than just seeing which is involved – and that the work may accommodate different interpretations of what it represents, quite apart from what the artist may have intended. Thus he says:

The work of art itself is expressive or representational, independently of the artist's initial intention, though what he intended to do usually has some relation to the result.[47]

Or more strongly:

The arbiter... will also remember to be patient with various interpretations of the same work, in view of the fact that, within limits, it can be seen as different things, as are paintings under the suggestion of different titles, some of which aspects even the artist may have been blind to.[48]

10. A difficulty with Aldrich's view is that there would seem to be a phenomenal difference between a work which merely lends itself to seeing something in it and one which embodies a meaning or meanings – that is, one whose finality is to present meaning which it has. Thus when I look at Kandinsky's *Accompanied Contrast* I see a large blue form on the left as a door of a stagecoach – not vacillatingly but constantly, no other represented meanings offering themselves to me for its interpretation –[49] and some forms on the right as a setting sun and a salad-oil bottle on its side. But it seems clear also that these possible interpretations are not any part of what is meant by elements in this painting even though these representations can be seen *in* the work. Only the shape is suggestive of the interpretation and even this is not such in any insistent way. Details of it in fact resist this sense. Further there are no other details which would tend toward reinforcement. In short, as in the case of ink blot interpretation, there is both a lack of appropriate elements which we might expect and details left over, which if they do not clash with the organization in question at least do

[46] *Ibid.*, pp. 2, 41, 51.
[47] *Ibid.*, p. 49.
[48] *Ibid.*, p. 93. See also p. 3.
[49] Here it is appropriate to say "I see it *as* a door" since it is not clearly representative of such, merely lending itself to this interpretation. There is another alternative open in this instance – seeing it as non-significatory.

not fit in and must be ignored.[50] On the other hand, Rouault's *Two Women in Profile* displays a meaning which not only is seen in the work but also presents itself as belonging to and structuring the work. There is a definite drawing together of its qualities around its represented meaning which does not permit us to stray from what so clearly appears as there and as meant to be there; everything "fits."

Of course there are cases not so clearly one or the other, but this does not alter the fact that the difference in the two instances seems to be one which is not merely of degree; and while Aldrich's excellent treatment of the subject seems sound as far as it goes, it does not adequately account for this difference or explain whether the meaning is somehow truly present in or embodied in the work.[51] Aldrich's thought does not so explicitly tend, as Ingarden's does, to separate the aesthetic object from the material thing; but the problem is to account for the identity of the aesthetic object with the material thing when the latter tends to be characterized as only *potentially* containing the meanings which are seen in it.[52]

11. As in the case of the difficulty involved in the disagreement between Morris and Rudner, Maritain's doctrine of intentionality – with its notion of the presence of the significance of a sign in the sign – furnishes a possible approach by which to deal with the problems noted in Ingarden's and Aldrich's positions. The artist's vision endows the work with a meaning or intentionality in terms of which the work is structured "entitatively."[53] That is, its material is physically organized in such a way that its meaning as given it by the artist is made to appear in it. Now while ink blots and Kandinsky paintings can be seen as such-and-such, this meaning (at least in the instances in mind) is not communicated to these productions by the executor and does not structure or reside in them. I may *see* it *in* the blot or the painting and they may *accommodate* or lend themselves to what is seen in them, but still I as beholder must in such a case – in spite of what Aldrich claims – impose the meaning on them since it has no existence in them at all. In contrast, I can, in the case of what is truly (intentionally) present in, for

[50] This is not to deny that Kandinsky's work under discussion is organized. It is only to say that the suggested representational meanings do not enter into its organic wholeness.

[51] Put another way, Aldrich's view does not adequately account for the differences which give rise to the locutions "I see a face" and "I see it as a lampshade" or for different possible uses of the latter expression.

[52] See Aldrich, p. 21.

[53] As Maritain states it in one place, the poetic sense in the work is responsible for its inner consistency, its configuration, and its very being and existence. (*CI*, p. 191).

example, a Rouault painting, awaken the latent meanings of the work and perceive what is really embodied in it in an intentional mode of being.

This brings us to the question of *virtual* presence. Maritain, too, holds for an active role of consciousness in bringing it about that the meaning appears in the work. This is crucial in relating Maritain's theory of signs to Ingarden's view since there is agreement with Ingarden that there are, overlying pure sensory perception, psychic acts by which the aesthetic object is realized. Nothing in Maritain's thought, however, suggests that these are of a sort that "improve" upon the physical characteristics of the fabricated work,[54] thereby disengaging at the outset an aesthetic object from it. But the latent meanings – *virtually* present in the physical work – *are* brought to a state of actuality by the activity of consciousness. At the same time, there is for Maritain a real interaction between the physical work and consciousness since the meanings are not just potentially present. The meanings are embodied in the work – not entitatively and not actually, but truly there none the less, intentionally and virtually. Consequently, it is not a case of imposing a meaning on it or even of it merely *causing* me to experience something which it does not in some way possess. This being so, Maritain's view does not call for a *separation* of aesthetic object from physical work. It is true that a work *considered* as aesthetic object with its representational elements would not be fully actualized until it is experienced. But what is experienced is the fabricated physical thing itself with the meanings that it already has prior to the experience. Its meaning is not imposed upon or projected into it but rather simply made to come forth by the intentional activity of consciousness.

Thus one might say that although the work taken as aesthetic object does not become separated from the physical object, the latter exists as

[54] At this point we encounter a language difficulty. 'Work' will continue to be used as it has been in the preceding – in Ingarden's sense. At the same time, the point is being made that Maritain means more by it than this, since for him 'work' also means that which is aesthetically experienced. If, however, 'aesthetic object' were to be used exclusively to refer to what Maritain means by 'work,' the resultant emphasis would be misleading since it would stress an "objectification" that is not in keeping with Maritain's thought. (Maritain himself does not adopt this usage). It is the *produced* object which is that which is aesthetically experienced, and 'work' emphasizes this point. Thus, though 'work' *means* more (has a greater sense or intension) for Maritain than for Ingarden, the reference of the term is the same for both. In the sequel it will always be used to *refer* to the physical, fabricated object. But from taking it in Ingarden's *sense*, we shall come to take it in Maritain's, since indeed this is the whole thrust of the discussion. The context should indicate what sense is to be understood in each instance.

[55] As explained in Chapter III, for Maritain the intentional being of any knowledge is of necessity not restricted to being a material thing or one of its inhering "entitative" qualities.

such a work in a context of minds. A mind has presided over the forma-
tion of it; the shaping of the material is governed by the "spirituality"
of the artist's vision[55]; and minds are able to awaken – and to see –
to some degree these poetic meanings in the work which are available
there. As Maritain says at one point about creative activity, the intelli-
gence of man seeks to produce "a work at once material and spiritual,
like ourselves, and in which superabounds something of our soul."[56]
And just as for Maritain there is no radical dualism in man, so too there
is none in the work. It is one work, a physical object, but one in which
dwells a sense that is both the imprint of creative mind and an avail-
ability for minds to awaken and take delight in.

As a consequence of Maritain's making the sense an integral part
of the work rather than something to which the work taken only as a
deployment of matter in space accommodates itself, the work tends to
be a *communication* of poetic experience. The sense of the work is not
just the way I see it, but what is *there*, having been put there by the
artist. Maritain cautions that experience of the work must not be merely
a mirroring of our own customary feelings – a sort of free-wheeling
association in its presence. Rather "we must listen to the interiority of
the work and to the poetic sense, be open to what it conveys... And
this requires a sort of previous, tentative *consent* – to the work and to
the intentions of the poet – without which we cannot be taken into
the confidence of the poem."[57] Here, of course, we must not understand
Maritain in a more rigid way than he has in mind. The work is con-
crete, an "existential achievement" rather than a counter for abstract
meaning; and consequently it has, as Chapter IV has explained, an
ambiguity and diffusiveness of meaning in virtue of which it may mean
more than or succeed in conveying less than the artist had in mind.

... a great work lives a life of its own throughout generations – admired, detested,
forgotten, rediscovered; and the facets of its message are perpetually changing.
What matters is that something be perceived of what was contained, even vir-
tually, in the inexhaustible intuition from which it proceeds. And it is our good
fortune if the smallest bit of it is really conveyed to us.[58]

[56] "An Essay on Art," p. 88.

[57] *CI*, pp. 208-209. In the earlier *SP*, Maritain puts it more strongly. He observes that
Reverdy's poems are obscure, and experiencing their beauty requires consenting to the ob-
scurity. "The fact is that such a preliminary consent, I mean a consent to the intentions of
the artist, is always required for the understanding of a work of art and the communication
which that understanding presupposes." (*SP*, p. 45).

[58] *CI*, p. 209.

Thus Maritain here combines his idea of the artist's intention as the criterion for the meaning of the work with what as a matter of fact does occur in aesthetic experience – that works may have a value or display a significance which does not entirely correspond to that consciously intended by the artist.[59] Still, on the one hand one *strives for* the intentions of the artist as a goal in the beholding of the work, and on the other hand it is the sense which has structured the work and which is really dwelling in it that is rich with the ambiguities of meaning referred to by Maritain. It may have facets or correspondences which the artist does not see; but this does not alter the fact that it is not, for Maritain, some sense other than what the artist has communicated to the work.

We have said that if the sense is an integral part of the work, the latter tends to be communicative of poetic experience. But if the work as produced object is *essentially* communicative, there would be grounds here too for thinking of the object of aesthetic awareness as separate from the physical object since the latter would tend to become only a vehicle for the former. Its only function would be to signify the meaning by disappearing in the face of it. Maritain, however, is careful in speaking of communication not to make this separation. The artist seeks to bring to concrete expression his poetic vision, working primarily for the good of the work. As a social being he may have a real need to communicate, and because the work is intelligible its meaning is communicable. But communication is for Maritain not the end which governs the fine artist's activity.[60] The artist, in seeking to create something which embodies or expresses in a concrete way his poetic experience, produces an object which has its own beauty, which is a delight to behold because of its own intelligibility. This embodiment is a "world of its own." It borrows its meaning from the world but asks us to suspend belief or disbelief and accept it on its own terms as a unique thing.[61] It has both a certain density to it as it stands in front of me and at the same time a certain openness or communicativity as it takes up into it meanings caught by the artist in things and as it

[59] Of course, just that there is ambiguity need not mean it is not intended by the artist. Alternative interpretations such as one finds in Kafka's "A Hunger Artist," for example, seem to be there by design. In this case, in fact, it would seem as though the multiple interpretations are meant to be taken together, each adding its significance to the symbolism of the piece.

[60] *A & S*, pp. 63; 205, n. 138; *SP*, p. 49.

[61] As he expresses it in one place, "Nature... is the inspirer of an imaginary world which he [the artist] draws from Things..." (*CI*, p. 23).

displays or radiates them, so to speak, for the benefit of minds of beholders.

12. Maritain has striven accurately to describe aesthetic experience. That this is so is indicated by the degree to which he has, I believe, succeeded in it. But it is also indicated by the fact that he does not sacrifice fidelity-to-experience for the sake of system. The examination and analysis undertaken here should have made this point evident. But still further, this fidelity is made possible by the fact that Maritain has attempted to account for aesthetic experience in terms of a meta-physical tradition which is not reductionistic. This feature it owes to its well-known doctrine of the analogy of being, its fundamental notion. Because being is not identifiable with any one of its modes, the way is opened for things to be in many ways. As a result there can be inten-tional as well as entitative being, virtual as well as actual being, and the like. Consequently, Maritain is able to provide a theoretical basis for the richness of aesthetic experience that seems not to be possible with less sophisticated metaphysical apparatus. It is far beyond the scope of this book to treat further or to evaluate these metaphysical pre-suppositions; others have engaged in these pursuits in books and ar-ticles too numerous to mention. It is sufficient to say here that because Maritain's views are able to provide a subtle theoretical foundation which does not lead to the exclusion of aesthetically rich facets of our experience of art, his position deserves serious study in any attempts to resolve the issues which have occupied us throughout the book.

APPENDIX

We have spoken in the body of this study about the inability of intellectual analysis, for Maritain, to comprehend the total meaning of a singular thing or event in its uniqueness. It seems well to elaborate this point a little further, isolating Maritain's underlying ontological reasons.

Needless to say, Maritain, basing his views on a Thomistic ontology and epistemology, does not regard the furniture of the world as made up of irreducible entities corresponding to the parts of a proposition and structured in a way that corresponds to the structure of the language – however formulated – used to refer to it.[1] Metaphysically speaking, for the followers of Aquinas it is the *thing* and the thing as a whole in all that pertains to it – the tree, Fido, Socrates – which is the ultimate irreducible and not the various properties and relations which belong to it and which one can isolate in thought.[2] Except for names of things, language refers through the medium of concepts[3] which iso-

[1] Thus the structure of the S-P (subject-predicate) proposition, e.g., is not a reflection of or isomorphic with, a substance-accident structure in things; instead, the predicate signifies *what* that to which the subject refers is, in some cases essentially and others accidentally. In short, the relation of subject and predicate in S-P propositions is to be understood in terms of the traditional doctrine of the predicables rather than the predicamentals. What happens when one assumes the contrary can be illustrated by the case of Bradley and his problems which lead him to require an absolute as a ground of unity. See his *Principles of Logic*, Book I, Chapter II; *Appearance and Reality*, Chapter II. For its part, *exemplification*, born out of a similar assumption about the way language means, is not altogether immune – as an escape from the Bradley regress – from being labeled a *deus ex machina*. See B. Russell, "The Philosophy of Logical Atomism," in *Logic and Knowledge* (London, 1956), Chapters II and III, and passim.; E. Allaire, et al., *Essays in Ontology* (Iowa City, 1963).

[2] There are problems, of course, determining in various cases what metaphysically is truly a thing rather than a collection of or a part of a thing. Cf. *Creative Evolution*, pp. 15-16.

[3] And because of this, expressions have sense as well as reference. Maritain's approach to the logical problems which Russell's Theory of Descriptions is designed to solve would without doubt utilize the supposition theory. See Maritain's *Introduction to Logic* (New York, 1937), pp. 59-72; 95-96; 222-223. See also Strawson's "On Referring," *Mind*, 59 (1950), pp. 320-344 for a critique of Russell growing out of a distinction of meaning and reference.

late intelligible *aspects* of unitary things. These aspects are not constituent entities making up a whole, the unity of which would require an ontological glue – and perhaps even a further glue to glue the glue to the glued – to hold them together.[4] Consequently, one could not even theoretically string together abstract concepts of aspects of things or linguistic symbols of these concepts and thereby reconstitute cognitively the individual whole.[5] Moreover, the concept grasps aspects of things or things in terms of an aspect only insofar as the aspect is duplicable in many and not in its unique mode of being instanced in a given case.[6]

All of this simply means that there is a metaphysical depth to an individual, temporal existent which resists any attempts to exhaust it conceptually or reflect it linguistically. Although Maritain would classify himself a realist, he is saying that there is a uniqueness about what exists which poetry can and does attempt to grasp in its concreteness – rather than in its duplicable aspects understood as universal. It is this kind of meaning which can organize a work such that the work is an end in itself, a "world of its own," and not just a vehicle for the transmission of something abstract and universal.

In connection with the mention of intelligible aspects or natures, a final observation is in order. What we have said about these aspects, which because they are not *entities* are not referred to in ordinary non-metaphysical discourse, has implications with respect to the problem

[4] And these aspects cannot be terms of real relations since they are not entities or parts of entities.

[5] In spite of Maritain's denunciation of Bergson's view of the concept as not properly recognizing the capability of the intellect to grasp things as they are, the Thomistic position in general on the concept and Bergson's agree on the point being annotated. For Bergson a concept does not represent a *real part* of the whole, but only a *partial notation* or aspect. Thus a whole cannot be reconstituted by stringing together symbols – either conceptual or linguistic – which represent the results of intellectual analysis. If analysis were dismemberment into real parts, i.e., really distinct entities or discrete parts, one could theoretically do this, but such is not the case. Concepts are merely partial expressions of the whole from one standpoint. To add all our concepts of a thing together would be to multiply points of view, but would not give us a comprehensive grasp of the organic whole. This Bergsonian doctrine would have to be understood somewhat differently to make it square with Maritain's Thomism, but there would be agreement on the main point. [See *Introduction to Metaphysics* (New York, 1949), pp. 34-36; *DK*, p. 127; *BPT*, pp. 307-309]. As Maritain puts it, concepts are a disengagement of essences, which exist in things in a state of singularity. These essences are not entities or *things* but rather are immanent in things, determining them to be what they are – essences are not a *that which* but a *that by which* something is such-and-such. (See "On the Notion of Subsistence: Further Elucidations 1954" in *DK*, Appendix IV, pp. 435-436. Compare what he says in this article written in 1954 with his critique of Bergson's view of the concept in the early *BPT*, pp. 138-141. See *DK*, p. 127, for an illuminating statement of Maritain's view of the concept).

[6] See "On the Notion of Subsistence: Further Elucidations 1954," pp. 435-436.

of truth in art. These meanings in things can be taken over by the artist (without reference to any entity in the world) and made to function in the organization of a work so that they appear in it more manifestly than in things.[7] From this point of view it can be said that a work is true insofar as it is meaningful. (As Heidegger phrases it, truth in this sense is the "discoveredness of what is.")[8] The work may make no references to real individuals and no general assertions about the world, but it will have a significance of its own about which true statements can be made. Furthermore, because it must borrow its meaning from things,[9] it reflects or "imitates" in its own concrete way the world from which it borrows as it affects the poet. Thus by implication, at least some of the statements which are true of the work will also in some sense be true of the world, even though the purpose in creating the work may not be to "say" something about the world. Thus 'Play x tells the truth' would not necessarily mean that there are statements in x that are true of something in the world but rather that x has a meaning and that some statements about x which intend aspects of that meaning will also in some sense be true about what is independent of the work.[10] For Maritain, however, the work of fine art is not meant to convey knowledge. The work's intelligibility is borrowed from things and from the whole of the situated artist's world, which it will therefore reflect; but the work is a new creation, a unique "world of its own" in its perfect singularity. The delight which is its reason for being is a delight in the splendor that the work itself has.[11]

[7] See *FP*, p. 127.

[8] "Origin of the Work of Art," pp. 676-680.

[9] Above, Chapter III.

[10] Cf. Ingarden, *Das Literarische Kunstwerk*, pp. 297-308 and 311, especially 307. This analysis would apply to the plastic arts as well.

[11] See *CI*, pp. 45, 86, 134, 166.

BIBLIOGRAPHY

Aldrich, Virgil C. "Art and the Human Form," *Journal of Aesthetics and Art Criticism*, 29 (Spring, 1971), pp. 295-302.
"Design, Composition, and Symbol," *Journal of Aesthetics and Art Criticism*, 27 (Summer, 1969), pp. 379-388.
Philosophy of Art. Englewood Cliffs, New Jersey: Prentice-Hall, 1963.
 Anderson, James F. *The Bond of Being*. St. Louis: B. Herder, 1949.
 Ballard, Edward G. "In Defense of Symbolic Aesthetics," *Journal of Aesthetics and Art Criticism*, 12 (September, 1953), pp. 38-43.
 Barr, R. R. "A Relational Analysis of Intentionality," *The Modern Schoolman*, 40 (March, 1963), pp. 225-244.
Beardsley, Monroe C. *Aesthetics: Problems in the Philosophy of Criticism*. New York: Harcourt, 1958.
 Bell, Clive. *Art*. London: Chatto & Windus, 1949.
 Berall, Nathan. "A Note on Professor Pepper's Aesthetic Object," *Journal of Philosophy*, 48 (November 22, 1951), pp. 750-754.
 Bergson, Henri. *Creative Evolution*. New York: Modern Library, 1911.
An Introduction to Metaphysics. New York: Liberal Arts Press, 1949.
The Two Sources of Morality and Religion. Garden City: Doubleday, 1935.
 Bilsky, Manuel. "The Significance of Locating the Art Object," *Philosophy and Phenomenological Research*, 13 (June, 1953), pp. 531-536.
 Bosanquet, Bernard. *A History of Aesthetic*. New York: Meridian, 1932.
 Brazzola, Georges, "Introduction à la poétique de Jacques Maritain," *La Table Ronde*, January, 1959, pp. 62-66.
"La Poésie et les sources créatrices dans la vie de l'esprit," *Recherches et Debats*, 19(July, 1957), pp. 66-68.
 Callahan, John L. *A Theory of Esthetic According to the Principles of St. Thomas Aquinas*. 2nd ed. Washington: Catholic University Press, 1947.
 Calmel, Thomas. "Frontières de la Poésie," *Revue Thomiste*, 48 (1948), pp. 123-141.
 Chisholm, Roderick. "Intentionality and the Theory of Signs," *Philosophical Studies*, 3 (1952), pp. 56-63.
 Clancy, William P. "The Intuition of Maritain," *Commonweal*, 59 (December 25, 1953), pp. 309-310.
 Collingwood R. G. *Principles of Art*. Oxford: Clarendon, 1938.
 Coomaraswamy, Ananda K. "Intention," *American Bookman*, 1 (1944), pp. 41-48.
 Croce, B. *Aesthetic*. New York: Noonday, 1922.
 Darbellay, Jean. "Jacques et Raïssa Maritain: 'Situation de la Poésie',"

Bulletin Thomiste, 15 (July-September, 1938), pp. 407-419.

Dewey, John. *Art as Experience*. New York: Capricorn, 1934.

Dimler, G. "Creative Intuition in the Aesthetic Theories of Croce and Maritain," *New Scholasticism*, 37 (October, 1963), pp. 472-492.

Donagan, Alan. "The Croce-Collingwood Theory of Art," *Philosophy*, 33 (1958), pp. 162-167.

Donnelly, Francis P. "The Where and Why of Beauty's Pleasure," *Thought*, 5 (September, 1930), pp. 261-271.

Ducasse, C. J. *Art, the Critics and You*. New York: Piest, 1944.

Dufrenne, Mikel. *Esthétique et Philosophie*. Paris: Editions Klincksieck, 1967. *Phénoménologie de l'expérience esthétique*, 2nd ed., 2 vols. Paris: Presses Universitaires de France, 1967.

Elton, William, ed. *Aesthetics and Language*. New York: Philosophical Library, 1954.

A Guide to the New Criticism. Chicago: Modern Poetry Association, 1948.

Fallico, Arturo B. *Art and Existentialism*. Englewood Cliffs, New Jersey: Prentice-Hall, 1962.

Freye, Northrop. *Anatomy of Criticism*. Princeton: Princeton University Press, 1957.

Gallagher, Donald and Idella. *The Achievement of Jacques and Raissa Maritain: A Bibliography 1906-1961*. New York: Doubleday, 1962.

Gaillie, W. B. "The Function of Philosophical Aesthetics," *Mind*, 57 (1948), pp. 302-321.

Gilbert, Katherine. "Recent Catholic Views on Art and Poetry," in her *Aesthetic Studies*. Durham, North Carolina: Duke University Press, 1952.

Gilby, Thomas. *Poetic Experience: An Introduction to Thomist Aesthetic*. London: Sheed & Ward, 1934.

Gilson, Etienne. *The Arts of the Beautiful*. New York: Scribner's, 1965.

"The Forgotten Transcendental: Pulchrum," in his *Elements of Christian Philosophy*. New York: Doubleday, 1960.

Painting and Reality. New York: World, 1957.

Grace, William J. "A Scholastic Philosopher and the New Criticism," *Thought*, 17 (September, 1942), pp. 489-498.

Hamm, V. M. "Creative Intuition and Scholasticism," *America*, 90 (October 31, 1953), pp. 127-129.

"The Ontology of the Literary Work of Art: Roman Ingarden's 'Das Literarische Kunstwerk'," *The Critical Matrix*. ed. Paul R. Sullivan. Washington: Georgetown University Press, 1961.

Hausman, Carl R. "Maritain's Interpretation of Creativity," *Journal of Aesthetics and Art Criticism*, 19 (Winter, 1960), pp. 215-220.

Hay, Gerald Conrad. "Maritain's Theory of Poetic Knowledge: A Critical Study," Dissertation, Catholic University of America, 1964.

Hayen, A. *L'Intentionnel dans la philosophie de saint Thomas*. Paris: Desclée de Brouwer, 1942.

Hazo, Samuel John. "An Analysis of the Aesthetic of Jacques Maritain," Dissertation, University of Pittsburgh, 1957.

Heidegger, Martin. "Origin of the Work of Art," trans. A. Hofstadter, *Philosophies of Art and Beauty*. ed. Albert Hofstadter and Richard Kuhns. New York: Modern Library, 1964.

Henze, Donald F. "Is the Work of Art a Construct?" *Journal of Philosophy*, 52 (1955), pp. 433-439.

"The Work of Art," *Journal of Philosophy*, 54 (1957), pp. 429-442.

Hospers, John. "The Croce-Collingwood Theory of Art," *Philosophy*, 31 (1956), pp. 291-308.

Ingarden, Roman. "Aesthetic Experience and Aesthetic Object," *Philosophy and Phenomenological Research*, 21 (March, 1961), pp. 289-313.

Das Literarische Kunstwerk. Halle: M. Niemayer, 1931.

Jarrett, James L. "More on Professor Pepper's Theory," *Journal of Philosophy*, 49 (July 3, 1952), pp. 475-478.

John of St. Thomas. *The Material Logic of John of St. Thomas*. trans. Yves R. Simon et al. Chicago: University of Chicago Press, 1955.

Joyce, James. *The Portable James Joyce*. New York: Viking, 1946.

Kahn, S. J. "What Does a Critic Analyze?" *Philosophy and Phenomenological Research*, 13 (December, 1952), pp. 237-245.

Köhler, Wolfgang. *Gestalt Psychology*. New York: Liveright, 1929.

Langan, Thomas. *The Meaning of Heidegger*. New York: Columbia University Press, 1959.

Lechner, Robert. "Jacques Maritain: Metaphysical Beauty," in his *The Aesthetic Experience*. Chicago: Regnery, 1953.

Levi, A. W. "Scholasticism and the Kantian Aesthetic," *New Scholasticism*, 8 (July, 1934), pp. 199-222.

Lévy-Bruhl, L. "Correspondence: Lettre à propos de l'article de J. Maritain: 'Signe et Symbole'," *Revue Thomiste*, 44 (1938), pp. 482-483.

Lewis, C. I. *Analysis of Knowledge and Valuation*, LaSalle, Illinois: Open Court, 1947.

McCall, R. E. "The Metaphysical Analysis of the Beautiful and the Ugly," *Proceedings of the American Catholic Philosophical Association*, 30 (1956), pp. 137-146.

McKeon, Richard P. "Literary Criticism and the Concept of Imitation in Antiquity," *Modern Philology*, 34 (August, 1936), pp. 1-35.

Madaule, Jacques, "Métaphysique et poésie: ouvrages récents de M. et Mme. Maritain," *La Vie Intellectuelle*, 4 (1936), pp. 322-329.

Maritain, Jacques. *Approaches to God*. trans. P. O'Reilly. New York: Harper, 1954.

Art and Poetry. trans. E. de P. Matthews. New York: Philosophical Library, 1943.

Art and Scholasticism and the Frontiers of Poetry. trans. Joseph W. Evans. New York: Scribner's, 1962.

Bergsonian Philosophy and Thomism. trans. Mabelle L. and J. Gordon Andison. New York: Philosophical Library, 1955.

Creative Intuition in Art and Poetry. New York: Meridian, 1953.

The Degrees of Knowledge. trans. under the supervision of Gerald B. Phelan. London: Bles, 1959.

Distinguer pour unir: ou, les degrés du savoir. New ed. Paris: Desclée de Brouwer, 1946.

Existence and the Existent. trans. Lewis Galantière and Gerald B. Phelan. New York: Pantheon, 1948.

Georges Rouault. New York: Harry N. Abrams, 1954.

An Introduction to Logic. New York: Sheed & Ward, 1937.

"Language and the Theory of Sign," *Language: An Enquiry into its Meaning and Function*. ed. Ruth N. Anshen. New York: Harper, 1957.

Neuf Leçons sur les notions premières de la philosophie morale. Paris: Pierre Téqui, 1951.

La Philosophie Bergsonienne. Paris: Rivière, 1914.

"Poetic Experience," *The Review of Politics*, 6 (October, 1944), pp. 387-402.

A Preface to Metaphysics. New York: New American Library, 1962.
Quatre Essais sur l'esprit dans sa condition charnelle. Paris: Alsatia, 1956.
The Range of Reason. New York: Scribner's, 1952.
Ransoming the Time. New York: Scribner's, 1941.
Réflexions sur l'intelligence et sa vie propre. Paris: Nouvelle Librarie Nationale, 1924.
The Responsibility of the Artist. New York: Scribner's, 1960.
Scholasticism and Politics. Garden City: Doubleday, 1940.
Maritain, Jacques and Raïssa. *The Situation of Poetry*. trans. Marshall Suther. New York: Philosophical Library, 1955.
Maritain, Jacques and Jean Cocteau. *Art and Faith*. trans. John Coleman. New York: Philosophical Library, 1948.
Moore, G. E. *Principia Ethica*. London: Cambridge University Press, 1903.
Morris, Charles W. "Esthetics and the Theory of Signs," *Journal of Unified Science*, 8 (1939), pp. 131-150.
"Science, Art, and Technology," *Problems of Aesthetics*. ed. Eliseo Vivas and Murray Krieger. New York: Holt, Rinehart and Winston, 1960.
Signification and Significance. Cambridge, Massachusetts: M.I.T. Press, 1964.
Signs, Language and Behavior. New York: George Braziller, Inc., 1946.
Morris, Charles W. and D. J. Hamilton. "Aesthetics, Signs, and Icons," *Philosophy and Phenomenological Research*, 25 (March, 1965), pp. 356-364.
Noon, William T. *Joyce and Aquinas*. New Haven: Yale University Press, 1957.
Oesterle, John A. "Our Poetic Knowledge," *Proceedings of the American Catholic Philosophical Association*, 29 (1955), pp. 86-99.
Osborne, Harold. *Theory of Beauty*. London: Routledge and Kegan Paul, 1952.
Peirce, Charles Sanders. *Philosophical Writings of Peirce*. ed. Justus Buchler. New York: Dover, 1940.
Pepper, Stephen C. *The Basis of Criticism in the Arts*. Cambridge, Massachusetts: Harvard University Press, 1945.
"Further Considerations of the Aesthetic Work of Art," *Journal of Philosophy*, 49 (April 10, 1952), pp. 274-279.
"On Professor Jarrett's Questions," *Journal of Philosophy*, 49 (1952), pp. 633-641.
The Work of Art. Bloomington, Indiana: Indiana University Press, 1955.
"The Work of Art Described from a Double Dispositional Base," *Journal of Aesthetics and Art Criticism*, 23 (Summer, 1965), pp. 421-428.
Pepper, Stephen C. and Karl Potter. "The Criterion of Relevancy in Aesthetics: A Discussion," *Journal of Aesthetics and Art Criticism*, 16 (December, 1957), pp. 202-216.
Phelan, Gerald B. "The Concept of Beauty in St. Thomas Aquinas," *Aspects of the New Scholastic Philosophy*. ed. Charles A. Hart. New York: Benziger, 1932.
Phillippe, M.-D. "L'Esthétique de Jacques Maritain," *Revue des Sciences Philosophiques et Théologiques*, 41 (1957), pp. 245-248.
Pouillon, H. "La Beauté, propriété transcendentale chez les Scholastiques (1220-1270)," *Archives d'Histoire Doctrinale et Littéraire du Moyen Age*, 21 (1946), pp. 263-329.
Prall, David W. *Aesthetic Analysis*. New York: Crowell, 1936.
Régis, L.-M. *Epistemology*. New York: Macmillan, 1959.
Rieser, Max. "Roman Ingarden and His Time," *Journal of Aesthetics and Art Criticism*, 29 (Summer, 1971), pp. 443-452.
Rover, T. D. *The Poetics of Maritain*. Washington: Thomist Press, 1965.
Rudner, Richard. "On Semiotic Aesthetics," *Journal of Aesthetics and Art Criticism*, 10 (September, 1951), pp. 67-77.

"The Ontological Status of the Aesthetic Object," *Philosophy and Phenomenological Research*, 10 (1950), pp. 380-388.

"Some Problems of Nonsemiotic Aesthetic Theories," *Journal of Aesthetics and Art Criticism*, 15 (March, 1957), pp. 306-308.

Sartre, Jean-Paul. *The Psychology of Imagination*. New York: Citadel, 1948.

Sillem, E. A. "Jacques Maritain and the Philosophy of Art," *Dublin Review*, 229 (1955), pp. 176-187.

Simonin, H. D. "La Notion d'intentio dans l'oeuvre de S. Thomas d'Aquin," *Revue des Sciences Philosophiques et Théologiques*, 19 (1930), pp. 445-463.

Simonsen, Vagn Lundgaard. *L'Esthétique de Jacques Maritain*. Paris: Presses Universitaires de France, 1953.

Sparshott, Francis. "Mr. Ziff and the 'Artistic Illusion'," *Mind*, 61 (1952), pp. 376-380.

Steenberg, Elisa. "The Scholar's Object: Experience Aesthetic and Artistic," *Journal of Aesthetics and Art Criticism*, 30 (Fall, 1971), pp. 49-54.

Tate, J. "Plato, Art and Maritain," *New Scholasticism*, 12 (1938), pp. 107-142.

Turner, V. "M. Maritain on Creative Intuition," *Month*, 12 (November, 1954), pp. 270-280.

Ushenko, Andrew P. *Dynamics of Art*. Bloomington, Indiana: Indiana University Press, 1953.

Van Ackeren, G. F. "On the Contemplation of Beauty," *The Modern Schoolman* 18 (1941), pp. 53-56.

Vivas, Eliseo and Murray Krieger, eds. *The Problems of Aesthetics*. New York: Holt, Rinehart and Winston, 1953.

Weiss, Paul. *The World of Art*. Carbondale, Illinois: Southern Illinois University Press, 1961.

Wellek, René and Austin Warren. *Theory of Literature*. New York: Harcourt, 1942.

Wild, John. "An Introduction to the Phenomenology of Signs," *Philosophy and Phenomenological Research*, 8 (1948), pp. 217-233.

Wimsatt, W. K., Jr. "The Foundations of Aesthetics," *Thought*, 23 (December, 1948), pp. 691-694.

"The Structure of the 'Concrete Universal' in Literature," *PMLA*, 62 (March, 1947), pp. 262-280.

The Verbal Icon. Lexington, Kentucky: University of Kentucky Press, 1954.

Wimsatt, W. K., Jr. and Monroe C. Beardsley. "The Affective Fallacy," *Sewanee Review*, 57 (1949), pp. 458-488.

Wittgenstein, L. *The Blue and Brown Books*. New York: Harper, 1958.

Philosophical Investigations. New York: Macmillan, 1953.

Wollheim, Richard. *Art and Its Objects: An Introduction to Aesthetics*. New York: Harper & Row, 1968.

Ziff, Paul. "Art and the 'Object of Art'," *Mind*, 60 (1951), pp. 466-480.

INDEX OF NAMES